Art for

FRA

The Essential Guide to
Viewing Art in Paris and its Surrounds

Art for Travellers

FRANCE

The Essential Guide to Viewing Art in Paris and its Surrounds

BILL AND LORNA HANNAN

ILLUSTRATIONS BY ERIN ROUND

I

Interlink Books
An imprint of Interlink Publishing Group, Inc.
New York • Northampton

First published in 2004 by

INTERLINK BOOKS
An imprint of Interlink Publishing Group, Inc.
46 Crosby Street, Northampton, Massachusetts 01060
www.interlinkbooks.com

Cover painting: Hubert Robert's *Imaginary View of the Grand Gallery of the Louvre in Ruins*

Library of Congress Cataloging-in-Publication Data
Hannan, Bill.
 France : the essential guide to viewing art in Paris and its surrounds / by Bill and
Lorna Hannan.
 p. cm. —(Art for travellers)
Includes bibliographical references and index.
 ISBN 1-56656-509-X (pbk.)
 1. Art, French—Guidebooks. 2. Art—France—Guidebooks. 3.
France—Guidebooks. I. Hannan, Lorna. II. Title. III. Series.
 N6841.H36 2003
 709'.44'07444--dc21

 2003000188

All painting reproductions are used in this book with the kind permission of:
The Bridgeman Art Library; The Louvre, Paris; Musée Marmottan Monet, Paris;
Musée d'Orsay, Paris; Musée National d'Art Moderne, Paris.

Printed and bound in Korea

To request our complete 40-page full-color catalog, please call us toll
free at 1-800-238-LINK, visit our website at **www.interlinkbooks.com**,
or send us an e-mail: info@interlinkbooks.com

Table of Contents

Introduction

About the Trails

The art in France is from every possible epoch, but this guide concentrates on the great art movements that originated in France: the cathedrals of the Middle Ages (Section 1), the painting of the 19th-century Impressionists (Section 2) and some 20th-century art (Section 3). The French have also collected a great deal of art from other countries. Like the Impressionists, most of these collections are in museums in Paris. The highlights of these collections are described in Sections 3 and 4.

Nearly all of these periods and collections can be seen in and around Paris. The exception is the art of the Middle Ages, which can be found in abundance throughout France but is very well represented in Paris and its surrounding region. In short, you can become thoroughly acquainted with the best of French art by setting up in Paris, so this guide concentrates on Paris and the areas surrounding it. Public transport in Paris is so good that you can stay anywhere, but the inner districts along the river– *arrondissements* 1 to 6 – allow you to walk to most places and are wonderful just to stroll around anyway.

Because travellers have different interests, we've divided the art riches of France into several sections, each covering a different category. In Section 1: Paradise on Earth, we propose trails around the huge riches of medieval art in and near Paris. Section 2: After the Naked Lunch, contains trails that cover Impressionist and Post-Impressionist painting. The painters were mostly French and their works are nearly all in Paris. Many individual works are discussed in detail. The third section, Art and Anti-art, goes in search of representative examples of the art of the 20th century, some French, some international. Many of these works are in the Georges Pompidou Center. Finally, Section 4: World Art in the Louvre, proposes trails through that museum's large and diverse collections of ancient Greek art and Italian and French painting. At the end of the book are appendices – biographical notes, a list of saints, Biblical terms and events (to help you understand medieval art), a glossary and an index.

INTRODUCTION

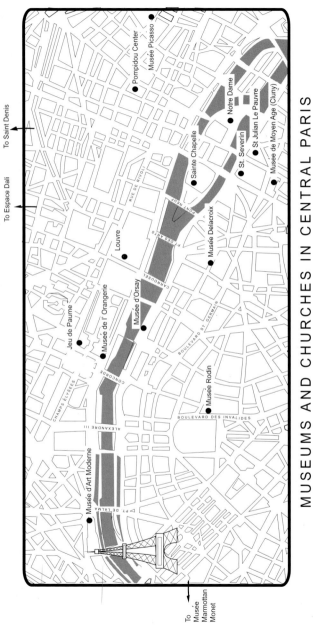

MUSEUMS AND CHURCHES IN CENTRAL PARIS

In our opinion it's best to take things slowly so that you can think about and remember what you see. To help you select we have indicated in each section what we think is most worth seeing if your time is very limited. If you have just one day in Paris, do the starred items in Trail 1 and 2 (The Impressionists and Post-Impressionists) in the morning, have lunch at the Orsay, then walk along the river to Notre Dame and study the sculpture of the west façade, the buttressing and the rose windows (Trail 1 of the Middle Ages).

Tips for the Traveller

When planning your itinerary, check opening days first. Mondays and Tuesdays are favored in France as days of closure. You'll find opening times listed for each museum in the trails. Shops often close on Mondays, too.

- Churches are open from sunrise to sunset or later if there are services or concerts. Touring is limited during services. There is usually no entrance fee, but special sections such as crypts, treasuries, towers and the like have to be paid for and sometimes include a guided tour. Consider leaving something for the upkeep of the church. Some concerts and recitals are free, but most are not. (They are listed in the weekly *Pariscope,* available at kiosks and issued on Wednesdays.)
- Most museums charge entrance fees. They can range from 4 to 10 Euros. National museums (Orsay, Louvre etc) have few discounts, except for young people. Others give over 60 kinds of discounts. You often have to ask for the age discount because it is often not advertised. Ask for "seniors." A few museums do not charge entry to their permanent collections. Big places such as the Louvre have one free Sunday a month. Museums and tourist offices sell a *Carte Musées et Monuments* (ticket for museums and monuments) for multiple visits over one, two or three days, but unless you want to rush around several museums each day, it doesn't look worth the money.
- Tipping in restaurants throughout France is minimal, but if you don't want a sit-down meal, bakeries have large stocks of hearty sandwiches and other snacks. Lunch in France is the main restaurant meal and fixed price menus cost much less at midday than in the evening. Since lunch starts a bit after noon and restaurants can be crowded, you have to count on a fairly short morning. Quite a few museums get around this problem by having restaurants within the museum – a bit more expensive generally but worth it for the

INTRODUCTION

convenience and the ambience. Carry some water if you can.

- In Paris, signposting and travel information are very good. Maps of the metro are legion and metro stations have maps of the quarter around them as well as maps of the rail and bus systems. In this guide, locations in Paris are always given in relation to the nearest metro underground station. The same tickets can be used for all rail and bus travel within central Paris.

- Make a realistic assessment of your stamina. Art touring shouldn't be treated as a test of endurance or self-denial. Have nothing to do with the idea that any place has to be done in one single visit! Big collections just become burdensome if you take that approach. Decide beforehand what you're going to concentrate on and basically stick to it. Focus on a manageable section, take your time, and plan some rest periods. Stretching exercises performed periodically can really help that low back pain that some people get after long periods standing.

- Decide whether and how you want to make a record of the trail. Notes? Sketchbook? Photos? Flashes are forbidden – you will be reminded of this by an attendant just about every time you take out the camera. To get a good view of sculpture, stained glass and architectural detail in medieval cathedrals, low power binoculars are a great help.

- Museums and galleries have non-paying toilets. The city generally has few public toilets, nor can they be found at railway stations. Take advantage of the ones you see.

SECTION 1:

PARADISE ON EARTH: FRENCH ART OF THE MIDDLE AGES

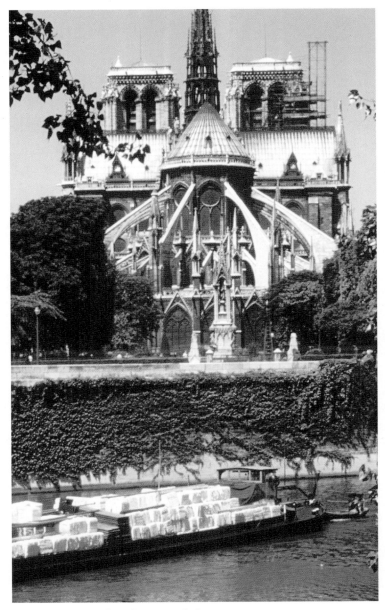

Notre Dame, viewed from Ile St. Louis looking west

Introduction

A Brief History of Medieval Architecture and Art

In the Middle Ages, architecture was mostly concerned with building the great churches. There are two major styles: Romanesque and Gothic. This guide deals with early Gothic, which developed in and around Paris.

The Romanesque style, prevalent from the 10th to 12th centuries, set out to create a solid, contemplative, earthly space into which the light of heaven filters indirectly from above. Exteriors were splendidly sculpted and interiors were usually painted. Although the painting has seldom survived neglect and modern restorers' taste for austerity, there is still a sculptural feast to be relished. Both Notre Dame de Paris and Notre Dame de Chartres retain some Romanesque sculpture on their west portals. Great Romanesque churches and monasteries are still the highlight of art touring in central and southern France. Many are pilgrimage churches along the famous road that leads to Santiago de Compostela in Spain. The style was often best expressed in monastic centers of which Cluny was the wealthiest at the beginning of the 12th century.

The shift to Gothic, in the middle of the 12th century, was marked by more advanced technology and planning. With this came the sophisticated use of buttressing to raise ceilings even higher and to empty walls of stone. Soon, the walls were almost entirely of glass. Stained glass was used, as painting had been, to tell the Christian story. Sculpture continued to flourish but gradually became more humanized. In effect the Gothic style re-created a heaven on earth in response to an age when humanism was replacing the mysticism of earlier centuries.

The early story of Gothic building is one of audacious innovation. The builders resolutely stuck to stone construction but virtually defied their material by seeking more light. The masons of the Middle Ages understood and worked stone as it had never been worked before and

has never been worked since. They did astonishing things with it that are beyond the technical capacities of masons of any other time. So entranced were they by the possibilities of building in stone that they took unimaginable risks, pushing up to enormous heights, and succeeding in making buildings with methods that are still only barely understood. Essentially, they put their trust in the mystique of geometry and the astonishing talent of their masons. Each building attempted to go higher and look less solid. For a long time the great church at Cluny, later destroyed in the Revolution, was the tallest church in France – 81 feet high, an astounding height for a Romanesque barrel-vaulted church. Notre Dame de Paris exceeded it by nearly 9 feet. Chartres soared 99 feet high and Amiens 114 feet. Finally, limits were reached: Beauvais rose 132 feet from pavement to keystone (higher than Saint Peter's in Rome) but fell over during construction and was never completed.

Paris and the area around it, known as the ile de France, is the birthplace of Gothic art. One of the world's great building booms happened there in the 12th and 13th centuries, and the great works of this period were the cathedrals. Because they were built of stone, they come to us today in reasonably complete form in spite of natural disasters, revolutions, neglect, and vandalism.

At their peak, the cathedrals were lavishly decorated works whose external gilt and paintwork sparkled in the sun and whose stained glass attempted to create the marvellous light of heaven within. As well as being richly ornamented with sculptures, gilded, painted in rich blues and reds and highlighted with precious and semi-precious stones, they were also lavishly endowed with precious objects by church, state, and citizenry. Over the centuries, the gilt and the paint have not been renewed so that we now see them as austere works in natural stone colors. What remains of their rich endowments in precious metal works and miniature works has mostly been transferred to museums.

The concentration of artistic effort on cathedrals in the 12th and 13th centuries reflects both the political status of the church and the economic and urban growth of the times. The intellectual basis of Gothic art at its peak in these centuries was religious. The great cathedrals were commissioned by bishops and their symbolism and iconography conceived by theologians. They were designed and built by master architects and stone masons who understood how theological ideas could be translated into the most abstract elements of building, and decorated by sculptors and glass workers whose art was sometimes

astonishing and always accomplished, learned and innovative. Their financing expressed not only the pride of a whole community but also its faith in the Christian view of the universe.

Some cathedrals took centuries to complete but those such as Notre Dame de Paris and Notre Dame de Chartres, which were built at the peak of enthusiasm, had their essential structures up within a couple of generations. By the end of the 13th century, Gothic art was beginning to run out of steam. A lot of it continued to be built and called Gothic but its intellectual force had waned.

These art trails concentrate on three of the greatest buildings that stand at the junction of the Romanesque and Gothic periods, when the ideas of the Gothic were in full tide. Saint Denis, the earliest, but unfortunately most damaged, exploited many-colored light as an analogy of the divine. Its mastermind, the Abbot Suger, wanted to bring paradise ("The true light of God," said Suger) into the sacred site that was the repository of France's patron, Saint Denis.

The sculptors of Saint Denis, brought in from the south of France, worked on other cathedrals, including Chartres, which was partly destroyed in 1194 but soon rebuilt. Notre Dame de Paris suffered greater damage from church authorities and activists of the French Revolution over the centuries but was brilliantly retrieved and restored in the 19th century. Saint Denis had to survive bad 19th-century restoration before finding a sympathetic restorer. (Viollet-le-Duc in both cases.) Of the three, Chartres remains the most intact. It is unquestionably one of the world's greatest buildings and one of the world's greatest collections of sculpture.

In addition to the buildings, there are collections of objects and art works of the time in the Louvre and the National Museum of the Middle Ages. In both places, statues, stained glass windows, and capitals can be seen up close. In addition, there are miniatures, jeweled reliquaries, and ceremonial objects made for the church of that time that reveal extraordinary skill and control of materials as well as vivid pictorial imagination.

Some architectural terms, such as voussoirs and tympanum are extensively used in these Trails and may be unfamiliar to the reader. The glossary at the back provides a ready reference to these terms and they will soon become part of your art vocabulary. Saints, Biblical terms, characters, and stories – also part of the medieval art vocabulary – are described in other appendices for those who are not familiar with them.

INTRODUCTION: ART OF THE MIDDLE AGES

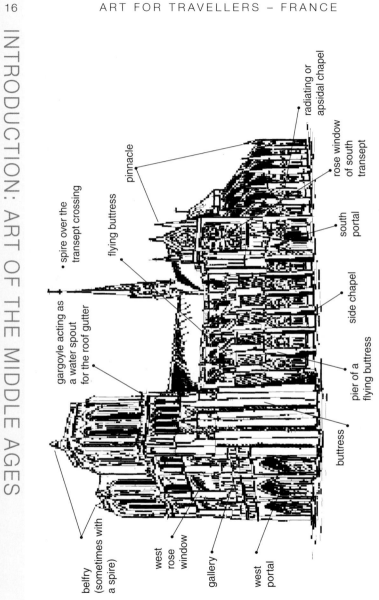

The external features of a typical Gothic cathedral

- spire over the transept crossing

pinnacle

flying buttress

radiating or apsidal chapel

rose window of south transept

south portal

side chapel

pier of a flying buttress

buttress

gargoyle acting as a water spout for the roof gutter

belfry (sometimes with a spire)

west rose window

gallery

west portal

Three Major Figures in Medieval Architecture

SUGER, ABBOT OF SAINT DENIS (1081–1152)

The Abbot Suger was a truly remarkable man who came from a quite unremarkable (even poor) family and, in an age of hereditary privilege, rose to take his place with the highest in the land. He took advantage of every opportunity to become learned, cultured and politically influential. As abbot of the monastery of Saint Denis, he had its basilica rebuilt under the direction of Pierre de Montreuil. Its beauty and prestige have attracted visitors for 900 years. The wondrous light-filled transept was, for Suger, designed to represent God's goodness to humankind. Although the basilica was outside the Paris of his day, it was established as, and remains today, the official burial place of the French royals. In his lifetime, Suger's ties to royalty were strong; he filled the role of regent for two years while the King Louis of the day was at the Crusades. His portrait, close to Christ's, can still be seen in the Last Judgment at the main door of the basilica. Several objects that belonged to Suger are now in the medieval collection of the Louvre as testimony to his fine eye for precious objects.

JEHAN DE CHELLES (DIED 1265)

A 13th-century master builder, Jehan was born in Chelles, to the west of Paris. It is sometimes suggested that he was a cousin of Pierre de Montreuil, an equally prestigious master builder of the same time. From about 1256 until his death in 1265, he worked on the remodelling and additions to Notre Dame de Paris, on which building had begun in the 12th century and which his work now made higher and lighter. In this work, he followed the lead of Pierre de Montreuil's work on the innovative transept of the Basilica of Saint Denis. He was responsible for three of the original rose windows at Notre Dame, but not for the southern rose, which was still unfinished when he died. At the base of the southern portal of Notre Dame de Paris are the words (in Latin) that commemorate his work: "In 1257, on Tuesday February 12th, this work was begun in honor of the Mother of Christ and in the lifetime of the Master Mason Jehan de Chelles." After Jehan's death, Pierre de Montreuil took over and saw the original southern rose window of Notre Dame through to completion.

PIERRE DE MONTREUIL (DIED 1267)

Pierre de Montreuil was another 13th-century master builder – one of the few greats of that time whose names survive today. Master builders filled the roles of architect, structural engineer, supervisor of construction and, often, supplier of materials. Pierre lived in Saint Germain on the Rue du Four and worked in the Paris region. When it came to designing for light, his was a genius that has stood the test of time. We still see his work today in the transept of the Basilica of Saint Denis, where he was in charge from 1230–1268, and in the wonderful Sainte Chapelle where dramatic scenes, set out in the light of stained glass, lead the eye through great sweeps of biblical history. On the death in 1265 of Jehan de Chelles, Pierre took over and completed the work. Examples of his work in the Museum of the Middle Ages (also called Musée de Cluny) underline the message left for us by the monks of Saint-Germain-des Pres on his epitaph. "Here lies Pierre, born at Montreuil, a flower overflowing with the perfume of virtue, in his lifetime, the Doctor of Masons. May the King of Heaven place this flower on eternal heights. He died in the year of Christ 1267." Today, a monumental garden in his honor is set out in the grounds at the northern entrance to the Basilica of Saint Denis.

An Overview of Trails in this Section

The Trails through the Middle Ages pay particular attention to the architecture and sculpture of the early Gothic period, when daring innovation scaled high peaks. Trails 1 and 2, Notre Dame de Paris and Sainte Chapelle, are both in the Ile de la Cité and could conceivably be done in a day, depending on how much time you spend on the riches of Notre Dame. Also in the heart of Paris are the medieval art museum collections, visited in Trail 3. This may be accomplished in a single day as well. When you visit the Louvre, you may even decide to go directly to World Art in the Louvre, Section 4, to view Italian and French paintings. The Louvre, however, has such enormous collections we advise breaking it up into subject areas and seeing it over several trips. Trail 4 goes a little farther afield, to one of the founding buildings of the Gothic style, Saint Denis, which is located on the edge of central Paris but reachable by metro. Trail 5 takes you on a short walk through the Left Bank. Trail 6 goes outside Paris for a one- or two-day trip to the great cathedral of Chartres and other cathedrals to the west and north of Paris.

TRAIL 1:
Notre Dame de Paris

Location: Near Cité Metro Station, Parvis-Notre Dame, Ile de la Cité
Opening Times: The church is usually open from 8:00 am to dusk.
The Crypte Archaeologique or Underground Archaeological Museum is
open from 10:00 am to 6:00 pm or 5:00 pm during winter. The Museum of
Notre Dame is open on Wednesday, Saturday and Sunday afternoons
between 2:30 and 6:00 pm.
Admission: Free to the church; about 5 Euros to the Crypte
Archaeologique, with reductions for the over 60s; about 5 Euros to the
Museum of Notre Dame

To walkers Notre Dame is a landmark visible from both the left
and right banks of the Seine on either side of the Ile de la Cité in
central Paris. Choose the day you visit carefully. Sundays are
largely reserved for church activities and your freedom of movement is
restricted. On Saturday it is crowded and the chairs have been put out
for Sunday. During the early part of the week, chairs are cleared to the
side and you can get a good feel for the majesty of the nave of the
cathedral. Bright days are obviously better for seeing the stunning rose
windows and in general for seeing the interior.

A plaque on the wall just past the southern transept tells us that the
cathedral, dedicated to Our Lady of Paris, was begun by Maurice de
Sully, the bishop of Paris, in 1163 CE. The bishop wanted a church for
Paris in the new manner pioneered by the Abbot Suger at Saint Denis. A
new cathedral could both assert the supremacy of the cathedral of Paris
and give glory to Mary, probably the most significant cult figure of the
12th century. We do not know whom he commissioned to begin this
great work.

If you look carefully at Notre Dame, you can easily spend a half-day
here, have lunch, and then go onto Trail 2, Sainte Chapelle, at the other
end of the Ile de la Cité.

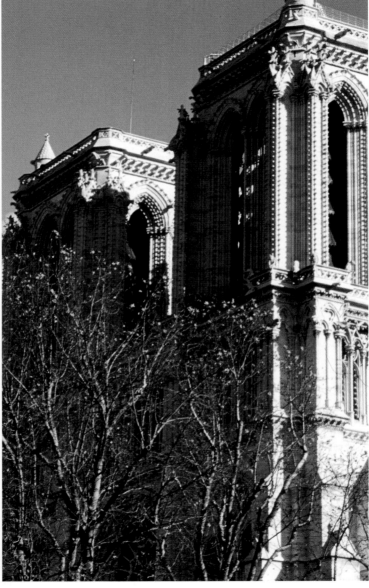

The main façade of Notre Dame

The Exterior

THE PARVIS

The parvis (the word comes from Latin for paradise) is the area of open space in front of the cathedral. In Merovingian times, around 600 CE, an earlier cathedral to St Etienne (St Stephen) was built here, reputedly a very dark but gorgeously decorated building. Its outline is still marked on the parvis in cobblestones. On your left as you face the cathedral you'll see a flagstone in the ground labelled "Porch of the old cathedral of Saint Etienne." The original parvis of Notre Dame came up to about the row of stone posts standing across the space. The rest was covered with hospitals, churches and shops. A wide street (for the time), over six yards across, led to the old parvis. This is marked on the paving now as Rue Neuve de Notre Dame de Paris and was created so that the carts carrying the stone for the new cathedral could get in to make their deliveries. If you stood in the center of the Rue Neuve at the time the cathedral was built, you would have seen the central doorway but not the whole façade. Try it.

The streets nearby were filled with the shops of scribes, booksellers, goldsmiths, food shops, wine sellers – much as the side streets leading to Notre Dame de Paris are today. A number of these old buildings are marked on the ground. Such was the centrality of Notre Dame de Paris to the kingdom of France that it was the point from which all roads from Paris to the rest of France were measured: in the ground about 13 yards from the front door is a piece of brass surrounded by the words "Point zero des routes de France."

The present parvis was created in the 19th century by Haussmann, the town planner who also created the *grand boulevards* so beloved of the Impressionist painters.

THE MAIN FAÇADE

Since work lasted from 1200 to 1250, the main façade itself is the work of several architects and includes many sculptures. Work on cathedrals was frequently delayed, sometimes by lack of money, but often so that the building would settle and the mortar set (which then took a long time). When a delay was necessary, the master and his workshop would shift to another site. When work resumed, the same master would not necessarily return. So, for a church of the period, the façade of Notre Dame de Paris seems rather uniform and symmetrical. It is divided horizontally into

three parts: the portals and statues on the lowest level, the rose window layer, and the two towers. It is important in looking at any medieval building to remember that the builders and ecclesiastics who instructed them took the symbolism of numbers and geometry very seriously. The life of the spirit and the heavens was constructed to perfect geometric principles and geometry was a means of mirroring the ideal spiritual world. The presence of two square towers anchoring the façade relates the western end of the church to the material world thus: in medieval numerology, two is the material side of the duality in which one is the spirit. The towers have four sides and are based on the symbolism of two (two squared equals four) so they represent the material world that the people leave in order to enter the House of God.

Those in charge of the cathedral kept up the gilding and painting to the end of the 15th century, after which there were several centuries of neglect and vandalism. Later, at the urging of French literary figures – particularly Victor Hugo – it was

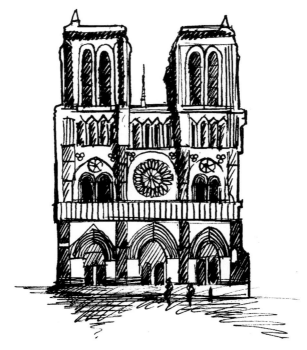

Notre Dame of Paris

comprehensively restored and renovated by the great 19th-century architect Viollet-le-Duc. Such works as the heads of the line of kings, the large statues in the niches of the portals, and the gargoyles and grotesques that you see if you toil up the staircase of the Northern Tower, are his.

Before we turn to the intricacies of the lower level, look at the uppermost two levels.

THE ROSE WINDOW

The centerpiece of the second layer is the great western rose with the statue of the Virgin and angels in front of it. The rose was gilded so that from the outside it would have glinted preciously in the sun to match the glow that the sun gave it on the inside. The stone is from quarries nearby and when newly cut would have been whitish as it is now when it's cleaned. On either side of the rose, the supports of the building are trimmed down to fine colonnettes – so fine that it seems they could be suspended from the building rather than supporting it, which is what they do. The Middle Ages was one of the few eras in which builders exclusively used stone, but the medieval architects are here turning stone into space and the colossal weight of the stone is absorbed into what looks like decoration.

THE TWO TOWERS

The third layer, the towers, shows some of the asymmetry of the façade. The southern or right tower is less decorated than the one on the left and has different openings visible within. Between the two towers, you can glimpse the spire that sits over the point where the nave and the transept cross. The original spire eventually collapsed and this one is a 19th-century work. Some speculate that Notre Dame de Paris was meant to have spires, at least on the towers.

Now we will view the lower level in detail. It contains the three portals and the great line of kings whose heads were knocked off in the Revolution and are now in the National Museum of the Middle Ages (see Trail 3 in this section). The revolutionaries thought the statues were of kings of France, but they were the kings of Judah and could have stayed. When the building was new, the three portals and the gallery of kings were painted and gilded.

The best surviving sculpture of the façade is in the three portals below the row of kings. As you face the western or main end of the cathedral, the smaller portal on your right is known as the Portal of Saint Anne; the central portal is the Portal of the Last Judgment and the portal on the left is the Portal of the Virgin. There is so much marvellous sculpture here that you almost need to set up camp out in front. Binoculars will help.

THE PORTAL OF SAINT ANNE

Dating from the 13th century, the portal tells the story of the mother of Mary. It begins in the last quarter of the lower lintel where Anne and her husband Joachim are offering something to a priest. Both are under arches inside a building. The building in fact is the temple in Jerusalem, identified by the lamp inside. The story continues to the right of the lintel and then in the four statues, which stand at the feet of the channels (voussoirs) that run from there up to the top and down the other side of the tympanum. Part of the story is also in the very middle, projecting from the lintel above the central statue of Saint Marcel. The beginning of the story shows Anne and Joachim's offering being rejected (because they are childless) by the rabbi whose left hand is appealing to a nearby scroll for authority. To the right of the severe Rabbi, we see Joachim greatly stressed by his childless condition and setting off with a companion for a spell in the desert. In the first statue on the voussoir Joachim is shown looking after his sheep out in the desert. In the next, an angel talks to Joachim and tells him that his wife Anne is going to have a child. Back in the center of the doorway, just above the central statue, an angel gives the good news to Anne. In the third voussoir, Joachim is making his way back to Jerusalem. In the fourth, he embraces Anne beneath an arch.

The dress of the figures in this story is medieval. The story is taken more from legend than the Bible, but it has the great medieval gift of summarizing the essence of a story visually. At the time, most ordinary people would have been familiar with the story and would have had no trouble identifying its series of dramatic moments. The sculptor would have been taking care to make his work fit with that of the 12th-century sculptures above it but it is simpler in its subject matter and somewhat more down to earth than the glorious ethereal figures above it.

The statue of St Marcel in the middle (below St Anne receiving the good news) and the eight large statues at the feet of the

voussoirs are re-creations from the 19th century. The originals were destroyed partly by neglect and partly by revolutionaries. Restoration was by the highly talented Viollet-le-Duc.

On the left side of the lower lintel of the Portal of Saint Anne, another legend is told. Mary, now aged 15, has to choose a husband. Since Mary is of good birth, a number of suitors line up. The suitors bear branches to the altar of the temple just behind where Mary is standing. The winner, however, is the old man who makes a late appearance on horseback. He is chosen because of his blossoming rod. Saint Anne greets him. Despite his age and lowly occupation, he and Mary join hands with Anne and Joachim and they are married. Mary has long hair and wears a crown. The story of Mary and Joseph then continues to the right side of the lintel. In the first pair, Joseph asks Mary to forgive him for having doubted her story about why she was pregnant. An angel hovering above confirms her account. In the second pair, she helps him up off his aging knees so that they can set off and wait for the birth. In medieval times, Joseph was always thought to have been a fair bit older than his bride.

On the upper lintel and the tympanum above, the story is continued. This part of the story dates from the 12th century and was on a part built before the transepts of the cathedral were widened. It was shifted to the new position when the building was being reshaped prior to its completion. This explains why the portal is a mixture of work done at such different times.

The clue to its overall tone, both in narrative and style, is given by the portrait of the Virgin Enthroned, above. The theme is the royal status and majesty of the Virgin. The total effect, which is achieved with elegant line and posture, is like a royal procession.

Beginning at the left, the prophet Isaiah, who predicted the coming of the Messiah in the Old Testament, has been brought in to watch the proceedings. Next, the archangel Gabriel, a highly elegant and princely figure, announces the conception to Mary, who appears to accept the news with grace. She then tells her cousin Elizabeth, who embraces her in a somewhat ladylike manner. In the middle, Mary has given birth and is lying back in a luxurious bed. Above her, in equal luxury, is the child. A trio of angels preside over the accouchement from a cloud. Joseph has nodded off, as fathers will when it's all over. Some shepherds with their flock gaze around at the heavens, which as we know, are ringing with "Hosannas." Behind the shepherds, a couple of

NOTRE DAME DE PARIS

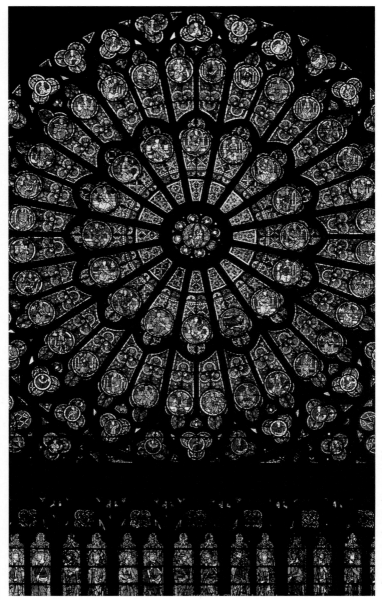

photo © Giraudon / Bridgeman Art Library

North transept rose window depicting the Virgin and Child in the center surrounded by Old Testament characters

villainous looking characters attend King Herod who will shortly launch a massacre of all male children of Christ's age. The three kings, sometimes referred to as the Magi, have dismounted from their horses to pay their respects.

The whole of the scene from end to end takes place under canopies or buildings, presumably representing not Bethlehem but Jerusalem as the heavenly city. The sculpting of the figures tends much more than the 13th-century ones to abstraction and idealization. Essentially they are from and in another world in which these events are replayed and glorified. It is not a huge sculpture, but despite its recounting of five separate events, it has the spaciousness and measured dignity of a ritual.

The Virgin in Majesty is the great figure of Notre Dame de Paris. Also from the 12th century, the Mother of God is seen here in her glory, enthroned, with God on her knee, flanked by angels and the royal and clerical patrons of the Cathedral of France. The throne is Jerusalem, the heavenly city, in miniature. The Virgin wears a crown and carries a scepter. God is a smaller figure in her lap as though on a subsidiary throne. Christ is still a child, practicing his teaching, his right hand and two fingers raised in the teaching position and the left holding a child's book. The drapery of the Virgin draws in from all sides to meet the drapery of the Child as though she is absorbing him. These are rare moments in the history of sculpture. One must go almost to the kore of Ancient Greece to be moved by such a balance of realism and abstraction.

PORTAL OF THE VIRGIN

To preserve the narrative, go past the big central portal to the smaller portal at the left. This portal, created in the 13th century, shows Mary crowned in heaven. Firstly, above the door itself, this portal can be seen as a single story, telling of the earthly events surrounding the death of Mary. It is based on apocryphal texts from many centuries retelling stories of dubious origins and posing as true expansions and additions to the stories recorded in the Gospels. These stories were popular in the 13th century when an abundance of sculpture and painting made them widely available. Their very popularity naturally caused them to be taken for gospel, so to speak. One of them, the Assumption of the Virgin, continued to be so popular that a 20th-century Pope declared it to be a matter of faith for all Catholics.

Working from the bottom of the tympanum, three kings and three prophets from the Old Testament flank the Ark of the Covenant. In medieval symbolism, the Ark of the Covenant is one of the representations of Mary because it carried the Lord's promises about the future as she had done. Despite being actually somewhat perched up on the lintel, the kings and prophets seem comfortably seated. Their feet and crowns break the frame of the lintel and they are engaged in a communal activity of inscribing a long scroll.

The complex scene above is popular in the Eastern Church under the name of the Dormition of the Virgin, which is the story of the Assumption. The figures around the bed, apart from Christ and two angels, are the 12 apostles. Christ is distinguished by a halo with the crucifix set in it. St John is seated, looking youthful on the far right. St Peter with his keys is seated on the left. The legend of the Assumption or Dormition was that Mary told an angel that she wanted to see her son, but before she died, she wanted to say goodbye to the apostles. The angel caused St John to be transported to Mary's house, where apostles appeared. Mary lay down on a bed, which in this scene is represented as a sumptuously carved piece of furniture, and waited for Christ and the angels to come and take her up to heaven. Thus she becomes the only mortal to be taken bodily into heaven without passing through either the corruption of death or the indignity of being judged for the conduct of her life.

Apart from St John, the apostles are a solemn, bearded group, matured by their missionary activity. Mary's soul is taken into heaven and her body taken by the apostles to a bejeweled coffin to wait for its translation uncorrupted into heaven. The sculptor has carved such a coffin for Mary to be placed in. Originally the coffin would have been gilded and decorated with precious stones. By means of these events, the legend equates Mary with Christ by giving her a form of resurrection.

Above the Assumption comes the "Crowning of the Virgin as Queen of Heaven." This scene is the key bearer of the symbolism in the piece. Surrounded by angels, Christ and Mary sit side by side on a throne. Beside the throne and around the voussoirs is a great flurry of angels with candles and heavenly figures with musical instruments. An angel in a cloud places a crown on Mary.

The symbolism of the scene gives a different view of Mary from the Portal of Saint Anne. In this case, Christ is the king of all and

Mary will be his chief auxiliary. Her posture now is that of one accepting an honor, even though it is from her own son. In the Portal of Saint Anne, he was a child and in need of her protection. Here, she is also being blessed by Christ, which further emphasizes the new hierarchy of their roles. Christ, in becoming man, had humanized the remote and often fierce God of the Old Testament, but then Christ went back to being God and God continued to allow any amount of catastrophe and injustice to plague the peoples of the world. The new human face of heaven would be Mary who could intercede for humanity. Such symbolism is an immense burden for sculptors to carry, but they had the visual language and they knew how to use it.

Around the outer sides of the doors, starting halfway up on the left and continuing on the right from the top down to the middle, is a series of carvings of the year as the 13th century lived it in the Paris region. Each month has a double panel of a Zodiac sign and an activity. The cycle begins, however, with a panel on the left of the months showing a woman riding a whale. She represents the ocean and is matched in a similar position on the right by a representation of the earth. Like the Zodiacal signs, these are pagan references to goddesses of sea and earth.

The Labors: As you follow the months, you see a man being waited upon, another warming himself at a fire, a peasant pruning a vine, wheat growing, a falconer, hay making, sharpening a scythe, reaping, trampling the grape harvest in a hearty tub, sowing a field, rounding up and then killing a hog.

The Seasons: Beside the figure of the Virgin, which like the other tall statues is an imitation of the original and not the genuine 13th-century original, are depictions of the seasons. On the left is a succession starting at the bottom with winter and ending at the top with summer. The change of season is represented by images of men becoming progressively younger and less clothed. On the right side are panels showing the Ages of Man from the infant to the elderly.

Saints and Martyrs: The eight tall statues on either side of these doorways are all restorations. The subjects of the statues however could mostly be guessed at from the clues provided by the very lively bas-reliefs underneath their niches. On the right side, for example, under St John the Baptist nearest the door, an executioner is handing St John's head to Salome, who danced lasciviously for the King and thus earned the right to John's head.

To St John's left and your right, St Stephen, patron of the preceding cathedral on this site, is about to have another stone hurled at him by a figure lifting it high in the air and is well on his way to martyrdom. Next to Stephen is St Genevieve, another of the patron saints of Paris. An angel is re-lighting a candle for her each time a demon tries to blow it out. The candle itself used to be a highly prized relic in the cathedral until the Revolution got rid of it. The next figure cannot be identified. On the other side of the door, beneath the statue of St Denis holding his head, the executioner is swinging his axe. Beneath the two angels in the frame nearest the door we see St Michael killing the dragon, who represents the devil. The devil is thus cast out of heaven. On the left, there is a charming picture of an angel tipping a devil into the firmament to drift forever like space junk among the stars.

CENTRAL PORTAL – THE LAST JUDGMENT

The Last Judgment, based on either the Book of Revelation or in this case on St Matthew's description of the end of the world, was often the subject of medieval portals. This portal was built around 1210. It serves as a reminder to pilgrims entering the church of the test of life they must ultimately face. Placing it at the western end of the cathedral reminds us that we are at the end of the world where the sun sets.

The portal has been considerably vandalized, not just by the revolution but by the church itself. The central pillar (between the two doors), the lower lintel, and part of the upper lintel were knocked out in the 18th century so that processions in which tall canopies were carried could get into the church. You can see a line on the right of the upper lintel where the restoration meets the original. In fact, the four figures on each edge of the upper lintel – four damned on one side, four saved on the other – are all original. The originals of the angels sounding their trumpets on the outer edges of the lower lintel are now in the National Museum of the Middle Ages (See Trail 2 in this section). The figure of Christ passing judgment is more or less as it was, as also are the voussoirs. The statues of the apostles below are recreations, as is the central figure.

There are several themes portrayed in this portal.

The Dead Arise: In the Last Judgment angels sounding trumpets waken the dead. Each person then passes before the archangel Michael who weighs the good and evil done in that person's life

and reports the result to the Judge who directs the good to go to his right into paradise and the wicked to his left where they are carried off by devils. The lower lintels (restorations) show the dead wakening to the trumpet blasts. The upper lintel (original on the outer edges) shows the angel with the scales in the center next to the devil, who is vainly trying to influence the result. It further shows the damned being led off to Christ's left and the elect going to the right.

The Judgment: The top (original) shows Christ sitting in judgment with angels, the Virgin and St John. The lower right sections of the voussoirs contain more images of the damned but the greater part of the sculpture in these sections is of the elect sitting benignly with crowns, the medieval symbolism for the heaven-bound. Originally, paradise and its inhabitants would have glowed in gold and the inferno in red. The entire scene is full of symbols and, as usual, the sculpting itself is conscious of the symbolic meaning it communicates. If the restoration is indeed accurate, as it is believed to be, the dead were carved rising fully clothed and identifiably of various ages and social positions. This is unusual as the rising dead are usually shown naked.

The Torments of the Damned: The depictions of the torments to which the damned from the upper lintel are being led are as vile as the sculptor can make them. The devil stoking the cauldron in which sinners will be boiled takes a typically fiendish delight in his job. The apocalyptic horse riders are ugly naked figures. Kings are mounted by bishops who are then sat on by a foul, grinning monster. People are stabbed and beaten and eviscerated. Of course, by comparison, paradise seems much less eventful, but much happier. On the left near the door, a prophet benevolently holds a trio of youngsters he has presumably helped to save. A celestial orchestra is sculpted around the voussoirs.

Christ as Judge and King: The figure of Christ in the center is shown not as a sober or even vengeful judge but as one who has suffered and risen. His halo is cruciform. He is holding up his hands to show the wounds of the nails and the wound of the spear should be visible on his naked torso. The angels beside him carry the symbols of suffering – crosses, nails – over which he and by extension all good people triumph. Kneeling on his right is his mother, crowned as Queen of Heaven, and on his left, St John, his favorite apostle. That both are kneeling signifies that they will plead for people before the Judge. Justice is therefore flanked by

mercy and confirmed by the fact that the Judge himself has been tormented and betrayed by the world.

Parable of the Five Wise and Five Foolish Virgins: Originating in the 12th century on either side of the doorway, this is now the work of restorers. At the top of the rising row of five wise virgins is an open door. At the top of the five foolish virgins, the door is closed.

Virtues and Vices: Underneath the restored statues of the apostles are original bas-reliefs. The virtues are along the top row and the corresponding vices are placed underneath. The virtues are women sitting on thrones and carrying seals, which symbolize their various attributes. The figures below are infinitely more varied and lively. On the right, for example, Courage dressed in armor is above Cowardice, shown by a man running away from a hare or perhaps a rabbit. Under the next one, a woman – presumably Anger – is stabbing a monk who was probably telling her off. Under the third virtue, a woman is kicking a servant in the head. Leaving aside the one in medieval armor, the virtues are seated figures with shields. The vices, however, are quite frankly of contemporary scenes.

PORTAIL ROUGE (RED PORTAL)

Go now to your left, along the north wall of the cathedral, to find the Portal Rouge. A gift of St Louis, it is easily found because it is above a small doorway painted red. It is the work of the famous Pierre de Montreuil, and was executed between 1265, when he started work on Notre Dame de Paris, and St Patrick's Day 1267, when he died.

The tympanum contains Christ sharing a throne with Mary who is being crowned by a flying angel. The angel's wings fill the point of the arch. The kneeling King Louis IX is on the left and his wife, Marguerite de Provence, is over on the right. Louis was made a saint on the basis of the extremely austere and generous life he had led. He had himself beaten with chains, prayed lengthily during the night, wore hair shirts, diluted his wine, fed the poor even at the royal table, tended to lepers and the sick and denied himself many pleasures, including for long periods those of the bed. At the same time, he embarked on unsuccessful Crusades and further endowed the lavish churches of his time. One of his triumphs was a complicated set of financial arrangements with the Venetians, which ended in having the

cathedral's most valuable relic, the Crown of Thorns, returned to Notre Dame de Paris. Marguerite de Provence, his wife, came from a successful royal family and her descendants took part in the ruling of France up until the Revolution. She was, like her mother-in-law Blanche of Castille, an extremely formidable woman. The sculptor shows the pair as young nobles, although they would have been older at the time. The king is associated with Mary, the servant of God, now a royal person in her own right. The figures overlap the boundaries of the arch, which helps them to be seen in depth. In every figure, the simple folding of the drapery clearly indicates the body. In this manner, 13th-century sculpture embodies classical values.

Around the tympanum are a number of themes and stories.

The Story of Saint Marcel: Around the tympanum, there are six scenes from the life of St Marcel, a Bishop of Paris from 417–436 and one of the city's patron saints. Marcel was a celebrated worker of miracles and highly thought of. On the left side, he is shown baptizing people and celebrating Mass. On the top right, he is teaching, and below that overcoming a serpent. This may be the devil or it might be a picture of one of his miracles. There is one tale that recounts how he overcame a serpent that had been eating the corpse of a lady in her tomb and horrifying the locals. Whereas the scene with the king and queen is still and sober, as befits its location in paradise, the scenes from the life of St Marcel have the animation of earthly activities.

Animal Decorations: Sitting inside decoratively linked lozenges at about waist level is a favorite medieval mixture of real and imaginary beasts, each sculpted with a mixture of the vivacious drawing and decorative space-filling beloved of illuminators, miniaturists, and makers of jewelry. They are delicate and must have invited generations of children and churchgoers to run their fingers over the outlines. It is rare to find an artwork that one is allowed to touch. If you look up, you will see the guttering in the shape of winged monsters springing out somewhat like toads from the side of the building. These are however a later addition to the building.

NORTH PORTAL

Continue down along the wall of the cathedral until you come to the North Portal. Both the North and South Portals are from sometime after 1250 when the two arms of the transept were

extended by a bay so that they would be outside the line of the chapels between the buttresses and could contain the great roses that would let more heavenly light into the cathedral's interior.

The Story of Saint Theophilus: The top two sections of the tympanum tell the story of St Theophilus, one of the many versions of the Faust story. The story-telling demonstrates the skilled compression of events so often found in medieval visual narrative. It starts on the left of the middle row with Theophilus bending his knee to a fat, smug and crafty looking devil. He is exchanging Theophilus' soul for temporal power. Next, to the right, Theophilus is seen enjoying his nefarious power. He regally hands out "money" to a supplicant but at the same time, his supply of largesse is being replenished by a devil behind him. Next, again to the right, is his moment of repentance. There is enough of a building to indicate that he is in a church or chapel and within, there is a tiny figure of the Virgin. In the last frame, on the right again, the Virgin has become the tallest figure, dispensing mercy to a kneeling Theophilus and banishing the craven, cringing devil. Above, in the point of the arch, a relieved Theophilus is beside the bishop who is telling a crowd of listeners the tale of his pride, repentance, and salvation.

Scenes from the Life of Mary: This story is told on the lower lintel. From the left are the Nativity (the birth of Jesus), the Presentation (when his parents took him to the temple), the Massacre of the Innocents (when Herod had the baby boys of Bethlehem massacred in an attempt to prevent the coming of the Messiah) and the Flight into Egypt (when Mary and Joseph rode off to Egypt on a donkey and successfully escaped the massacre). Since the 12th-century Portal of Saint Anne on the west façade tells the same story, you can make some comparisons between the approaches of the 12th and the 13th centuries. The 12th century told a regal story – the birth of a king to a queen. The 13th-century bed on which Mary lies, propped on an elbow, is more modest, as are the other details.

Statue of Mary: This is the only large original statue from Notre Dame de Paris that remains in its place and is whole, although the child has been broken off. It was probably carved by a master sculptor carving for Jehan de Chelles, who devised the rose and this façade. This puts the date somewhere after 1250. The statues that were around in the niches have been destroyed and not replaced.

This version of the Virgin has all the grace of a classical Aphrodite. There are obvious differences from the classical canons. The waistline is considerably higher and the curve of the body, reflecting the fact that the woman is holding a baby, is a single curve rather than an "S," and the body is more slender. At the same time, the drapery is sculpted to delineate the body and the conception of the figure is more that of a living human being than of a goddess in human shape. This is a work of sculpture that is motivated by iconography. The other comparison that can be made is with the much more regal and unearthly treatments of the Virgin by 12th-century sculptors. Interest has shifted to the human shape, from the soul to the body. Whether this change in sculptural style accompanied theological and social shifts (or perhaps, declines) is a matter for historians to ascertain, but what we see allows us to believe that in medieval art, thought and social practices were indissolubly tied together.

At this point you may wish to make a short detour, as opposite is the small Museum of Notre Dame. It contains illustrations, paintings, documents and objects from the many different periods of Notre Dame's history.

THE MUSEUM OF NOTRE DAME

Inside the doorway, a painting from 1780 shows Notre Dame de Paris before the revolutionaries took to it and Viollet-le-Duc restored it. You can see the seal of Bishop Maurice de Sully who had the old Saint Etienne Cathedral pulled down and the "new" Notre Dame de Paris built. There are engravings showing the parvis and buildings around the cathedral before the Revolution and before Haussmann's work. There is also material about the fate of the cathedral during the French Revolution and about the great scholar and restorer Viollet-le-Duc, including drawings of his plans for spires on the two towers. You can also see the letter signed by Victor Hugo, J.A.D. Ingres, and others calling for the cathedral's restoration.

Go back to the front of the building to the gates near the river that let you into the park beside the cathedral. Take up a position where you can see the façade of the south transept from outside the fence.

THE SOUTH FAÇADE

The north and south transepts were both extended in the 13th century after the rest of the building had been completed. The enlarging of the north transept was the work of the master Jehan de Chelles who was responsible for the great northern rose window. Its brilliant example would be followed across Europe during the rest of the century in the period known as *rayonnant* (radiating), which takes its name from the concept of the rose window. Jehan de Chelles died before the south transept was finished and it was completed by Pierre de Montreuil. Today, it is enclosed within the grounds of the presbytery so that the sculptural detail is hard to see without binoculars. The façade, however, is a huge and majestic creation. The greater part of it is actually glass but from outside what we see are the outlines of the windows – the tracery of the rose and the smaller roses above it. The effect is like lacework on a grand scale. The side buttresses have their verticality tempered by inset statues and the tapered spires on colonnettes at the top of each. The windows are held in two sections by horizontals, and the lower horizontals of glass windows and blind arcades are broken by the exaggerated pointing of the main portal arch and seemingly innumerable smaller pointed arches clustered around the base. Behind the uppermost point of the transept rises the spire, similarly light-looking despite its immense weight. The ensemble is an exercise in establishing a few large geometric elements in about four separate storeys – small circle at the top, then large circle, then lancets, then triangles – but then softening and commenting on each with masses of geometrically based tracery derived from the large elements.

The Story of Saint Stephen: The tympanum of the portal of the southern façade tells the story of St Stephen, whose great fame rests on his being the first Christian martyr, stoned to death in Jerusalem. The story begins at the bottom left of the lintel, where St Stephen is disputing with Jewish scholars. On the right of the scene, Stephen is hauled before a judge. One of the "police" is clearly a Negro in Roman armor. In the panel above, Stephen is stoned to death by a mob that includes a child. On the right side of the panel, Stephen, now martyred and therefore a saint, is being lowered into a coffin by two men while priests and a woman stand around.

Above this scene, in the top of the tympanum, Christ and angels wait for the soul of the first Christian martyr to make his ascent

NOTRE DAME DE PARIS

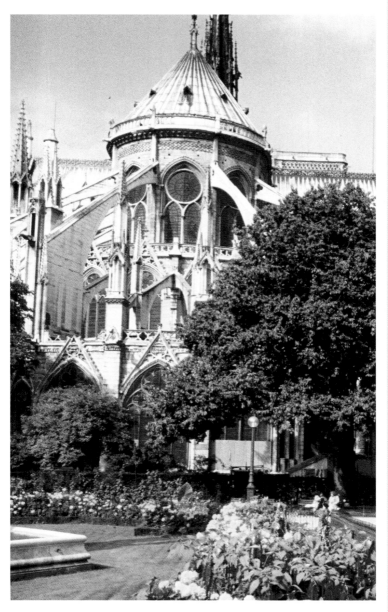

The apse of Notre Dame

into heaven. The whole story is marked by considerable touches of realism: the rabbis' faces show frustration; one of the women listening to Stephen is feeding a baby; the stoning mob is vicious.

Scenes of Parisian life: You will not be able to see these scenes on the south transept in any useful detail without binoculars. Near ground level, one on each side of the portal, are panels, and inside each panel is a quatrefoil – a shape like a four-leafed clover. Outside the quatrefoil are reliefs of ordinary people of the time, generally going about their business, apart from the odd encounter with mythical beasts. Within each quatrefoil are four pictures. Some of the scenes are a bit obscure but several are extremely vivid. On the panel on the right side of the door are scenes from the student life of Paris in the 13th century. In the top left picture, the students are creating a deal of disorder. On the right however, they are listening attentively to a teacher, their backs turned to the viewer.

It need hardly be said that such scenes of secular life are very rare in cathedrals. Why these are there at all puzzles the scholars.

Walk around the eastern end of the cathedral. From the center of the park, if you stand well back, you get a general view of the buttressing of the cathedral.

THE BUTTRESSES OF NOTRE DAME DE PARIS

Without buttressing, a stone building the size of Notre Dame de Paris would fall over. These were started in the 12th century and modified in the 13th century. The early architects of these churches understood that the buttresses could be built up in steps, starting with an extremely stout buttressing pillar on the outer edge of the building but rising up from there in steps that could be hollowed out. By the beginning of the 13th century, however, a builder had the startling idea that the weight of the highest part of the building could be carried down by a single flying arc into the buttress – hence the term flying buttresses. This is a feat of engineering that would tax today's builders with all their sophisticated instruments and calculation. From the back of the cathedral, you can see that there are actually two sets of arching or flying buttresses, one supporting the walls about half way up and the other flying to the very top of the building. There are two lower arches to every one of the grand fliers.

Between the heavy buttresses, rising up from the ground from which the fliers take off, there are chapels built out to the

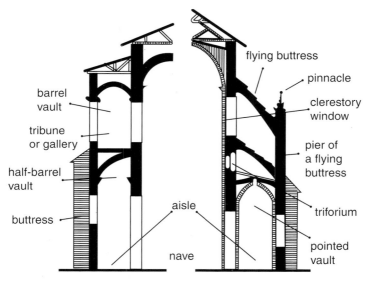

A side elevation of a typical Gothic cathedral

boundary line. These chapels were not in the original building so in the 12th and 13th centuries the geometry of the buttressing was fully exposed. Even so, the buttressing of the choir of Notre Dame de Paris is one of the great sights of Paris and one of the thrilling sights of western architecture. Views of the buttressing can be enjoyed in other vantage points so keep a look out for them.

The Interior

The circulation of visitors is fairly strictly controlled, especially when there are a lot of them. You enter at the right and exit at the left. As soon as you enter at the right, you will pass through what is called the narthex, which is like a vestibule with a lower ceiling before the main part of the building starts. This is dark, and will seem darker when you come in from the light. The Treasury is not worth visiting but if you feel up to it, climbing the north tower gives you a view of Paris and a closer look at some of the features of the cathedral.

NOTRE DAME DE PARIS

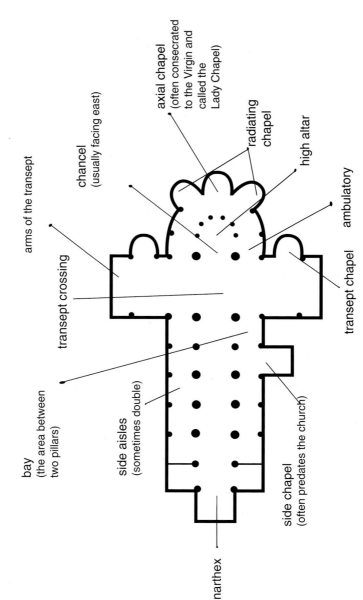

axial chapel
(often consecrated
to the Virgin and
called the
Lady Chapel)

radiating
chapel

high altar

chancel
(usually facing east)

arms of the transept

ambulatory

transept crossing

transept chapel

bay
(the area between
two pillars)

side aisles
(sometimes double)

side chapel
(often predates the church)

narthex

The ground plan of a typical Gothic cathedral

THE NAVE

Make your way into the nave (the central part of the church that starts in front of the big organ loft). Take a chair and look around. You will see two rows of massive columns and above these columns, thin columns – colonettes – rising to several times the height of the big columns to meet in groups of six on the ceiling. You will see that most arches are pointed, not rounded. A pointed arch gives greater height and a stronger sense of upward movement than a round arch. There are three basic layers. The lowest layer is the set of columns with open bays between, each column leading into aisles and chapels. On each side of the nave, there are two aisles. These continue as an ambulatory right around the altar. Their purpose was to allow for the circulation of large numbers of worshippers and pilgrims at the same time as others were standing at side altars.

The second layer is a gallery. Each bay of the gallery is divided into four by slim columns – except for the last bay nearest the organ loft, which is only about half the size of the other bays. The gallery running around the nave is called a triforium. It is not accessible to visitors but its main purpose seems always to have been to make the building seem light and to admit a partly concealed source of light. Above the triforium are tall windows. This is called the clerestory. Its function is to let in light and to raise the height of the building. The builders of the 12th and 13th centuries saw greater height as greater closeness to God.

Most of the nave is the work of the second master builder, or architect. However, you can see on the sixth column where another builder took over. The first builder constructed the eastern end of the church, including the present apse and sanctuary. The whole thing took about a century to complete but Maurice de Sully, the bishop who commissioned the cathedral, lived to see the basic building (that is the choir and nave) completed. The choir and transepts then took another 50 years.

Look down the nave and right through to the eastern end. You will see that the axis of the church is not a straight line. The sanctuary, where the altar is, bends to the left. You can check this by counting the black diamonds that make up the pavement of the nave. If you try to line up the center of the old main altar with the center of the new altar in the middle of the crossing (where the transept crosses the nave) you will find that you are not standing in the middle of the row of diamonds but a little to the right. You

could also try lining up the pillars at the front and the back of the choir. You'll find that you are standing a little out from the side of the nave. There are several theories as to why the nave does not line up with the choir. The romantic theory is that the ground plan was meant to symbolize the tilt of the head of the dying Christ on the cross. This is based on the idea that the church is in the shape of a cross and in French at least the eastern part of the church is called the *chevet*; a word derived from the Latin word for head. The practical theory is that when they built the nave, having completed the eastern end, they found they had to avoid some other buildings in the crowded quarter to fit the church in. However, other churches have the same lean and cannot all have had the same problem. A third theory was advanced by John James, author of *Chartres: The Masons Who Built a Legend*, (Routledge & Kegan Paul, 1982). It is that it is a deliberate imperfection. The builders knew what they were doing. Of course it would be straight if the builders wanted it to be (they were not incompetent) but only the true House of God in the ideal other world should be perfect. There are other traditions that adopt the idea of building deliberate imperfections. In this case, we do not have sufficient evidence to decide for sure what the explanation is.

THE WINDOWS

The windows of the triforium and clerestory are obviously modern works, abstractions by Jacques le Chevalier in the late 20th century. The original windows of the nave were removed and destroyed in the 18th century because church authorities wanted to increase the amount of light inside. Most of the original glass is in the two roses on the western (above the organ) and northern (to the left of the transept) sides. The fact that there are three layers of bay, triforium and clerestory satisfies the great liking for the number three which symbolizes such things as the Trinity or the sum of one (heaven) and two (earth), or the three cardinal virtues (faith, hope, and charity) and so on.

THE CEILING AND THE ROOF

Above the clerestory, colonnettes bend in groups of six until they meet at a crossing (ogives) in the middle of the ceiling. These are the ribs that criss-cross on the ceiling. They are the real innovation and mark of the Gothic, more so than the slightly pointed or broken arch. The breaking of the round arch is certainly important to

achieve greater height but it is the ogive that does the key structural work. The greater breadth of the nave called for the ogives or vaulting to cover two bays. They form three columns on each side from which spring six ogival ribs meeting in the center. The side aisles on the other hand are narrower and the roofs lower, being supports for the tribune or gallery above. The gallery is vaulted bay by bay with four ribs springing from four columns to meet in the center and then an arch marking the boundary of the bay.

The vaulting that you see from inside the nave represents the total determination of the Middle Ages to present worshippers with a building where everything they could see was entirely made of stone. In fact, there is a timber roof above this vaulting. It is the timber that carries the tiles or the lead of the exterior roof. The building method involved putting up the timber roof first so that the builders could work on the vaulting from above. Seen from above, which only happens occasionally on an arranged specialist tour of a Gothic cathedral, the size of the keystone that keeps all the vaulting in place is quite terrifying. It is of enormous size and weight. It is astounding to think of such enormous weight being supported by such light elements as you see now from within. These keystones are usually seen from below as sculpted bosses.

THE PILLARS

Look down to the great pillars that support this in fact immensely heavy but light-looking building. The big columns or pillars are plain, except for capitals (the top part) decorated with vegetal motifs. This decoration is a direct continuation of classical columns reinterpreted to carry this extraordinary new conception of a building; it is also a reminder to us that the Middle Ages knew and understood antiquity but rather than imitate it in the sometimes slavish way of the Italian Renaissance, adapted it to its own purposes.

Go towards the crossing, which is usually fenced off. Before the 20th century, it would have been open and the choir itself (starting on the other side of the transept) would have had a metal grill. The Second Vatican Council called by Pope John 23rd in the second half of the 20th century said that church altars should be brought out closer to the people and face them. The result of this and some other reforms of Vatican Two led to further mutilation of old churches. An altar which, from a distance, looks inappropriately like a butcher's block, occupies

the crossing of Notre Dame de Paris. It must be said however, that the former main altar with its showy Pietà and the Kings Louis XIII and XIV disguised as pious supplicants was even less attractive.

THE CROSSING

The nave, for reasons best known to a builder who took over after some construction had taken place, is about a yard wider than the choir. It is easy to see that the crossing is not a square as it should in theory be: if you look up at the ogives, they are not a square. Also look up at the very first bay on each side of the nave and nearest the crossing. Unlike the other bays, a full-length window does not fill the clerestory (the top part). Instead there is an empty rose surmounted by a smaller window.

From here, maneuver into a position to see the rose windows, especially the northern rose, which was the one on your left as you entered. Take a seat. Binoculars are a help but are not essential. Occasionally as you follow the circles around through binoculars, a medallion in which a blue figure glows against an even deeper blue background will suddenly startle you. The experts still speculate as to the source of these blues, as in later centuries they have proven hard to duplicate.

THE ROSE WINDOWS

The northern rose: Of the three roses, which were the glory of the original stained glass of Notre Dame de Paris, only the northern rose survives in its largely original form. Jehan de Chelles enlarged the northern transept between 1230 and 1250 to correct the exterior shape of the building and improve its stability. The opportunity was taken to shed much more light into the building via roses and the windows below them. The shape of the rose is a clear homage to the Virgin. The northern rose is the largest circular work of the Middle Ages. It consists of many separate elements held together by their own tension. It is 13,000 square feet in size and only a little over one third is of stone. Eighty-five percent of the glass here is original. A great deal of it is in the form of criss-cross and vegetal decoration. The images taken from the Old Testament up to the time of Christ are in the rings of medallions that wheel around the central image of the Virgin and her infant. The image of the Virgin herself is not original but the 80 subjects from the Old Testament are almost all original.

NOTRE DAME DE PARIS

In the first ring of 16 medallions are the 16 prophets who foretold Christ's coming. In the second circle, the 16 medallions divide into 32 medallions, each containing a king from the Old Testament and in the outer circle, in the midst of groups of three circles, are a further 32 images of priests and patriarchs.

The western rose: If you swing around to the western rose, you see behind the organ the very restored work of an earlier master and predecessor of Jehan de Chelles. This was built about 1220 and has the astonishing proportion of 86 percent glass. (The southern rose was considerably bigger and needed the higher proportion of stone.) The western rose was built from the center outwards and hence was described as radiating or, in French *rayonnant*, which term also came to mean the spreading out of the style. The restorations have retained the iconography of the original. The Virgin is seen at the center as a queen surrounded by her royal ancestors, virtues and vices, then signs of the Zodiac and signs of the months – subjects that are repeated in the sculpture of the western portals. The organ in front of the rose is a noted instrument and played by many maestros but it also played its part in the destruction of the glass.

The southern rose: This restoration is a *chef d'oeuvre* of the 19th century. Originally begun in 1270 by Jehan de Chelles, it weakened somewhat over time, lost a great deal of its glass and was eventually restored with its iconography very largely intact by Viollet-le-Duc. Christ as the Redeemer is in the center of this window, surrounded by apostles, martyrs, and Doctors of the Church. Among other things, there are figures from the New Testament with the Evangelists perched symbolically on the shoulders of prophets.

To strengthen the total façade, Viollet-le-Duc rotated the rose slightly to make one of the thicker shafts the vertical. This gives a cross shape to the window, which should be compared with the considerably more rose-shaped northern window opposite. Notre Dame de Paris would once have been filled with stained glass windows.

THE AMBULATORY

The ambulatory is the walkway around behind the main altar. There are many reasons why you may not be able to walk right around the ambulatory. For example, some special events are held there and the area is often closed off. If you can't go in, go up as

close as possible and see how the space has been constructed to allow for some to visit and pray at chapels while others circulate around the cathedral. This was important at a time when any cathedral or major church had relics that people would want to see and might come in groups to visit. Most of the big pilgrim churches are designed in this way. The windows of the chapels at the back also allowed for more light to enter the church at the eastern or altar end. The combination of the very public main altar and nave with more private chapels and ambulatory meant that the cathedral could cater to a wider range of the devout and allows it to cater to a wide range of visitors today.

This completes your intensive tour of this magnificent cathedral. For more historical information, you may wish to go to the far end of the parvis to visit:

CRYPTE ARCHAEOLOGIQUE OR UNDERGROUND ARCHAEOLOGICAL MUSEUM

The museum consists mostly of foundations with streets, some walls, stairs, and doorways dating from Roman times until the demolition of much of the parvis in the 19th century. It is excellently arranged and explained, which is a relief on an archaeological site since they are often obscure to the non-specialist. This crypt gives you an elaborated idea of what once filled most of the parvis and helps you to picture the surroundings in which the present cathedral was built.

The explanations begin with the settlement of the island in the middle of the Seine by the Parisii. There are foundations from the Gallo-Roman city of Lutetia, including, near the end of the display, a central heating system of the period. The foundations of the buildings that occupied the parvis both before and after Notre Dame de Paris was built are outlined and explained, and the life of the times illustrated by a range of engravings.

From here, depending on how tired you are and how much time you have spent here, you may wish to have something to eat and stroll to the other end of Ile de la Cité, where you will find the magnificent Sainte-Chapelle.

Trail 2:
Sainte Chapelle

Location: 4 Boulevard du Palais, Ile de la Cité, Metro Cité, St Michel or Chatelet, RER St-Michel

Opening Times: 9:30 am (10:00 am winter)–6:30 pm (5:00 pm winter) daily. You must enter 30 minutes before closing time.

Admission: 4 Euros, discount 1 Euro

This beautiful chapel can be seen in a few hours, perhaps after spending the morning at Notre Dame. If you are there at sunset, so much the better, as the light within is wonderful at that time. Take binoculars, if you have them, to better view the details of the stained glass window. Sainte Chapelle is inside the Palais de la Cité alongside the Palais de Justice (law courts). You can distinguish it by a steeple not unlike the one on Notre Dame de Paris but made of wood. The steeple is from the 19th century and is the fourth to be put on the building.

Some attribute the building to Pierre de Montreuil. Others, including John James (*The Traveller's Key to Medieval France*) say that the lower chapel had a different builder from the upper. This was possibly because once the lower chapel was completed, the project had to wait for the medieval mortar to dry, and the original builder may not have been available when the next part of the job came up. It is deservedly the most famous example of Rayonnant Gothic. Given the assurance which the medieval masons and architects had by that time, it is a building almost purely of glass. It is supported outside simply by stepped buttresses.

You enter through the two-tiered main portal, into the lower chapel, which was used by servants, and climb a spiral staircase into:

UPPER CHAPEL

The visitor's first impression is that you have wandered into the inside of a jewel. Clusters of fine colonnettes are crowned by capitals high up on the wall and support very elegant ogival crossings. Between the

SAINTE CHAPELLE

colonnettes at ground level are blind arcades with a recess on the left where royal persons used to sit. Above that rise unbroken lines of richly colored stained glass. About two thirds of the glass you see here dates from the 13th century but the restorations are very hard to pick since they are set amongst originals.

The chapel was built between 1243–1248, and was commissioned by King Louis IX of France (St Louis) to hold Paris' most precious relics. These were in the shrine in the center of the east end of the chapel, the end you are facing when you arrive. The reliquary itself was melted down during the French Revolution but the most precious of all, the Crown of Thorns, was saved and is now in the treasury of Notre Dame de Paris. To get hold of this prime relic, Louis snapped up an offer by the Emperor of Byzantium. He sent monks to pick it up, but when they got to Constantinople they found that it had been pawned to a Venetian. Louis got it out of pawn for a small fortune: the document of the transaction is now in the French National Archives. When you return outside, note the thorny outcrops on the pinnacles – these are a symbol of this relic.

It is difficult in a single visit to take in much of the detail of the windows. They contain an encyclopedic number of scenes ranging from *Genesis* through the Old and New Testaments to the Apocalypse. For most of the scenes, you need a good knowledge of the Old and New Testaments and various collections of holy legends. We cover just a few highlights from each section. A "window," set between two columns, consists of four vertical windows called lancets. The windows are usually read from left to right and from bottom to top.

WINDOW OF THE RELICS

As you emerge from the spiral staircase into the upper chapel, the set of windows immediately to your right tell some of the stories of the relics for which the Sainte Chapelle was built. Only about one third of the stories of the relics are original panels.

The bottom row shows St Helena, the mother of Constantine the Great, going to Jerusalem to get the True Cross as told in *The Golden Legend*, a popular medieval work about the lives and doings of saints. St Helena established a tradition of making such trips to famous relics. By the Middle Ages, this was a popular passion. At the time, two great pilgrimage destinations presented real difficulties: Jerusalem, because it was in the hands of people they called the Saracens, and Rome, because the crossing into Italy was considered dangerous and you were likely to be set upon by robbers.

SAINTE CHAPELLE

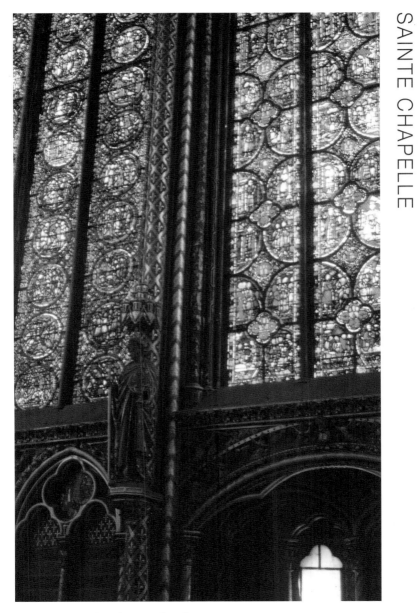

Stained glass window of Sainte Chapelle

On the ninth level of the stories on the window and in the fourth lancet (counting towards the right) are some scenes of St Louis bringing back the Crown of Thorns.

If you look around all of the windows you will notice that each set uses different patterns for containing the scenes of their stories, The one with the relics that you have just been looking at has alternating small quadrifoils with large trefoils. In between these are heraldic signs such as the fleur-de-lis and castles.

OLD TESTAMENT WINDOWS

Apart from the window with the relics, the windows around the walls and the first two narrower ones on each side of the semicircular apse are from the Old Testament.

The first set of windows deals with the stories of Genesis. The second set of windows on the left is from Exodus. It gives a detailed narrative of the life of Moses. A great deal of this is original glass – 92 of the 121 scenes. Reading from the bottom left, you see baby Moses put in the Nile, found and then adopted. Above, in the second row in the second lancet, Moses finds the Burning Bush and in the next picture, God appears. Further up, panels relate the trials and sufferings of the Jewish people.

As you progress around the wall from here, the windows successively tell stories from Numbers, Deuteronomy and Joshua, Judges, and Isaiah and the Rod of Jesse. Then there are three windows dealing with New Testament scenes on the curve. Window 10 returns to Old Testament themes, with stories from Ezekiel, Jeremiah and Tobaih, Judith and Job, Esther, and The Book of Kings. Then you are back at the Window of the Relics.

Look at the story of Judith. On the eighth line up is one of the key events of her life, often painted by Renaissance artists. On the left is the banquet at which Holofernes gets drunk; next, to the right, Judith wields a sword over the sleeping Holofernes while a servant crouches at the foot of the bed. In the next, she receives Holofernes' gruesome head.

NEW TESTAMENT WINDOWS

The three at the very end, backing the former relic area, are of the New Testament. The story of Christ's Passion is told in two lancets. The reliquary hides a fair bit but the crowning of Christ with thorns, obviously a key scene in this place, can be seen in row eight in the right lancet. Christ is seated in green between two

torturers and the Crown of Thorns is shown in red.

To the left, a pair of lancets pictures stories of John the Baptist, Mary and the childhood of Christ. In the left-hand lancet, four rows up, John is writing the Apocalypse on a scroll. Behind him are the seven churches of Asia. In the right-hand lancet, the second oval shows the Annunciation and above it, the Visitation. Further up is the Nativity and the shepherds, the Presentation in the Temple and third from top, the Massacre of the Innocents.

THE APOSTLE STATUES

Six of these wooden statues are originals painted by restorers in the 19th century, and can be seen on the 12 pillars around the chapel. Three other originals are in the Museum of the Middle Ages in Trail 3.

THE ROSE WINDOW

The rose is a 15th-century work in what is known as the "flamboyant style," for reasons that are obvious when these tree-like shapes are compared to the elaborated geometry of the rose windows of Notre Dame de Paris and Chartres. The theme is the Apocalypse, the end of time as envisaged in the 15th century. Christ sits at the center surrounded by seven candlesticks and seven churches. The horsemen gallop out. At about eight o'clock you can see an angel sounding the trumpet. At four o'clock, devils take away the damned. The overall coloration is quite different. Blues and reds are subdued by comparison with the 13th-century work.

In the next Trail, you will see some original scenes from these windows displayed in the National Museum of the Middle Ages (Musée de Cluny) across the river along the Boulevard Saint Germain.

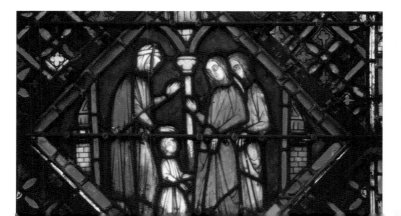

TRAIL 3:
Medieval Art in Museums

This trail involves visits first to the National Museum of the Middle Ages and then the Louvre, both in central Paris, the first on the left bank, the second on the right. Each museum requires a separate half day. If you are starting from Notre Dame, go to the bridge at the far end of the parvis called Le Petit Pont. Cross and continue along Rue Saint Jacques to Boulevard Saint Germain, turn right and the entrance to the museum is in the last street before the Boulevard Saint Michel. On the way along Rue Saint Jacques, you will pass Saint Severin. If it's open, look inside to see a late Gothic interior with flamboyant columns and tracery.

Musée National du Moyen Age
(Musée de Cluny)

Location: On the corner of Boulevard Saint Michel and Boulevard Saint Germain in the 5th arrondissement and close by Metro and RER Saint Michel

Opening Times: 9:15 am–5:45 pm. Closed Tuesdays. Watch out for lunchtime concerts of medieval music.

Admission: 5.5 Euros (full) 4 Euros (discount)

Room 3

The first stop in this excellent museum is Room 3, to admire Coptic needlework from the 4th to the 6th century CE. Coptic art is the art of the early Christian Egyptians and formed a bridge between late Greco-Roman painting and early Christian painting. The large eyes, frontal faces and schematic figures soon found an echo in such Christian art as the first mosaics of Ravenna.

photo © Juliana Spear

Musée National du Moyen Age

Jason and Medea:
2.75 in. diameter, from the 4th or 5th century

This small tapestry medallion, thought to be from the story of Jason and Medea, illustrates the bridging nature of Coptic art. It shows the two attempting to capture the Golden Fleece which is guarded by a snake. The figures are not at all rigid though they are somewhat frontal. It is hard not to see a parallel with depictions of Adam and Eve, the serpent, and the Tree of Knowledge. The color is remarkably assured.

Room 3

Here there is a group of stained glass windows displayed. They present a variety of subject matters that illustrates the way in which dramatic moments are used to tell stories.

The Resurrection of the Dead (Resurrection des Morts):
stained glass from Sainte Chapelle, c.1200

This and the following examples of stained glass are 12th and 13th-century originals. The angel summoning the dead shows how much can be packed into a fairly small frame while at the same time giving major space to the colors that will stand out from a distance, especially the blue and green. The fitting of the figures into the circular frame seems to have been effortlessly achieved but it is, of course, very artful. The angel floats on another plane from the naked dead rising from their tombs. Their nakedness symbolizes their entry into another life. Interestingly, the blue, which serves as a background and a dominant color, has floral patterns. The patterning might distinguish heavenly skies from others or may simply be the type of glass available at the time to the artist.

Crucifixion:
stained glass from Sainte Chapelle, c.1275

This is one of a group of four in a burning blue. Against the blue sky, the white figure of Christ follows a commonly seen S curve but in this case, it is not a smooth and graceful curve. The agony of Christ is emphasized by the twist of the body and the downward sweep of the hands.

Baptism of Christ (Baptisme du Christ):
stained glass from Sainte Chapelle, c.1275

This is one of three scenes from the life of St John the Baptist who emerged from a life in the desert to announce the coming of Christ. Christ – in the middle – is flanked by an angel and the wild brown figure of John the Baptist. The surrounding, mainly blue glass, consists of some plain pieces, pieces with fleurs-de-lis, shield shapes, and so forth. This suggests again that they may have been assembled somewhat arbitrarily from piles that the artist was using.

The Dance of Salome (Danse de Salomé):
stained glass from Sainte Chapelle, c.1275

King Herod promised anything to Salome, who was notorious for her lascivious dancing, if only she would dance for him. Her mother, the Queen, piqued at having been spurned by John the Baptist, persuaded Salome to ask for his head. (He was in prison at the time.) In this scene, Herod and his wife are seated inside arches watching and Salome is doing a full backward bend. She still has some of her legendary seven veils on. Herod does not look especially excited but he is, after all, sitting next to his wife. Salome's dance looks very demanding.

Salome Brings John the Baptist's Head to Herod (Salomé Apporte le Chef de Jean Baptiste a Heroiade):
stained glass from Sainte Chapelle, c.1275

In this scene, although she is carrying her grisly prize, Salome contrives to have a provocative curve to her back. Spots of red seem to be splashed around simply for decoration. Though blue is still dominant, especially as the color of Salome's gown, not all the blues are the same.

David and Saul (David et Saul):
stained glass from Sainte Chapelle, c.1275

This is one of several pieces in flaming red. Compare this to the blue of the John the Baptist pieces. They are a dignified pair, set within wisps of arches. Their symbols identify them: Saul has the scepter and David the harp. Their royal status justifies the brilliant reds of their garments.

Job's Flocks Are Taken from Him
(L'Enlèvement des Troupeaux de Job):
stained glass from Sainte Chapelle, c.1275

This is a large scene from an Old Testament narrative, in which Job's faith was tested by one who has seemed to many to be an exceptionally harsh God. In this scene, devils have been sent to relieve him of his sheep. Job puts up with it but the active characters in the scene are the sheep and the devils. The sheep bound about and jump, frightened by devils with horns. One red-faced devil has a lolling tongue. Another is grey like the walking dead.

Joseph Sold by his Brothers (Josef Vendu par ses Frères):
stained glass from Sainte Chapelle, c.1275

This predominantly red piece tells the famous Old Testament story. The heartlessness of Joseph's brothers is brought out by the ways in which both the boy and his brothers are pictured. The leading brother is shown as the villain, the one who probably thought the transaction up. The second brother, with the money secured, looks indifferent. Joseph however is a figure of pathetic innocence in his short smock, bared legs and the open gesture of his hands. Despite the relatively crowded scene, the artist has managed to work in a friendly looking camel.

The Blinding of Samson (L'Aveuglement de Samson):
stained glass from Sainte Chapelle, before 1248

In this savage scene, the act of mutilation is shown explictly. The villain is distinguished by reds, which are the dominant colors of the scene. The brutality seems heightened because the villain's arms are decoratively curved. The story from the Old Testament is about Samson – a legendary strong man – who was inveigled by Delilah into having his hair cut. Since his hair was the source of his strength, he became vulnerable and so was ultimately blinded.

Murder Scene (Scéne de Meutre):
stained glass from Sainte Chapelle, before 1248

Red is splashed on his head and the hands of the murderer are blood red. There are not enough clues to know exactly what the

story is. It is interesting to note, though, that the use of red, which seems from a distance to be so beautiful, and to send glorious color down into the church, does not always come from beautiful scenes. It is a reminder not to sentimentalize stained glass. Its makers did not.

Adoration of an Idol (Adoration d'un Idole):
stained glass from Sainte Chapelle, before 1248

The Hebrews were worshipping a golden calf when Moses came down from the mountain with the Ten Commandments engraved on two tablets. Here a man is worshipping a golden calf. The eye is drawn immediately to the precious color. There appear to be flames under part of an altar and the scene is neatly shaped to fit the space.

Two Monks Witness Saint Benedict's Ascent into Heaven (Deux Moines Assistant à la Montée de Saint Benoit en Ciel):
from Saint Denis 1140

The shape of this panel suggests it is part of a window about the life of St Benedict from somewhere in the apse of Saint Denis, which you'll visit in Trail 4. St Benedict was the founder of the greatest order of monks in medieval Europe. The work would have been commissioned by the pioneer of the Gothic style, the Abbot Suger of St Denis, between 1122 and 1150. The postures of the monks, the sketching of the drapery, the tilt of the heads and the large almond eyes are strongly reminiscent of the earlier centuries of Christian art. The subject, and the drawing of the monks who themselves seem to aspire to heaven, combine to give the work the spirituality that was said to characterize the pioneering work in the great abbey. It comes from the time when Saint Denis was the lighthouse of the new architecture. It was an art in transition between what we know as Romanesque and Gothic and it contains the strength of both.

The Charity of Saint Martin (Charité de Saint Martin):
from the church of Varennes–Jarcy Essonn, 1220–1230

St Martin was a Roman soldier who, legend says, cut his cloak in two to clothe a beggar. Martin is identified by name in the top left corner. His cloak is very long and highlighted in gold as sacred

symbols often are. The beggar is characterized by a skinny torso, his ribs shown by lines. St Martin's status is indicated by the fact that he is mounted. The church this work came from no longer exists. The panel was found in the 19th century at Varennes.

Part of a Jesse Tree:
from the church of Varennes-Jarcy Essonn, c.1220

A "Jesse tree" (see Appendix of Biblical terms) illustrates the royal genealogy of Christ through Mary, so Christ, shown in the top panel surrounded by seven doves, sits above Mary, who is flanked by two prophets. Here the composition is deliberately formal, symmetrical and replete with symbolism. Christ is in the teaching position and Mary has a regal pose. Both are framed by mandorlas (the intersection of two circles). The number of doves is significant, as seven represents the seven virtues, the seven truths and the seven arts. The prophets flanking Mary establish her important genealogy. The composition is interwoven with the symbol of the tree, which is still used today to represent family relationships.

Proceed now to Room 8. The door of this room is the:

Portal by Pierre de Montreuil:
c.13th century

The abbey of Saint Germain-des-Prés, not far from this museum, contained a Lady Chapel built by Pierre de Montreuil in the 13th century. This piece is from that chapel, which was demolished in 1802. The portal is modest. Pierre de Montreuil does not presume to teach the monks their own trade with any didactic sculpture but creates something homely for them. This is, however, a very elegant homeliness with a delightful alternation of thin and thinner colonettes between simple vegetal patterns.

Go through the Pierre de Montreuil portal into Room 8. Most of the room is taken up with original pieces from Notre Dame de Paris.

Adam:
originally of painted stone just over 6.5 feet tall, c.1236

This figure of Adam comes from the façade of the south transept. Along with Eve, he would have framed the figure of Christ at the

Last Judgment. The right hand, which has been restored, would have once held the apple. The pose has many classical references and reflects the spread of humanism in the Gothic period. This is a graceful, slim, and rather boyish figure, conceived in the round. Unlike the figures of antiquity and the Renaissance, it is not a heroic figure, and it is perhaps this that most significantly distinguishes the early humanism of the Gothic period. It has not yet reached the idealizing of muscular figures, which would eventually mark the triumph of humanism. The original would have been painted in color. Far from idealizing God's first human creation, the sculptor has given Adam a hint of dejection in the drooping rather than squared shoulders, as though he is actually now confronting mortality rather than eternal reward.

The Kings of Judah:
from the western façade of Notre Dame de Paris, before 1248

Opposite the entrance portal to this room is a series of heads that once crowned the great line of statues of the Kings of Judah across the western façade above the entrance portals to Notre Dame de Paris. Since popular belief had it that these were in fact former kings of France, the French revolutionaries smashed all their heads off. Though much damaged, they survived and were discovered 200 years later in 1977 in La Rue de Chaussée d'Antin some distance from Notre Dame de Paris and near the later built Opera.

Originally painted and situated beneath the golden rose window, they would have looked even more diverse than they do now, but the medieval sculptor's imagination is still manifest. Although they were all frontal statues and in a majestic mode, each head is made individual in some way – by the hair or beard, the set of the mouth, the shape of the head, the setting of the eyes, the direction of the head or by the differences in the crowns, which color would have emphasized.

Angels with Trumpets:
from the tympanum of the central portal of Notre Dame de Paris; right hand side 1210, left side 1240

The revolutionaries were not the only vandals to attack Notre Dame. In 1771, church authorities destroyed part of the main entrance in order to admit larger processions than the Middle Ages had ever contemplated. These angels, with their trumpets ready to

MEDIEVAL ART IN MUSEUMS

sound a great call, were among the victims. There is a great deal of movement among the figures and an observable difference between those on the left and those on the right.

To the right side of the entrance to this room (Room 8) there is a large stand of headless figures from the north and south portals of Notre Dame.

Figures from Notre Dame de Paris Portals:
1240–1258

The south transept façade was dedicated to St Stephen, the patron saint of the earlier cathedral of Paris. St Stephen, the first Christian to be martyred, was stoned to death. This incident is illustrated on the tympanum of the southern portal. The tympanum included statues of St Stephen flanked by apostles and martyrs. Some of these can be identified among the headless figures by their priestly clothing and the skulls they are carrying. St Stephen himself is in priest's clothing and holding a book, presumably the Gospels, out in front of him.

Among the whole collection, there is a substantial variety of detail and of style. Some are in a fairly restrained style that could be called classical; some are in a more agitated style that could be called Baroque. Stylistic differences might represent either different sculptors or different periods. Much of the effect of the sculpting, now that it is headless, comes from the treatment of the drapery and the assumptions that one is led to make about the positioning of the body beneath. The drapery is used to reveal the essentials of the body and to indicate the identity of the figure – be it monk, teacher, apostle or martyr – but it also has clear-cut formal functions. The straight and curved lines are treated as much like abstract patterns as they are realistic falls of cloth. The economy of the sculptors' skill is striking. This is the work of confident artists who had something clear to say and knew how to say it. The remains of paint indicate that the statues would have been quite brightly colored – unlike their diligently cleaned and whitened companions and replacements on the cathedral now.

Go now to Room 10, which contains capitals from Saint Germain-des-Prés from the 11th century. The art of the two centuries preceding the Gothic – that is up to about 1140 – is now called Romanesque. It is in significant ways a reworking of elements of Roman building, based on columns, rounded arches, and barrel vaults. Unlike some of their Renaissance and Neo-Classical counterparts, however, medieval artists

were never slavish followers of antiquity. Among their most endearing adaptations was the livening of the tops of columns, called capitals. Classical orthodoxy had it that capitals should be Doric, Ionic, Corinthian or some mixture. The sculptors of the Romanesque period made them into much more elaborate decorations and narratives. With their lust for height and light, Gothic builders eventually had no capitals to decorate.

Nearly all of the exhibits in this room are superb. You could spend a full morning here with a sketchbook.

Room 10

Capital of Christ the Teacher:
from Saint Germain-des-Prés, mid-11th century

On this capital, the magisterial role of Christ is symbolized. The right hand is raised in a teaching manner, the left hand has the world in its grasp and the figure itself is enclosed within a mandorla or almond shape. The mandorla is a potent piece of geometry formed by the intersection of two circles and often frames the figure of Christ. The protruding belly gives the figure something of a Buddha character and is a reminder that in many cultures, an ample belly is associated with spiritual superiority. Note too that Christ's hand is so placed as to overlap the mandorla. In order to make the transition from the smaller base to the wider top of the capital, colonnettes are carved at each side and set at an outward slope. To fill in the space that the sloping shape provides, another couple of figures are tucked in between the tops of the colonnettes and the sides of the mandorla. They were probably angels but one might be Mary peeking out from behind her son's shoulder.

Look along the line to the left of the Christ figure, to see:

Daniel in the Lion's Den:
from Saint Germain-des-Prés, mid-11th century

Here is a good example of the ingenuity that sculptors used to take advantage of the four-sided capital in which each side is a quadrilateral standing on its short side. Daniel is standing in the middle of the frame. The tilted frame is created by natural rather than arbitrary means. Each of the side frames consists of a lion devouring a lamb. The heads and the agonized twisted forepart of the lambs frame Daniel.

Still in Room 10, on the wall opposite on either side of the entrance to the next room are two crucifixions. Look at the one on the right:

Crucifixion:
from Le Puys, over 5 ft tall, late 1100s

This work typifies many of the great crucifixions over altars, many of which have not survived because they were made of wood and perhaps because religious fashions have been particularly severe about depictions of Christ on the cross. This crucifixion has both Romanesque and Gothic characteristics. The Romanesque is clear-cut in the geometric treatment of the loincloth and in the ethereal slenderness of the figure. The Gothic appears in the depiction of suffering with the head slumped on the shoulder. Romanesque or Gothic, it is an abstracted picture of misery. The gaunt figure has an immense nobility and the face is peaceful. The body shows that this is a man at the end of his suffering but the geometry indicates that this is a God figure, intended to inspire the faithful. The wood is poplar and would have been painted in color.

To the right of the crucifix there are:

Statues of Mary and Saint John at the Descent from the Cross:
polychrome wood, from Tuscany, c.1220

This is from a different artistic tradition but so striking that it cannot be passed by. The figures do give a better idea of what the coloring of statues might have been like, though age may have softened them misleadingly. The faces attempt no idealization of either holy figure. Despair is clearly on them and on the slump of their bodies. The drapery however is sufficiently beautiful and abstract to remind us that these are figures from another world, no matter how saddened they might have been in this one.

Now turn to the crucifixion on the left.

Crucifixion:
Polychrome wood, from Auvergne

This is an earlier work than the other crucifixion and represents a different sensibility. The refined geometry of the loin cloth is more marked; the body is upright with the arms stretched out horizontally in a gesture that is more like a welcome and an

embrace than the position of a body hanging on nails by its hands. The head, though slightly inclined, is solemn, the beard and hair both neatly and unnaturally arranged. It is a figure at once of authority and of mercy. The wood is from a pear tree.

To the left of the Auvergne Crucifixion are cases containing wonderful bronzes and ivories.

Ivories:
10th and 11th centuries

Side by side are some Venetian ivory pieces from the 11th century. They are from plaques used at the front of handbound books and show abstracted figures set within geometric patterns and decorated around with crosses and arches. Like the art of illumination, the whole is intended to decorate a page shape with a mixture of figures and calligraphic flourishes. Beside it is some remarkable looking work from Navarre in the 900's. Here, the figures are entirely schematic and almost every element from the head to the features, to the dress, to the gesture, to the posture, to the seats is abstracted. In both cases, one is well outside the Ile de France but the ebb and flow of interest in the tension between the figurative and the abstract is an enduring theme dating back many millennia.

Go through the opening between the two crucifixes and into Room 11. On the wall opposite are:

Three Apostles:
from Sainte Chapelle, 1241–1248

The upper chapel of the Sainte Chapelle featured statues of the 12 apostles. All were removed during the French Revolution and only six put back during the 19th century. Others are here in the museum. Saint John on the left is recognizable by his youth. The other two have lost their symbols but the museum identifies them as the Philosopher and the Melancholic. The customary depiction of apostles in classical-like dress gives them all a pronounced classical calm. The face of the Melancholic is particularly attractive for its handsome features, inward-looking expression, and the elegance of its coiffure. St John's youth is portrayed by the more relaxed posture that emphasizes the curve of the hip. Both come

MEDIEVAL ART IN MUSEUMS

across as classical figures but with softer expressions and postures than the more heroic images of antiquity. Beside them are fragments, which give indications of the still quite strong colors that would have been used on such statues.

Capitals from Catalonia:
end of the 1100's

The set of capitals from Catalonia, to the left of the entrance and of the apostles, illustrates the vigor and narrative skill of sculptors of Romanesque capitals. Although there are many local schools of sculpture in the Romanesque and Gothic periods, there was also a great deal of exchange and influence exerted, especially along the roads through France and across Northern Spain to the shrine of St James the Apostle at Santiago de Compostela. This famous pilgrim route of the Middle Ages, which is enjoying a grand renaissance today, was important not just for its religious significance but also as a focus of the establishment of Christian kingdoms and Western Christianity in Spain. In this, the king's ideological arm was the mighty French Benedictine order with its headquarters at Cluny and many monasteries around western Europe. The capitals have narrative scenes of Adam and Eve, of the Last Supper, of women buying holy oils to embalm the body of Christ on Easter morning, and carvings of wild animals, a much beloved subject of sculptors for millennia.

Wall Paintings:
from the Abbey of Charlieu, late 1100's

The solid walls of Romanesque churches, like the brick and plaster walls of Italian churches, were ideally suited to mural painting. Like the later stained glass, they tended to depict sacred narratives and encyclopedic expositions of the theology of the time. Not much has survived of this type of fresco painting in France. The lower picture shows a king donating a church building to a saint. The saint is thought to be either St Stephen, the first martyr, or Fortunatis, a martyr of the 3rd century. The church being offered is in the early Romanesque style, consisting of a rectangular gable with round arches and a very tall tower. Although the faces of both king and saint owe a good deal to Byzantine images, they are markedly different in expression. The differences must be interpreted as expressing some inner disposition of each character.

The king is shown as though he is offering some manner of reparation and the saint is benignly accepting it.

Go up the stairs to Room 13, where you will see one of the most prized possessions of the museum.

The Lady and The Unicorn (La Dame à la Licorne):
tapestries woven from wool and silk in Flanders to a Parisian design, late 1400's

These tapestries illustrate the super-refined courtly taste of the late Middle Ages. The theme of the five senses and attendant temptations was common in that era. This museum offers interpretations of the symbolism that are totally plausible, but the Middle Ages delighted in ambiguity and symbolism, so the scenes can probably be read on a number of levels.

For instance, the repeated use of the coat of arms of the commissioner is taken to suggest that the works are advancing the claim to nobility of a family from Lyons. Other interpretations might focus, not on the would-be noble lady, but on the unicorn and the lion. The unicorn was a popular mythical beast of the time and can symbolize many things, including Christ, or it can suggest more fantastic interpretations from the world of fairy stories. That being said, the appeal of the tapestries is more in their wonderful decorativeness than in their allegories. Each scene is set on a magic carpet floating in surroundings rich in flowers, birds, and beasts, and flanked by exotic trees standing in flowered grounds. The lady does not express a great deal, seeming rather too refined and absorbed in her tasks to tell us what she is about. The unicorn, however, is an amiable and expressive beast, presumably the source of the magic that sustains the scenes.

Room 16

Three crucifixes:
The first from the Abbey of Bonshommes, 12th century; the second from Limoges, 13th century; the third by Pietro Vannini, possibly from the 15th century

Precious objects such as those represented in this room repeat the iconographies of their ages in miniature. One wonders whether by some miracle only the very best survive or whether for some

millennia artisans working in these materials never did anything badly. Each item is exquisite. A long trend can be traced from the relatively skeletal work of early times through the sober formality of medieval work and on to the gorgeous decoration of the early Renaissance. If anything nudges ostentation it is the last crucifix.

Room 18

Misericordes:
from the choir stalls of Beauvais, 15th century

The idea of Misericordes illustrates the humanity, playfulness, and irreverence often to be found in the Middle Ages. Monks had to stand for long hours reciting the Offices of the Day, so carvers put a projection under the seat so that they could prop rather than stand. Hence the name "Misericord" loosely translated as "taking pity." Each of the supports is carved and the carvings range from the ingenious through to the downright bawdy. Naturally, given what normally reposed on them, they were not sacred subjects.

Proceed to Room 19 where there are two notable and astonishing pieces designed to adorn altars:

Room 19

Golden Altarpiece (Autel d'Or de Bal):
gold over wood with semi-precious stones, 11th century

The five figures of this shining altarpiece are identified above. Christ in the middle is "King of Kings and Lord of Lords." On his left are the archangels Gabriel and Raphael; on his right, the archangel Michael and St Benedict. Obviously the piece belonged in a Benedictine establishment. The drapery of the figures is essentially an exercise in abstraction. Christ has the upraised right hand of the teacher and in his left hand, the globe. The Greek lettering on the globe represents the first two letters of the word Christ (chi and rho) with the first and last letters of the Greek alphabet (alpha and omega) to signify that Christ is the beginning and end of the world. The three archangels are most important in the hierarchy of celestial beings, coming only after God and the Virgin. One of them, Gabriel, appeared to Mohammed and set him on the way to writing the Qu'ran.

Michael, commander-in-chief of the celestial army, ushered Adam and Eve out of paradise. Raphael advised Tobias' son and the old man's blindness was cured. St Benedict, who sits at the same level as the three, wrote the rules that formed the basis of Western monastic life down to the present day.

Room 20

Chapel of the Hotel de Saint Germain-des-Prés:
c.1500

The very last phase of the Gothic style is called the Flamboyant style. The vaults of this chapel demonstrate the passion for complication and decoration that essentially replaced the other-worldliness of Gothic at its peak. Ogives have been linked and re-linked until the whole thing looks more like embroidery than building. Handsome though the building is, it would be but a short time before the reformers decided that this was the art of a "Church Terrestrial" rather than a "Church Celestial."

The Altarpiece of the Pentecost:
from the Meuse region, gilded copper on wood and enamel,
1160–1170

The 12 apostles at Pentecost are visited by the Holy Spirit in the forms of tongues of fire. Christ above blesses them and urges them to spread the word, symbolized by the book in his left hand. Without drawing attention from the central action, the apostles are shown in various postures and with differently patterned enamel haloes. In particular, their gestures are quite different one from another. The piece takes advantage of some of the symbolism of numbers so popular in the Middle Ages and earlier. By being grouped in pairs they are within a framework of seven columns. These are both the seven pillars of wisdom of the Bible's book of Proverbs and the seven gifts conferred on them at Pentecost by the Holy Spirit.

Room 21

An Angel of the Annunciation:
from Pisa, polychrome wood, 1350–1375

Is this a Renaissance figure? The beginning of the Italian Renaissance is usually traced to Giotto. But Giotto was already

dead when this charming archangel was announcing the news of Christ's conception to Mary, his unwitting mother. The argument is complex. Was Giotto as much a painter of the spiritual Middle Ages as of the humanistic Renaissance? The sculpture of the 12th century and beyond in Paris shows a greater awareness and feel for classical form than the most dramatic and solid of Giotto's work. The heart of the problem is probably the word Renaissance and the coining of the term Gothic to describe work that later artists thought so inferior to their own as to be barbaric. This archangel would look at home in a museum of the Renaissance as an early work of the period, but it looks equally at home in a museum of the Middle Ages as a later work.

The Louvre

This half-day visit to the Louvre includes two collections: the sculpture of the Middle Ages, and *objets d'art* from the same period.

For full information on the Louvre, turn to page 245 in the Trails in the Louvre section. Brochures and maps are also available from the information desk in the Pyramid, where you enter. From this underground area, you'll see three escalators, one to each wing of the museum. For this Trail, take the one to the ground floor of the Richelieu Wing.

Location: Metro Louvre, entrance from Rue de Rivoli or the Tuileries Gardens
Opening Times: 9:00 am–6:00 pm (10:00 pm Wednesdays). Closed Tuesdays.
Admission: 7.50 Euros from 9:00 am–3:00 pm; 5 Euros after 3:00 pm and on Sundays. The ticket is valid for the day so you can leave and come back.

SCULPTURE OF THE MIDDLE AGES

The Louvre's small collection of sculptures was mostly rescued from damaged churches. Quite a few are from the south of France where the Romanesque style reached its peak, but there are others from the Ile de France where the age of Gothic cathedrals began. This collection, *Sculpture Française du Moyen Age,* is on the ground floor of the Richelieu wing off the Cour Marly. This is not a large area. Take your time to look closely at these works, which you would not be able to see in such detail in their original churches. We suggest an hour or two.

Room 1

In Room 1, we begin with viewing some works in the Romanesque style.

Columns and capitals:
from Gaul, 6th century

Opposite, as you enter Room 1, are a pair of decorated columns and a capital with human and animal figures. These illustrate the continuity of Romanesque art from the Roman Empire. The columns, which are decorated in geometric fashion with vines, grapes and leaves, would be at home in early Christian, Romanesque, or Gothic buildings. The marble capital, in its 6th century life, would have been decorated all over with acanthus leaves as Roman capitals were. It came from a Merovingian church and was quite possibly re-used from a Roman building. Most of the leaves were dispensed with and a story was sculpted in their place.

Room 2 continues the theme.

Room 2

Capital of Abraham and Isaac:
from Poitou, c.1150

A strong feature of Romanesque art of the 11th and 12th centuries in the south of France is the carving of stories on capitals. It was much less common in northern France where the stories are told on the main portals, around the doorways into the church, rather than at the tops of columns. The capital showing the sacrifice of Abraham comes from Poitou in the central west of France. At the time this was carved, Saint Denis in Paris had been consecrated and some work on Notre Dame de Paris had already started. In the Old Testament story, God had ordered Abraham to sacrifice his son Isaac as a demonstration of his belief in God. Abraham has Isaac by the hair and is about to cut off his head when he is interrupted by a messenger from God who tells him that he needn't sacrifice Isaac but can sacrifice an animal, which has been provided nearby. Abraham looks around, a bit startled, like a farmer who has been interrupted going about his business. The double theme of sacrificing a son and showing mercy at the last minute is meant to

be a parallel to the action of God sacrificing his son and showing mercy to humankind.

Two capitals: Trampling Grapes:
from Bourgogne, 1125, and

Monsters and Entrelacs:
from the south of France, 12th century

The subjects on sculpted capitals (and also on sculpted doors) are not exclusively sacred. There are also references to daily life and to mythology. The scene of trampling grapes might have represented September in a cycle of months, often symbolized by typical labors, and is a very suitable subject to come from Burgundy. The narration is quite clear cut, the carving fairly rough – especially the way in which the head of the man who is carrying the basket of grapes has been displaced. The eyes have black pupils set in them. The second capital nearby illustrates the use of mythology in decoration. These monsters are caught up in intertwining vines that trap them in a rampant geometry.

Both this motif and motifs such as the "Labors of the Months" occur in many other cathedrals and churches, sometimes as background decorative detail and sometimes as symbols of earthly life counterbalancing themes of the next world.

The Crucified Christ:
from Bourgogne, wood (originally painted and gilded) between 1225–1250

As part of a scene representing the dead Christ being taken down from the cross, this figure naturally contributes to the portrayal of grief in the now missing other figures. Crucifixions of the early to high Middle Ages do not necessarily emphasize Christ's suffering because his death is seen as a victory. A crucified figure therefore can be shown as a commanding royal figure. In this case, the other-worldly aspect of Christ persists in the treatment of drapery, which is formed into a circle at the knee, and in the slenderness of the figure. However, the scene of which it is a part, requires that he also be a lifeless and pathetic figure and this is conveyed by the angle of his body and the looseness of his arms.

Room 3

Two column statues: King Solomon and Queen of Sheba:
from Notre Dame de Corbeille at Essonnes

The royal portal at Chartres, which survived the fire of 1194, had a wide-ranging influence. These two column statues are readily identified as counterparts of the figures at Chartres, supposedly of Solomon and the Queen of Sheba. See from the side that they are in fact part of the columns as well as figures standing out beyond its edge. Both are very tall and elongated. The elongation makes it clear that they are creatures of another world. The woman is in a form of medieval dress and the male figure in ancient dress. The woman has plaits falling to her knees and the elongation of both is heightened by the treatment of the dress. The very long pleats and folds fall either straight or in large semi-circles. To some degree, the deliberately geometric treatment of the drapery is made plausible by the nature of the drapery and by the still, frontal posture of the figure. Some of the details, such as the queen's hand and part of her face, are rather clumsy 19th-century restorations.

Heads in a case:
especially Head of an Elder of the Apocalypse, 1140

In the case opposite the column statues, there are several pieces – including heads – from the much vandalized basilica of Saint Denis (see Trail 4). The heads on the top shelf come from the main portal of the basilica and represent the Last Judgment and are from one of the finest periods of medieval sculpture. There are a pair of apostles and two heads of "Elders of the Apocalypse." The elders are figures of doom, prophets of the end of the world. The heads of kings below come from the northern doorway of Saint Denis, which was sculpted over a century after the Elders of the Apocalypse. They are handsome and august – in no way forbidding like the elders. They have the faces of good rulers. There is no doubt that in their original painted state, those presently blind eyes would have been the penetrating eyes of just lawgivers.

Retable:
from Carrières sur Seine, 1150–1175

A retable is an altarpiece. This is an altarpiece that illustrates some of the very important ideas and features of sculpture in 12th-century

France. This was an image intended to elevate Mary to the highest possible place next to God. In this role, her figure is carved as a heavenly figure, upright, commanding and arranged to impress. Notice, for example, how the treatment of the drapery on and below the knees is arranged to create a pattern rather than reflect the natural fall of clothing. On the left side, Mary is given a more human posture. She looks startled, not simply at the sudden appearance of an angel, but at the news that the angel was bringing. This scene of the angel announcing Mary's conception and the scene on the other side, in which Jesus stands in the river to be baptized by John, are both scenes that announce the coming of Christ on earth. In the center too, Christ is still a child seated on Mary's knee. The architectural motifs above the scenes represent Jerusalem as the "Heavenly City." Of great interest in this altarpiece are the remains of color. Gold, blue, and red are easy to identify. Clearly all of the narrative part of this altarpiece would have been painted. Its effect must have been very like the brilliant colors of the paintings of later periods.

Room 4

In front and to your left as you go into the room is:

Saint Genevieve:
1200–1225

St Genevieve is one of the important patron saints of the city of Paris. She is shown here dressed in a nun-like garment, tied at the waist so that it falls pleated over the cord. She holds a book to signify her learning. She is shown as an upright frontal figure of the sort placed on the exteriors of buildings or in niches. She has a calm face and a faint smile intended probably to make her seem approachable.

Beside St Genevieve is another statue:

Saint Denis:
from St Denis, after 1250

Saint Denis is often depicted in his martyred state with his head cut off and holding it. In this case, since the head is not there, we have to get what impression we can from the stance. Whether he

had his head on his shoulders or in his hand, he is presented as an impeccable figure. He wears the robes of a bishop and has the easy stance of someone in authority. Scenes from his life figured on two of the church's doors and would have complemented this statue.

Now view two items, one from Notre Dame de Paris, the second from Notre Dame de Chartres. Both had sculpted screens around the sanctuary. Their function was to separate the canons who ran the church from the people. In both Paris and Chartres, 13th-century screens were destroyed by the church authorities and replaced with screens of lesser quality. The first one is from Notre Dame de Paris:

Descent into Limbo:
from Notre Dame de Paris, from the choir which was destroyed in 1627, middle of the 13th century

This fragment from Notre Dame de Paris indicates that it was concerned with the life of Christ. The "credo" or list of beliefs composed at the Council of Nicea, said that Christ "descended into Hell" after his death. The purpose of the descent into hell was to single out the good and the innocent who had died before his coming or without baptism. This would have included notables such as Moses and Plato as well as those who died in the Massacre of the Innocents. To escape the theological dilemma caused by having such people in hell the theologians invented "Limbo." Dante described Limbo as an amiable place with a good climate where the greats of ancient times sat about. Where the smooth and sexless bodies on this fragment belong is hard to say. The heads boiling in the pot on the right are presumably in hell.

Nearby upper left in a case, is the screen from Notre Dame de Chartres.

Saint Matthew at a Book:
from Notre Dame de Chartres and originally in the choir there, mid-13th century

This fragment depicts a straightforward scene from tradition: an angel dictating to St Matthew, suggesting that his Gospel is a sound account with divine imprimatur. The heavenly city is above, and the angel is working from a cloud.

MEDIEVAL ART IN MUSEUMS

Beside the *Descent into Limbo,* you'll find:

Virgin:
from the convent of the Ursulines at Abbéville in Picardie c.1270

By the 1200s, the trend is to make the Virgin an attractive young mother figure. This Virgin has no crown. She wears a medieval dress with a high waist and has an aristocratic flat chest. Her hip is angled out to support the child and give a fine curve to the body. Much is made of the folds of the garment falling from the waist. They are beginning to fall like the classically influenced drapery of later centuries.

Pass through Room 5 to Room 6, and on the right wall as you enter, you'll see two sculptural depictions of the Holy Mother and Child.

Virgin and Child:
from the Ile de France, 2nd quarter of 14th century

Virgin and Child:
from the Abbey of Chanoines Prémontrés de Blanchelande in Normandy, 1st third of the 14th century

By the 14th century, Mary had been inducted into the French aristocracy. In the smaller marble, both mother and child are smiling. The hip protrudes in a neat "S"; the folds of her garment are ample and sculpted as though falling naturally. She wears a crown and the child has finely detailed curls. The child's ball also signifies the universe of which he is king. The bird refers to legendary stories, or Apocrypha. One such told how, even as a young child, before he was officially supposed to perform miracles, he would revive dead animals. The larger piece has the nicely judged curve of a slender woman. There is a bird here too. Both smile and the child touches the mother's face as human babies will. From crown to foot, this is an elegant lady.

In the next few rooms, there are some funerary statues. You may wish to view them, or proceed directly to viewing the *objets d'art* from the Middle Ages in the Louvre.

Objets d'art

In medieval art, we often have to learn from miniature, highly valued objects in ivory, metal, glass, and enamel, though we surmise that larger works existed in quantity. Like the ancient Greeks, medieval people preserved their precious objects in treasuries. They did not leave precious objects in tombs, because they believed the dead would be going to heaven, where earthly objects would seem meretricious. Nonetheless, anyone of any wealth or importance commissioned precious objects to be displayed to the glory of God and the saints, and again, like the ancient Greeks, they dedicated them. To begin this part of the Trail, go to the Richelieu wing. Follow the corridor to the right and take the escalators up one floor. (These escalators, in a surprising setting designed by Jeoh Ming Pei, accentuate the height and space of the original building.)

The first three rooms contain objects from early Christian Byzantium to the 13th century in France and help to put medieval art in perspective. Only a few pieces in these rooms are covered here, but the total collection is extraordinarily rich if you are able to spare the time to look at miniatures and jewelry.

Room 1

The columns on each side of the entrance to Room 1 and the equestrian statue in the box immediately ahead of the entrance establish an important theme – the continuing influence of antiquity. The columns are allegedly from St Peter's in Rome at the time of the Emperor Constantine.

Charlemagne, Equestrian Statue of Emperor:
bronze (once gilded) figure 9th century, horse 18th century or restored in the 18th from a 9th-century original

The figure, usually said to be Charlemagne or one of his successors, Charles the Bald, is patently an evocation of imperial Roman statuary. The emperor is stiff and proud as a good horseman and emperor must be. He has lost his scepter but wears his crown and carries the ball in his left hand. The horse is dressed for a procession and the rider properly draped in the manner of the Roman emperors. The statue was made by the lost

wax method, which seems to have been developed and was certainly used in ancient Greece. Take a moment to look at the face, which carries an expression somewhere between self-satisfaction and amusement.

Charlemagne's reign is known as the Carolingian Renaissance because the warrior and the church combined to restore the civilization of Rome, which had for several centuries been dispersed in the west by various invasions from Africa and Northern Europe. Charlemagne initiated the "reconquest of Spain" and in 800 CE was crowned Holy Roman Emperor in Rome.

Other displays in this room are worth looking at, though not closely associated with this Trail. To the left of the Charlemagne statue are works from before and after his time. To the right are works from the Roman Empire of the east (Byzantium) in the 10th century. Once you've had your fill, go to Room 2, known as the Suger Room. The Abbot Suger was a towering figure of the 12th century and is credited with the initial development of Gothic in the work that he directed at the Abbey of Saint Denis. Saint Denis is the burial place of many of France's kings and queens and Saint Denis himself is patron saint of France. Naturally the abbey had a substantial treasury of precious objects offered, as their inscriptions often volunteer, to God and the saints.

Room 2

Vase de Porphyre or Suger's Eagle (Aigle de Suger):
vase dating from Roman times, gold ornamentation
from the 12th century

Suger's reworking of a Roman porphyry vase illustrates the relentless drive in such treasuries to augment the magnificence of pieces. As the inscription says, an already valuable vase, ancient and of precious stone, has been made even more valuable by the addition of a golden eagle. It is of course offered to God or the saints but its lavishness, both in material and artisanship, establishes the Abbot Suger on a level with the royals. That there are two more such objects probably establishes the extravagance of the Saint Denis treasury.

In the back left corner are stained glass windows.

Stained Glass Windows
from Soissons, 13th century

Medieval churchgoers had the double pleasure of being drenched in the light and color of these windows as well as of the familiarity of their subject matter. Stained glass windows were the people's illuminated manuscripts. As usual, the story starts in the bottom circle. At the bottom of the large window, two saints, Nicaise and Eutropie, are shown heading for the cathedral of Reims. Armed darker-skinned Vandals assail them. St Nicaise is put to the sword. In the upper circle, St Eutropie (the woman) is martyred and the warriors leave. In the lower half of the circle, St Nicaise is laid out and there are preparations for the laying out of Eutropie. A line of architecture ties the double side of the laying-out scene together across the middle of the circle. The saints are in Roman style robes and the Vandals in chainmail.

Room 3

The next stop is Room 3. Before you as you go through the opening is:

Virgin (Vierge):
from Paris, ivory, polychrome, 13th century

The 13th century's humanizing of the Virgin can be seen here in miniature form. This piece shows the Mother of God as a beautiful young woman nursing a jolly child. A human love of a high order is shown here in both figures. She is in the most graceful of mother poses – a slight curve to her right gives the infant just enough hip to be comfortable. To what extent does the drapery now fold and fall naturally in the late classical manner or in geometric patterns meant to have a beauty of their own? Are the eyes more or less almond shaped than the eyes of the Sienese school of the Trecento? Can we compare her smile to that of the young women of the Archaic period of Greek sculpture? Whatever your opinion, there is no doubt that the body of the Virgin Mother is more slender and high-waisted than any of her classical predecessors.

Once you have seen this, you have finished this Trail. We return to the Louvre in Section 4 to view Greek and Etruscan art and European painting.

TRAIL 4:
Saint Denis

Location: Close to the Metro Saint Denis Basilique and signposted
Opening Times: 10:00 am–5:00 pm
Admission: Free to the church; fees to see the tombs in the apse and
the crypt

A generous half-day will do justice to this Trail. There are good, cheap restaurants in the shopping center outside the metro.

The Metro – Line 13 to Saint Denis Basilica – takes you to within a few hundred yards of the basilica. As you leave the station, make towards the left. Most days, on your right, there will be an extensive market in full swing. This area housed an abbey that was well outside of Paris when it was built, and a sacred site because it contained the relics of St Denis, then the patron of Paris. For centuries it was the burial place of the kings, queens, and nobility of France. In modern times, it became an industrial suburb and more recently has been redeveloped as an attractive and well-serviced area with a university.

The Basilica of Saint Denis is generally regarded as the birthplace of Gothic architecture. It is memorably associated with the royal dynasties of France who were buried there from the 7th to the 19th centuries and with Suger who became the Abbot of the vast properties of the Abbey in 1122. Suger was a man of immense energy and skill. As soon as he had restored the finances of the ailing abbey, he set about rebuilding the church. He rebuilt the front part of the church (the narthex), and the east end (the choir) with amazing speed using imported builders and sculptors, mainly from the south of France. We do not know who his builders or architects were, but we do know that Suger was both an interfering and a prescriptive employer, insisting on the use of the ogive everywhere and on the necessary and transcendental role of light. We also know that his idea was that the church, a re-creation of paradise on

earth, would give worshippers the entire story of Old and New Testaments in compelling sculpture and radiant glass.

The front part of the basilica was dedicated in 1140 and the choir in 1144. Present at the dedication of the choir was a powerful assembly of royalty, clergy and commoners. According to one story, the common people crowded in so fast that the royals were beating them back with sticks.

Suger died in 1151 but about 80 years later the great Pierre de Montreuil added to the choir, transepts and nave, before he himself died in 1267. The building was completed in 1281. The old Carolingian church had been completely replaced and can be seen only in the crypt.

Giacomo di Varaggio's popular *Golden Legend* draws together the stories of St Denis that were probably the basis of his reputation. The author sets out the legend of St Denis much as it was depicted on the northern portal of this basilica and in other French churches built at the time. He calls St Denis the "Apostle of the Gauls" and the "Bishop of Paris" and says that he was tortured and executed, possibly on the site of the basilica, by the Emperor Decius about the year 250 CE.

His account also claims that this St Denis was the same person as Denis the Areopagite, the legendary bishop of first century Athens. Denis the Areopagite had been converted by St Paul and later corresponded with St John the Evangelist. Having visited Sts Peter and Paul in a Roman prison, he was dispatched after their deaths to France by the Pope of the day. He had two companions, Rusticus and Eleftherios.

The legend is that Denis' success in converting Roman Gauls infuriated the Devil, who saw his own pagan cults diminishing day by day, so he caused the Roman Emperor to have Denis and his two companions arrested. As they protested their faith to the authorities, a woman came and denounced them for having led her husband astray. The husband was promptly executed and the three saints scourged by a dozen soldiers. They were then loaded down with chains and flung into prison. The next day, Denis was roasted naked on a grill, and being presumed dead, his body was flung out to starving wild beasts. However, a sign of the cross from the still-living saint tamed the beasts and so, after further tortures, he was thrown back into prison.

There, as he celebrated the Mass, Christ appeared to him and gave him a piece of bread in recognition of his faith. The next day, after further tortures, Denis and his two companions were beheaded in front of a statue of the god Mercury. The body of St Denis then stood up,

picked up his head and led by an angel, stalked off from the hill of Montmartre to the present site of St Denis. The angelic music that accompanied this headless walk so moved the wife of the Roman prefect that she declared herself to be a Christian and was herself decapitated. The elements of this story can be readily picked up in the sculpted versions.

This Trail first covers the façades of the building.

The Exterior

THE WESTERN FAÇADE

Although Suger insisted on the then new ogival interior, he basically retained the Romanesque character of the façade of the church, which is what you still see today. Apart from the Gothic features – the rose and the quite sculptural decorations around the three doorways, which are very much in the early Gothic tradition – the façade conveys the strength and solid balance of Romanesque architecture. It has battlements, which relate it to the fortress churches of the Normans. It is sustained vertically by four beautifully spaced buttresses with only some slight ornamentation in their upper part. A pair of strong diagonals, which can be followed from the outer doorway through the central window below the rose and then up to the battlements, counterbalance the upward thrust of the great buttresses. Above the crossing of this diagonal sits the rose and below it, the rounded arch of the great portal.

Unfortunately for us, as far as the façade is concerned, it is the distant view that is closest to the original. A tower and spire on the left were demolished in 1839 and the sculptures of the portals and the original bronze doors have suffered immensely from the ravages of time, neglect, vandalism, and inept restoration. Only the eventual intervention of the great 19th-century restorer Viollet-le-Duc saved much of the basilica and replaced lost work with dignified substitutes.

THE WESTERN PORTAL

The sculptures of the portal of the main façade are perhaps the most lamented in the history of art. In Suger's time, they were a spectacular innovation because they evoked the spiritual journey of the person entering the church, reminding the worshipper of the

Last Judgment and of other Biblical events. They contained an epic narrative that would be taken up at Notre Dame in Paris and brought to unrepeatable heights in Chartres. Unhappily, both the destroyers and restorers of these sculptures have left us with impoverished images of what they looked like, even though they have retained the narrative.

Today's narrative has retained the tiny figure of Suger edging his way into the base of the mandorla shape surrounding Christ in Judgment. The reproduction of the original brass doors also shows Suger creeping into the supper scene at Emmaus, an encounter that some disciples had with their risen leader very soon after the Resurrection. Each of Suger's appearances shows him as a small monk edging his way into a box seat for one of the Big Moments and, we assume, shows either hubris or his sense of humor.

To gain access to the most interesting other part of the basilica, you need to go to the north side kiosk and buy a ticket. This takes you into the choir, the transepts, and the crypt and includes the necropolis, which occupies some of these spaces. But first go in the main entrance and stand somewhere in the nave.

The Interior

As soon as you go in through the portal into a sort of vestibule area called the narthex, you see how Suger had ogival vaulting included in the first part of his building. The Romanesque façade, allied with the ogives and the rose window, demonstrate the transition to the Gothic that occurred early in the 12th century in the Ile de France. As we see, it was a style that really took off.

THE NAVE

The nave itself, from the 13th century, is a work of great elegance but it is impossible to take in much detail until you have recovered from the overwhelming effect of the light. The original glass through which this light comes has largely been lost so that today we have a somewhat whitened version of it, but the example of Chartres suggests that it would have been just as light and vastly more beautiful when it was first created. This is what Suger sought. "A noble work," he wrote, "shines and it shines nobly. It illuminates souls and leads them by true lights to the one True

Light of which Christ is the True Gateway." Suger understood that through art, material things could lead people to the higher worlds of the immaterial. The nave carries lightness of construction to a high point of perfection. The broken arches of the ground level are supported by pillars with attached colonnettes ending in an bouquet of small capitals but the shafts are taking the thrusts of the ogives way, way above, uninterrupted to the point where the ogives spring out from the shaft.

The triforium or gallery is narrow so that its windows are themselves a source of light into the nave. The vaulting on each side meets broken arches, which give the ceiling maximum height; windows in patterns of lancets and trefoils fill the whole of this height. No style has ever – before or since – turned stone into so much intricate line.

THE CHOIR

Apart from the stained glass, which is mostly gone, the choir, from the 12th century, still gives us a good idea of the wonder that Suger had created. The inner part, closer to the altar, was refashioned in the 13th century. From its central part, you can see that it is all glass from the floor to the very top of the roof. It is raised because it is built above the crypt from the old Carolingian church. At ground level, even though there is a double ambulatory, light floods in because the chapels are only very shallow curves and the windowsills are well below the height of a person. The idea of a double ambulatory is more or less standard in any church that had precious relics and treasures. The inner ambulatory could be used for rapid circulation while people pausing to pray could use the outer ambulatory and its chapels. Even this apparently did not prevent people from being jostled and half-suffocated in the press of pilgrims.

In the next storey there is only a very narrow gallery behind the arcade of the triforium so light comes directly into the choir. In the upper layer, the clerestory, apart from a few shafts and some stone tracery, everything is glass.

Back in the ambulatories, notice how different vaultings deal with the expanding curve. In the inner ambulatory, notice how the greater curve of the outer edge is accommodated by a widening of space between the ribs. In the outer ambulatory, as the arc creates even greater spaces between the columns, a five-part ribbing is created – two ribs on the inner side and three on the outer. Notice

too how slender the middle set of columns is that divides the ambulatories. Compare them with those in Notre Dame of Paris (Trail 1) or Chartres (Trail 6) to see what a daring architect Suger had engaged.

The choir contains seven chapels with curved outer edges and another two before you reach the transept. In the middle one of the seven – The Chapel of the Virgin – the stained glass survived from Suger's time. It has however been taken away for an indefinite time to prevent further deterioration and what you see are photographic images on plexiglass. The photographic images are pale and only give you an idea of the narrative.

The glasswork commissioned for the gaps by Viollet-le-Duc gives you a better idea of the color that might have been there. A lot of the 19th-century glass in Saint Denis is awful but Viollet-le-Duc reinterpreted lost iconography with much learning and got his glass workers to provide a range of colors that evoke glasswork of the 12th and 13th centuries. Most of the windows' scenes carry titles stating the subject matter. A particular advantage is that the windows are placed close to eye level and the lettering itself can be read with the naked eye.

The Tree of Jesse: The two in the chapel illustrate the Tree of Jesse (see Appendix of Biblical Terms) and the life of Mary and Jesus. This Tree of Jesse is exactly reproduced at Chartres. Reading the window as usual from bottom to top, the tree grows out of Jesse and twines upward around three kings. On the fifth level is Mary and on the top level, Christ.

The Life of Mary: In the left window, the life of Mary is followed in six levels, going from bottom to top, starting with the Annunciation. On the left side of the Annunciation circle is a half circle showing Mary meeting her cousin Elizabeth while, on the right, an angel reassures Joseph that Mary's pregnancy has an honorable explanation. Back in the central circle, the archangel Gabriel is greeting Mary with an "Ave Maria" (Latin for "Hail Mary") and the impregnating dove is piercing her halo from a cloud. Mary is responding with a gesture of acceptance. The monk creeping into the picture to touch the hem of Mary's gown is identified in Latin as Suger.

In the second row, the scene of the Nativity is flanked by the shepherds hearing the heavenly music and, on the right, Christ being presented in the Temple. In the third row, the angels tell the three kings to follow the star, which they do on horseback. In the

fourth row, in the middle, Mary and Joseph are fleeing into Egypt while, on either side, Herod's soldiers are massacring all the male infants. In the fifth row, the 12-year-old Christ is teaching in the Temple while, on either side, Mary and Joseph are anxiously looking for him. The top row is a full scene, with angels, of the Dormition of Mary.

Go to the Chapel of the Virgin, to view:

Altarpiece of the Childhood of Christ: The skillful 13th-century carvers retained an air of spaciousness around narratives that are crowded with detail. In this piece three kings visit the reclining Virgin and the Child. Over on the right, Herod is savagely ordering the massacre of all male children who might threaten his dynasty and the family is escaping from this massacre by making their way to Egypt on a donkey. There is a parallel, possibly unintended, with the placement of figures in the Last Judgment: the heavenly figure is in the center; the good are on the right, and the villains are on the left. Whether intended or not, using the same order of events adds to the impact of the meaning.

In the sixth chapel, the Chapel of St Eustache, is:

Altarpiece of St Eustache: This 13th-century altarpiece tells the story of a Roman martyr popular in France in the Middle Ages. It is small wonder that he was popular since almost everything that could happen to a saint happened to him. *The Golden Legend* recounts that he – under his original name of Placidus – commanded the armies of the Emperor Trajan. Since he was a good man, God decided to lead Placidus and his family from their pagan beliefs, and spoke to him after assuming the form of a deer that he was hunting. Deeply impressed by this vision, he returned to his family to find that his wife too had had a vision of a crucifix that told her that the whole family would become Christians. After his conversion, the deer appeared to him again and told him that he would not go to paradise in glory after his death until he had been through so many trials in his earthly life that people would see him as another Job.

The first scene shows how, after many tribulations and being separated from his wife, Eustache tries to get his children across a river and loses one to a wolf and the other to a lion. Despite this, his whole family survives and Eustache is restored to the command of his armies until Trajan's successor, the Emperor Adrian,

SAINT DENIS

discovering that they are Christians, has them all boiled in a cauldron for three days. This kills them but their bodies are unaffected by their three days in boiling water. The second scene shows the boiling.

The whole altarpiece is quite finely decorated with trees which give it all a spacious background and placing the crucifixion of Christ at the center underlines the meaning of the story to the believers. It was a reminder that Christ died and that Eustache and his family were returning the favor.

In the seventh chapel, one up from this one, view in the Altar of Saint Osman:

Altarpiece of the Twelve Apostles: This 12th-century piece was found during excavations in 1947. The figures are turned slightly from the frontal position but the total impression remains of figures facing the front, closely framed by architecture. The architecture might be that of the Heavenly City. It welcomes rather than overwhelms the figures. The columns and capitals are decorated with various geometric and vegetal motifs. The heads of the figures are large in relation to their bodies. Who is who among them is not clear to the modern viewer and it is also not clear why ten of them are shown conversing in pairs and two are isolated.

The Effigies: Around the choir and transepts and in the crossing are effigies of royals buried in the crypt. The oldest of these are those commissioned by Louis IX in the mid-13th century. These are of the Merovingian, Carolingian, and Capetian dynasties. Each figure is represented as a 13th-century figure in 13th-century dress. The exception is the figure of Childebert, which came from the church of Saint Germain-des-Prés. He is shown holding that church. Another is a flat image with cloisonne work. There are also two of Louis' own children, Jean and Blanché. The earlier examples show the dead as though asleep and waiting for the trumpets to sound on the Last Day. The effigy of Catherine de Medici is startlingly different and suggests a terrible fear of death that is absent from the earlier representations.

Go downstairs into the crypt, which is the real burial place. If you have heroes and villains in your mental map of the royals of French history, you will find many of them here, but Napoleon is in the domed church in the grounds of Les Invalides.

THE CRYPT

There are clear signs so this area is easy to understand. Note the foundations and parts of the walls of the Carolingian church dating from the 8th century. Sections of the wall are well lit and show the type of wall decoration that was used in that early building. Around and outside the Carolingian church is another rounded chapel shape, an 11th-century addition to the church, called the Chapel of Hilduin. Within that are the rather damaged remains of Romanesque capitals, which were quite rare on the Ile de France and common in the center and south of France. Notice that, stylistically, they are very like the figures on the 12th century altarpiece above. On the outside ring of the crypt are the huge, round arched foundations built in the 12th century to support the choir of the present church.

Finally, go outside to the north side of the church where there is now a garden dedicated to Pierre de Montreuil. The raised circle with ornamental hedges represents a former rotunda-shaped mausoleum, built there by the Valois dynasty. Catherine de Medici, widow of Henri II, ordered it to be built but it was never properly completed and was pulled down in 1719.

The view from the Pierre de Montreuil garden gives a very good impression of how the basilica has been buttressed above the crypt. You can see that the buttressing of the 13th-century upper part of the choir is solidly anchored in Suger's wider apse. During Suger's lifetime, buildings still depended on the sort of massive upright buttressing used on the front of the church. By the 13th century, the architect of the reworked choir was using arches flying out from the buttresses and supporting the wall without blocking the light. Buttresses, however functional they are, are treated with as much decorative care and consideration for their elegance as the most esteemed parts of the church. Indeed, researchers say that stonework in parts of buildings that were never intended to be seen, such as foundations, were worked with as much care as those that would be seen.

TRAIL 5:
The Middle Ages in the
Latin Quarter

his short walk of an hour or two starts from Notre Dame and could end at any number of bars and restaurants. It is designed to give you some relaxing views and to allow you to drop into a few churches along the way.

From Notre Dame, directly outside the west façade with your back to it, take the bridge to the left – called *Pont au Double* – to the Left Bank and the Latin Quarter. The Latin Quarter, one of the oldest quarters in Paris, was where teachers congregated from afar and students gathered to hear them lecture or dispute. The language that they used was Latin. In 1253, Louis IX (St Louis) set up a college for some of these students. The college was to become the Sorbonne and the University of Paris developed from the college.

The bridge takes its name from a coin called a doubloon, which was a toll levied by the hospital on the Ile de la Cité. The open square (Square Renée Viviani) on the other side of the river, looking towards Notre Dame, gives you an excellent view of Notre Dame. The view of the cathedral – and the buttressing with all its fine detail – rates three stars in the Michelin guide. It is an opportunity to come to terms with its overall shape and proportions.

At the opposite end of the square from the river is the Church of St Julian le Pauvre, which is now a church of the Greek Catholic church and follows the Melkite rite. It was built in the 12th century but much rebuilt in the 17th. The ogival vaulting in the aisles is original. It used to be where the University of Paris held its assemblies until students were barred in the 16th century for vandalism.

The streets around the church, though by no means medieval, give some impression of the winding streets of earlier times, full of jumbled buildings and people going about their business.

Some of the streets on the north side of the cathedral leading off the Rue d'Arcole look medieval but are more deserted than this little section of the Latin Quarter. The difference from the rebuilt Paris of the 19th century, which we rightly admire, is that none of the streets are straight and none of the buildings uniform. The pleasure of such streets is that you continually come across a fresh view, though it may mean that you are sometimes momentarily lost. You will enjoy strolling through them at your leisure.

One of the views that keeps reappearing is the north side of Notre Dame. The feeling of the massiveness and centrality of the building that you get from wandering through the old streets on the island side or the Left Bank evokes the image that medieval citizens would have had.

One of the views from outside St Julian le Pauvre is of the Church of St Severin. To get to it, cross Rue St Jacques. This is the street that runs behind the apse of St Severin. After the 15th century it became the center of printing and bookselling. The street itself dates back to Roman times and was on the road that linked Paris to Orleans. It contains the Roman Baths, which are now part of the National Museum of the Middle Ages.

Saint Severin

Location: No 1 Rue des Pretres Saint Severin
Opening hours: Open during the day. Note that the church cannot be toured during services
Admission: No charge

Like the church of St Julien le Pauvre, Saint Severin has a long association with the student life of Paris. It has been a parish church for the Left Bank since the 12th century. The street on the south side of Saint Severin, Rue de la Parcheminerie, was once as the name suggests the gathering place of copyists and public letter writers.

The church is built on the site of a 6th-century hermit's oratory and the present church is the result of rebuilding from Romanesque through to late Gothic periods. Most of the present building is the result of work done between the 13th and 15th centuries. The 13th-century builder kept most of the plain Romanesque façade but widened it a bit. Most of the new church is in what is called the Flamboyant Gothic style. The Flamboyant style of the 15th century is the last period of Gothic architecture. The interior of Saint Severin is an object lesson in why it is called Flamboyant.

The Interior

The most striking part of the building is the double ambulatory – the curving aisles – which go right around the back of the altar. The reforms of the Second Vatican Council in the mid-20th century meant that altars were brought forward to the crossing. In this case, taking away the old altar has exposed the spiral central columns, which spectacularly continue their spirals up into the complex vaulting. Both the vaulting and the other less flamboyantly ornamented columns demonstrate both the virtuosity that Gothic architects commanded and the excesses to which they could carry that virtuosity.

The vaulting, for example, is no longer based on four or six ribs meeting in the center. Instead, a diagonal first splits the space between the four columns and each triangle is given three-ribbed vaulting. Breaks that separate the columns of the ground level from those of the upper levels, and which in earlier styles were often marked by substantial capitals at the upper levels, are now either diminished or dispensed with as the shaft runs straight up from floor to ceiling.

You can compare the more classic Gothic style with later styles by comparing the first three bays of the nave – starting at the entrance door – with the later ones that make up the rest of the nave. In doing so, you will also see some Late Renaissance butchery in the columns of the nave and around the altar. On the columns, part of the shaft has been cut away so that it can appear to rise from a carved support higher up the column. Around the altar are panels of marble and wood masquerading as bits of Renaissance building and the broken arches have been filled in with false round arches decorated with mock classical moldings.

The abstract Flamboyant stained glass around the apse is work by Jean Basin in about 1970. They depict the seven sacraments. If you go up closer, you can see that each one is labelled as the appropriate sacrament. The upper layer of the upper windows is from the late 15th century.

When you leave Saint Severin, you will have completed your Paris-based tour of medieval art and architecture. Continue on your stroll around the Latin Quarter if you wish, taking in its rather bohemian atmosphere. There is an enormous choice of restaurants of all flavors in the Quarter, so you may wish to replenish your strength at one of them.

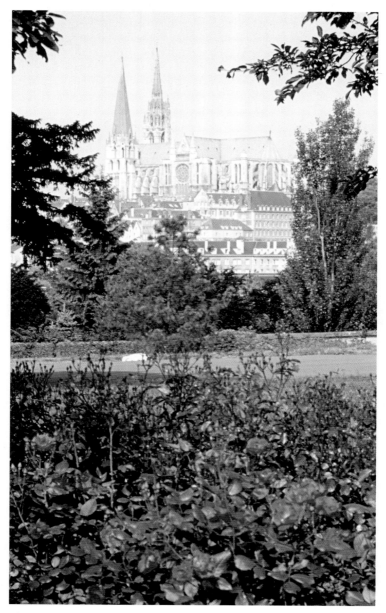

Chartres Cathedral viewed from afar

TRAIL 6:
Chartres & Gothic France Outside of Paris

B y train, this Trail is best taken in three trips. The first is a one- or two-day trip to Chartres; the second an excursion lasting over two days to take in Reims, Soissons, and Laon, and the third, a one-day trip to Beauvais. By car, you can accomplish it in two trips. First, there is the one- or two-day trip to Chartres followed by a two-day round trip from Paris to Reims, Laon, Soissons, and Beauvais and back to Paris. Since Chartres is one of the world's outstanding buildings as

well as being the prime example of a Gothic cathedral, we give it top priority. What you learn from Chartres can be applied to the other Gothic buildings, for which we give only brief notes.

The Trail is shown on the map, and trains are frequent, although it is worth checking timetables before you set off. Remember to check out details of other local sights at tourist offices along the way.

Chartres

Location: Chartres is a charming town about an hour southwest of Paris. Train travellers leave from the Gare Montparnasse. The cathedral is near the station, as are several hotels (among the cheap ones, the Jehan de Beauce is good).

Opening Times: 7:30 am (8:30 am Sunday) to 7:15 pm. No touring inside during services

Admission: No charge

Long before you reach Chartres, you'll see the outline of the church at the very top of the town. If your first view is from the railway station, its towers are immediately visible above you. A short walk through the charming streets of the old town brings you to the main entrance and there are several reasonably priced hotels close by. It would be best to plan for a stay of several days, but you can see the cathedral in a single day. Whatever you decide, don't fatigue yourself so much that you lose your ability to see what is in front of you. Vary what you are doing and take time out for coffee and lunch.

Sketching, even if you recognize that your own efforts are inept, is an effective way of focusing your eye on what you see. Take binoculars. They help even though a lot of the work is accessible to the naked eye.

Whether you start inside or outside Chartres will depend on the weather and the time of day. Obviously a sunny day will give you the best view of the windows from inside so in changeable weather it is best to take advantage of what sun there is. All things being equal however, it might be a good idea to vary your experience by looking at sculpture for a while, then glass for a while, then architecture and so on. Do not be dismayed by the knowledge that you will inevitably miss a lot. A month would not be long enough to take a reasonable look at everything in Chartres worth looking at. There are about 2,000 sculptures and over 600 stained glass pictures to take in, and each one

could occupy pride of place in most museums. The building is arguably the greatest single work of European art – the equal of the Athenian Parthenon and in a far better state of preservation.

The main entrance to the cathedral is marked by the two unequal towers and opens on to a modest parvis. (The original design was for nine towers but this proved too ambitious.) Apart from the asymmetrical towers, note that the façade is anything but uniform. Windows are placed at different heights and the blind arcades on the south side do not appear on the north side. This is one of the basic lessons of medieval architecture. It achieves an overall sense of unity without seeking uniformity in its detail.

In part, this reflects the fact that architects changed frequently, each bringing his own ideas and habits to the building. It also shows that a single building can succeed from a collective effort in which architects observe and respect the work of their predecessors but do not attempt to reproduce it for the sake of symmetry. To the medieval mind, the world, like God, was in its very essence diverse. Even the theologians who attempted to explain the nature of one God containing three persons conceded that it was an inexplicable mystery. Architects did not balk at expressing this diversity in their work.

A Brief History of Chartres

In the 12th century, Chartres was an intellectual center and the site of an important pilgrimage that continues to this day. In the Middle Ages people were drawn to its relics: a tunic that the Virgin was wearing at the moment of the Annunciation and the veil of the Virgin. The relics had been gifts from Charles the Bald in 876, who had received them from Charlemagne. Having them on the site made Chartres the center of the cult of the Virgin in Europe and from time to time, the relics invoked miracles on behalf of the town or defended it against enemies, who, it was claimed, would retreat when the relic was waved at them.

The church that stood on this site through most of the 12th century was almost totally destroyed by fire in 1194. By the greatest good fortune, the west façade, the main entrance you are standing in front of, including the glass, survived the fire. When the people of Chartres thought that various Virgin relics had been lost in the fire, they were dismayed and could not be brought to consider rebuilding her temple.

The sudden reappearance of the veil – or some portions of it – persuaded the town to rebuild, which they did in a fairly short time, in fact in the space of a generation. The work, taking place during the century of transition from Romanesque to Gothic style, was virtually completed in 40 years. Most of what you see today was finished in the 1230s. Since then, remarkably little has been added or removed, although the reputedly beautiful choir stalls and screen were smashed up by the clergy and replaced by the present screen. The wooden and lead roof was burned out (the lead was used for bullets during the French Revolution) and replaced by a handsome roof in the 19th century without causing great damage to the building or its glass. The roof is now iron and copper.

Time has destroyed some of the glass. Nevertheless, Chartres remains largely as it was when it was built. The sculpture is no longer painted as it would have been but the colors of the glass have lasted for seven centuries. Its survival is probably due to the fact that Chartres and its hinterland declined in importance for a long time so that neither restorers nor iconoclasts thought it was worth much energy.

We begin our detailed look at this marvellous building by surveying the spires, then by examining the west façade. For this section, you may allow anything between one and four hours. There are cafés nearby where you may break up the viewing, returning for a more detailed look at selected areas.

The Exterior

THE SPIRES

Spires, which many people associate with Gothic churches, were developed in northern France, and are potent symbols of aspiring to heaven.

The one to your right – the Romanesque southern spire, the "spire of the moon" – was finished in 1165 and survived the fire of 1194. The crescent moon on the top of the southern spire is a reference to the Apocalypse in which the woman rests her feet on the crescent moon. The sun and the moon are associated with Mary in accordance with a verse in the Book of Revelations, where one reads "There appeared a great wonder in heaven, a woman clothed with the sun and the moon under her feet."

The southern spire of Chartres is an especially fine example. At Chartres, the speed of the building meant that the tower and spire

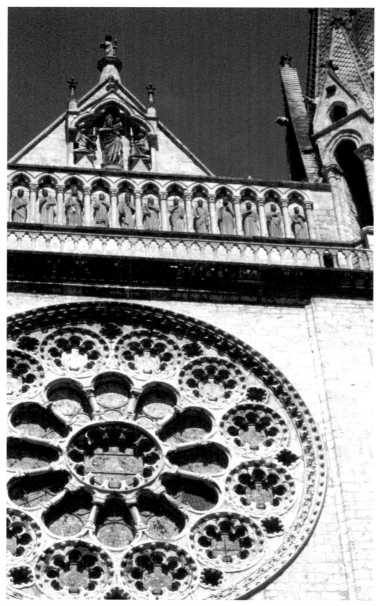

Detail of the façade of Chartres Cathedral

were built together. The tower is square and has three storeys, each with two windows, divided by horizontal cornices. On the top storey, the base of the spire is set out with eight sides, each marked by a gable with niches that deftly translate the square into an octagon. The continuity so obtained in the transition smoothes the upward thrust of the spire. The spire rises to a height of over 300 feet, showing only the ribs of its structure and the fine pattern of tiles, which themselves carry on the upward movement. Its simplicity and grace give little indication of how solid it must be to have survived not only wind and weather but also the two internal fires that consumed the woodwork supporting the mighty bells.

The northern spire is three and a half centuries younger, having been begun in 1506. The symbol at the very top of the ornate northern spire on your left is the symbol of the sun. The earlier spire continues the thrust of the tower upward with simple strength; the northern one is more a play of light and shadow perched on top of its tower.

THE WEST FAÇADE

THE PORTALS OF THE WEST FAÇADE (TOGETHER KNOWN AS THE ROYAL PORTAL) 1150

All three doorways – the set of doors you face as you stand in front of the church – in the west façade open into the nave of the church and contain elaborate narratives. This ensemble of doorways, called the Royal Portal, consists of a right, central, and left portal. The narrative sequence of the Royal Portal goes from the right to the left to the center. On the right is the Virgin Portal. It tells the story of Christ's birth to Mary and of her translation to glory with him when she becomes Queen of Heaven. On the left is the Portal of the Ascension. It shows the end of Christ's period on earth when he ascends into heaven. In the center is the portal showing the Second Coming of Christ. The sculptures in the voussoirs (the three channels inside the arches and around the tympanum) add detail about how these divine events relate to the human struggle.

The statues below come from the Old Testament. The New Testament is retold in a series of capitals just above the last statues, which run all the way across the three portals. The passion for complete exposition could hardly be better exemplified. Scholars, for example Emile Male, trace the influences and origins of the master sculptors of this part of the Royal Portal to the Abbot

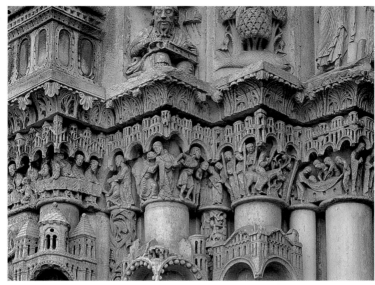

photo © Peter Willi

Capital frieze depicting Scenes from the Passion, from the south door of the Royal Portal, west façade

Suger's Saint Denis. Suger's sculptors were probably recruited to work in Chartres around the middle of the 12th century. The sculptures are a prime example of the tight doctrinal structure of carvings in medieval Gothic churches. It was a pattern that survived for another five to six centuries.

The Virgin Portal

Look more closely now at the right-hand doorway at the front of the church, known as the Virgin Portal. Reading the two lintels of the door, we first see from left to right the angel telling Mary she will have a child but remain a virgin. Next she visits her cousin Elizabeth who is carrying the child who will become John the Baptist and foretell the coming of Jesus. In the middle, Mary lies in state in what looks like a medieval bedroom. Above the bed is the child's cradle but the figures of watching animals and perhaps heavenly choirs have been lost. On the right of the Nativity are an angel and the shepherds who follow the star to see the newborn Messiah.

The upper lintel: Here the infant Christ is presented at the temple by his mother and his coming greatness is recognized. This

is carved as a single scene and looks like the work of a different sculptor from the one who did the longer narrative in the lower lintel. The figures in the upper lintel are shown in a more symmetrical and frontal manner. Like some other sculpture of the 12th century, the heads are bigger and out of proportion to the bodies. The whole has the feeling of a performed tableau. Each person in the tableau is framed by a little arch above.

The lower lintel: As well as being a narrative of several separate incidents, this contains several elongated figures with very fine drapery on the angels and the two women. The shepherds are given more space by the presence of their tiny sheep, typical of 12th-century sculpture. The sheep are themselves little master-pieces with long curved heads, meticulously incised fleece and knobbly knees. One of the shepherds is playing pan pipes.

The tympanum: A figure of the Virgin holding Christ and flanked by two angels is in the sophisticated style of the lower rather than the upper lintel but is likely to be by yet another sculptor. The shape of the tympanum is brilliantly exploited, with the seated Virgin taking up its full height and the angels' wings following the curve. The drapery is beautifully executed and the angels are swinging thuribles to surround the divine figures with incense.

The voussoirs or archivaults: Inside the voussoir nearest the Virgin are six angels and on the outer voussoir, seven female figures represent seven arts and sciences, each one accompanied by a male figure from classical times representing the same art. This division dates back into ancient times. The arts are the language-based grammar, rhetoric, and dialectic and the sciences are astronomy, geometry, arithmetic, and music. The 12th-century scholar John of Salisbury is often quoted as saying that medieval thinkers are simply dwarfs standing on the shoulders of the giants of antiquity. The study of antiquity was not the exclusive intellectual property of the 15th-century Renaissance; a solid respect for their knowledge infused the thought of those in the centuries beforehand.

The most easily identified are on the right and at the bottom, the female figure of Music hitting the bells near her head, accompanied by Pythagoras. Next to her is Grammar, who holds a switch and is teaching a couple of children to read. Above her and gazing up at the sky is Astronomy, who is paired with Ptolemy. The other figures are Rhetoric, gesturing like an orator and accompanied by Cicero, the noted exponent of rhetoric. Dialectic is shown with a serpent on her knees and accompanied by

Aristotle. Geometry is drawing on a tablet and appropriately accompanied by Euclid. Arithmetic has lost her sign.

The columns: Six astonishing column figures, three on either side, flank the Virgin Portal. We do not know whom they represent, but perhaps they are the people of the kingdom of heaven and they are ushering us, the living pilgrims, into their world. They seem to float out from the columns even though they are part of the rock that is supporting the building above. The sculptor, a great master, now nameless, has greatly elongated them so that they not only contribute to the upward flow of the building but hover magically before you as if the towering walls were entirely weightless.

Of the three on the right, two male figures with haloes are in ancient dress that falls over their arms like silk and gathers into impossible decorations around the knees. Their postures suggest that they may be Doctors of the Church from early times. The third, a woman, is in a form of medieval dress. Her dress is belted both above and below the waist and its bands have been set to make her belly protrude. There are interesting commonalities between these 12th-century female figures and the female figures (korai) of archaic Greek sculpture. Like the korai, the woman is wearing three garments and the lines of her cloak fall from the neck in ever widening semi-circles that create a sinuous vertical line. Also like the korai is the detailing of the long, plaited hair. This kind of detail belongs in the tradition of humanistic art whose intention is to embody the sacred in human form, a product of the doctrine of the Incarnation.

Between the column statues is a great profusion of human figures, mythical creatures, and animals entwined with foliage and decorated branches. Almost no surface has been allowed to escape the sculptor's hand – except, with great taste, the slender outermost column on each side, which gives us a measure of the full doorway.

The sculpted capitals: Below the voussoirs on both sides of the Virgin Portal the capitals narrate a story, surmounted by architectural detail representing Jerusalem. The sculpting varies the depth according to whether the scene is inside or outside. The arches over the heads of indoor figures are more prominent and corner buildings show depth. The sculpted city is linked to the shape of the doorway supports by stylized acanthus leaves, which have been used since ancient times.

GOTHIC ARCHITECTURE OUTSIDE OF PARIS

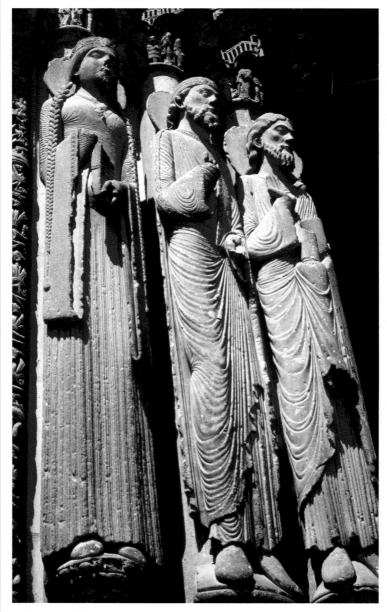

Sculptures on the west portal

The scenes on the capitals across the doorway, starting from the left, relate the life of Christ like a modern storyboard. Sitting above the columns separating the central door from the right door is a fairly damaged scene of the Last Supper. Beginning right over on the left side of this right portal is Jesus' betrayal by Judas, Jesus triumphantly entering Jerusalem on a donkey, Christ's family and friends putting him into a tomb and next to it (still on the left side) the women discovering the tomb empty. The scenes on the right-hand side appear to continue the story with Jesus coming back to life, meeting and having supper with apostles and disciples. The story of his life on earth is completed in the tympanum of the left portal, the portal of the Ascension, to which we now turn.

The Portal of the Ascension

The left side of the Royal Portal portrays the end of Christ's ministry and his ascension into heaven. However, the capitals are continuations of the Life of Mary that begins in the central portal.

The capitals: As a narrative, these capitals are read from right to left. The right side, fairly damaged, shows the shepherds and the Magi hearing about the birth of the Jesus. The capitals on the left of the portal show quite plainly the ensuing Massacre of the Innocents (see Biblical and Christian Characters, Stories, Places, and Terms). King Herod is seated between two columns with an upraised sword. His cross-legged posture is that of the arrogant villain and the sculptural flourishes on his clothing assert the heartlessness of wealth and power. The massacre is depicted with the mixture of violence and pathos so often used in scenes of this event.

The tympanum and voussoirs: Here is the central theme of this portal: the tympanum shows Christ ascending into heaven on a cloud. Parts of the cloud have been picked up like a sheet by a pair of angels who are inclining elegantly. Below the cloud, which continues as a frieze on the top of the lintel, angels are telling the listening apostles what is going on so that they can later write it up in their Gospels. Some of the apostles have now lost their heads but others have them cocked like people listening to a broadcast from above. The scholar Emile Male has no doubt that this is the work of the same sculptor as "The Virgin Enthroned" in the Virgin Portal. He points out that the angels are similarly placed and the figure of Christ is cut short to achieve a very close parallel between

the two tympanums.

The sculptures of the voussoirs portray favorite themes of the time – the signs of the zodiac and activities typical of the months of the year. The zodiac goes in and out of favor but was in favor in the 12th century and appears in Chartres on this portal and on one of the stained glass windows. In both depictions, the 12 signs are related to the months of the year. The zodiac is shown by its conventional symbols – Ram, Bull, Twins, Crab, Lion, and so on – and the months of the year by the largely agricultural activities of the months such as pruning in March, trampling grapes in September, killing a pig in November and so on.

The three figures on the left of the portal: These noble figures look as though they have stepped out of the legendary stories of King Arthur. They are dressed beyond the art of any material or any tailor and seem not to be of this world. No period of art has ever done anything so fine as this with drapery, which is molded like calligraphy that has been expanded to a huge scale. A number of sculptors worked on the statuary and the male figure in the center and the female figure to the viewer's left look very much like the work of the same sculptor. On both figures, the drapery on the upper part of the figure is cut into a number of patterns of overlapping concentric circle shapes. They appear as though drawn by a geometric instrument and the triangular folds falling from the knees and the hemline patterns below the knees are very similar. The other female figure, on the viewer's right, is one of the most commanding on the entire Royal Portal. She is taller than either of her companions and is dressed in a much more medieval fashion. Her upper garment is textured to show a rounded belly and is densely embroidered across the breasts. Her plaits fall to her waist across horizontally striped garments over her arms. Her rounded face, not unlike that of the good housewife, is quite different from the long aristocratic faces of the man and the woman.

The Central Portal

This portal shows the Second Coming of Christ, the Apocalypse.

The tympanum and voussoirs: One of the many beauties of Chartres is that the faithful enter the church under the image of a welcoming Christ. The central portal portrays heaven. Christ is seated on a throne framed by a mandorla and with a cruciform halo, his hand raised in blessing. He is wearing a woollen undershirt beneath his tunic, the folds of which are detailed. The bearded face is calm and kindly in a handsome sort of way. The

hair is carefully waved and falls down the neck.

Around this figure are four winged evangelists. Legend claims the Gospels to be accounts written by contemporaries of Jesus who are known as the Evangelists. Three of them are apostles and the other a disciple born in Antioch who got his basic material from Mary. Their symbols are: Mark, the lion; Luke, the ox; Matthew, the eagle; and for John, the man-angel. Below are the 12 apostles, in groups of three.

The sculptures around the voussoirs are angels and the elders of the Apocalypse. The angels on the inner circle are borne on scalloped clouds. Each of the elders holds a musical instrument in one hand and a bowl in the other. Quite a number of the faces are very worn and eroded, but fortunately the lower ones are less so. The angels are round-faced figures, capped with curls and framed by overlapping triangles representing feathers. The crowned elders are portrayed as kings, the higher ones seated but the bottom four – two on each side – standing. Like the angels, their eyes are raised towards Christ. The outer two have curled beards that make them seem older and more kingly than the philosopher faces of the inner two kings.

Emile Male believes that the lower four kings were created by the sculptor of the Virgin in the right doorway and the Ascension in the left. He attributes the figure of the apocalyptic Christ and the tall column figures below to the work of another particular sculptor. These two sculptors he believes to have been the greatest of the 12th-century sculptors at work on Chartres.

The capitals: The capitals narrate the early life of Mary. The story begins on the right-hand side with a scene from one of the legends of her life showing her being bathed in a tub. Next, she is visiting the temple with her parents. The next few scenes continuing over to the left side are damaged but appear to deal with her betrothal and marriage to Joseph and on the columns dividing the central portal from the left portal are an Annunciation and a Nativity. The mixture of damage and the fact that they are not all Gospel stories but come from Apocryphal material make the detail difficult but the story certainly starts off with Mary as a baby and ends up with her having a baby.

The total sequence of the story of Christ across all three portals is not in chronological order. The central portal and the left one carry a chronological sequence from right to left, starting with the Virgin as an infant and finishing with the Massacre of the Innocents. Then the life of Christ is resumed at the Last Supper on the panel between the central portal and the right portal and continues left to

right, finishing at his appearance to disciples after his Resurrection.

The column figures: The larger central portal has eight column figures rather than six. They are not arranged symmetrically. The four on the right-hand side are together but on the left side, one female is separated from the other three by a plain column. On this portal, a plain column stands out because the pedestals (the bottom part of the column), the columns themselves, and the capitals are so intensely decorated. Some of the decoration is vegetal with intertwined figures, some geometric. The geometry, though repeated on more than one column, is not used to create symmetry but diversity.

The figures, all with haloes, are holding scrolls or books – assuming, that is, that the broken ones were doing the same as their companions. Hence they can be taken to be teaching about the time when Christ will return in glory. The female figure in the right-hand group has the aristocratic medieval dress of other women on the portals on either side, while the two female figures on the left are given much simpler lines, partly by the fact that they are carrying scrolls and books. Both appear to be exceptionally elongated and tall. All three females are crowned whereas two of the males are not. One has holes where the pupils of her eyes would be and seems to be looking at you. Given what we know of ancient statuary and medieval works, we can presume that there were semi-precious stones set in these holes.

Imagine for a moment – try to get it in your mind's eye – that all of these statues and the portals as a whole, are intact: they are just freshly carved, and are gilded or painted with the same level of skill that has gone into their sculpting. That is what the people of the 12th century would have seen and visited week after week for all of their lives. And all of that framed by the golden stone of the cathedral itself.

THE BUTTRESSING

A row of five similar buttresses on the south side illustrates the way in which the huge weight of the upper part of the building is carried to the ground. The buttresses at the lower part are very thick. They are stepped to match the direction of the thrust of the building into the ground and to let more light into the windows between them. The windows are broad-arched openings filling the space between the buttresses. The top of the first storey is marked by a horizontal line of cornices and a small free-standing arcade.

The buttresses rise above this, continuing to narrow, and are ornamented by sentry-box shapes that are known as ostium. Each has a sculpted figure of a bishop.

Between the heavy vertical buttress and the upper half of the nave are the flying buttresses. The lower flying buttresses are penetrated by arcades of small columns. This cutting away of the mass of the buttress indicates where the real thrusts are. The top-most buttress simply dispenses with any intermediate supports and flies in an arc to the side of the building. In reality there are three flying buttresses and the lower two have been joined by columns so that it looks as though a section of a wheel is supporting the building.

Between the flying buttresses are the double windows surmounted by roses, which from the inside shed so much light into the nave. Above the second storey is another cornice and arcade similar to that marking the transition from the first storey.

THE SOUTH PORCH

Like the main west façade, the north and south entrances to the cathedral each have three portals, making nine altogether and hence continuing with the use of one of the major numerals incorporated into the building. But unlike the main western entrance, the north and south entrances into the transepts have porches built out in front of the portals. The North Porch and its portals are being restored and are only partially visible, so this trail does not cover it. The south is the sunny side, especially in winter, and appears somewhat lighter and brighter than the moss-gathering north side. The two porches themselves add to the profusion of decoration.

The entire façade of the south transept is copiously ornamented with colonnettes and ostium. The sculpture of the south portal deals with the triumph of Christ and the martyrs and confessors of the church, which, taken together, represent Christ's continuing life in the world.

THE CENTRAL PORTAL

In the central portal, the figure on the column is Christ Triumphant. He is trampling underfoot the lion and the dragon, both of which symbolize evil. To his right and left are the 12 apostles. You can identify some by traditional symbols. Paul, on Christ's left, is bald; John is smooth-cheeked and has a cup on the pedestal beside him. It might well be the cup of poison referred to in the Apocrypha. James the Greater is identified by shells, which

became a general symbol of pilgrims and are still used today to indicate the road to Santiago and the place honored as his tomb. The other James has a club. Matthew is holding his book, as is John. Peter carries the keys to the kingdom and a cross. Andrew also has a cross (both were to die by crucifixion). Bartholemew did have a knife but it has been broken off. The other four carry swords symbolizing their martyrdom but can't be individually recognized. They are all standing on top of figures, which might symbolize their victory over their persecutors.

Above these figures in the tympanum and voussoirs is another depiction of Christ's ultimate triumph, the Last Judgment associated with the Second Coming. Both the west façade and the western rose also depict this theme. There is little risk of repetition. This 13th-century one portrays Christ's humanity and dwells on the narrative of judgment, condemnation, salvation, torture, and ecstasy. The 12th-century one on the west façade shows Christ as the more abstracted figure of the Second Coming, framed in a mandorla and accompanied by four beasts. That Christ is in a far more abstruse and spiritual world with perhaps a greater opportunity for salvation. Whereas the central south portal is flanked in the left and right portals with scenes of confessing and dying for the faith, the two side portals off the west entrance depict the two human figures, Christ and Mary, who are translated directly into paradise by angels. The 12th-century mysticism has been replaced in the south porch by 13th-century humanism. Here Christ is seated in judgment and displays the wounds he suffered to redeem humanity. Mary is seated on his right and John on his left and they are praying for mercy on behalf of humanity. The angels beside and above them carry symbols of Christ's passion.

Around the tympanum are four voussoirs, each with a series of sculptures within them. In the outer voussoir, four angels are sounding the trumpets that proclaim the end of this world and the beginning of the New Jerusalem, which is the Kingdom of God. At the sound of these trumpets, the inhabitants of heaven (seraphim and cherubim) assemble in the first voussoir of the tympanum and the one closest to Christ. At this sound, humanity climbs out of its graves as shown in the second row across the arches.

The action then moves to the archangel Michael beneath the feet of Christ. He weighs up the deeds and misdeeds of each person. His scales are now broken. The good go to Christ's right and the damned are sent off to hell, which is represented by an open mouth. The

damned are seized by devils and subjected to sundry torments and jeers in the voussoirs to the left of Christ (on our right as viewers). The saved are led by angels away on Christ's right (our left) and we can track them around the voussoirs on their way into paradise.

Around the outer edge of the porch, a series of panels show what must surely be the elders of the Apocalypse with their musical instruments.

THE LEFT PORTAL

Here are a number of martyrs. Martyrdom is a form of triumph as the moment of death is the instantaneous moment of a martyr's arrival in heaven, already consumed by glory. All of these martyrs are men. Among the tall figures, St George can be identified by the scene on the pedestal where he is being killed on a wheel. The lintel depicts the martyrdom of Stephen who was stoned to death and is usually described as the first of the martyrs. One of the two deacons holding books is St Lawrence, usually honored as the patron saint of cooks because he was burned on a grid.

This completes your tour of the exterior – now the riches of the interior await you.

The Interior

It is hard to take in the design of Chartres. This is partly because the overall effect as well as the detail of the stained glass is overwhelming. It is also because it is based (according to scholars) on patterns of number and geometry that have symbolic value. Before you embark on a detailed tour of the inside, it is helpful to understand elements of the symbolism of the building.

The most obvious symbol, for example, is that of the cross – the whole church forms the shape of a cross. From the inside, however, you can see that it is not a completely straight cross. The axis from the front door through to the center point of sanctuary is slightly tilted to the south. Popularly, the tilt was thought to symbolize the drooping of Christ's head on the cross. The Australian scholar John James surmised that it could be a deliberate imperfection: that, as with Notre Dame de Paris, the idea was that no built object can rival God by being perfect, so it is necessary to build in an imperfection. Again, like the theories about Notre Dame, pragmatic explanations point to the fact that the builders of the new cathedral had to follow the foundations of the old and also to

avoid buildings that had grown up around the site. However, the shape of the eastern end, the part that contains the altars, ambulatory, chapels, apse, and so on, is consistent with the cross symbolism. It quite plausibly forms the shape of a head on top of outstretched arms. The orientation of the church with the sacred part facing east, towards the rising sun and the source of life, is a symbol that was already observed in the churches that the present Chartres was built over.

The number seven occurs in important features of the building. Seven is a number especially associated with the Virgin, who is patron of the seven arts and sciences. This had a double logic for those who commissioned the church. Firstly, Chartres was a center of pilgrimage and devotion to Mary. Secondly, Chartres was, for a period in the 12th century before Paris took over, the intellectual center of France, so the seven arts and sciences were important then. It is comparatively easy to see in both the bays of the nave and the number of chapels around the apse that the number seven is deliberately chosen by the builder. He fits them into the available space, even if he has to make, for example, the distance between bays unequal. The most obviously short bay is the one at the western end where the towers start.

As well as accepting the symbolism of shapes and numbers and working them in, the masons and masters had their own mystical views of the geometry they could create with their straight edges, set squares, and compasses. The conviction that geometry and number could express the perfection of the real – that is, the divine world – derived from ancient times and was affirmed by Doctors of the Church and great thinkers such as St Augustine. In a more practical way, geometry was of particular importance to medieval builders because measures were not standardized and one builder would fit in with his predecessors mainly by preserving or adapting ratios rather than measures.

The circle is seen as a powerful symbol of perfection and hence of the divine, and figures such as an interlocking set of three circles acquire added value by their reference to the Trinity, three cardinal virtues, and so on. The ground plan of Chartres shows that it is based on an interlocking set of circles that originate from key points in the structure, such as the center of the labyrinth, the center of the crossing and the mid-point of the sanctuary, and the outer pillars of the transepts.

Other figures have their own symbolism. The triangle is another representation of the Trinity and the square is based on the number two which sums up the duality of the world – that is, the division into essence and matter. The hexagon uses the so-called perfect number, six (because its factors 1, 2, and 3 add up to itself), found at the center of the labyrinth.

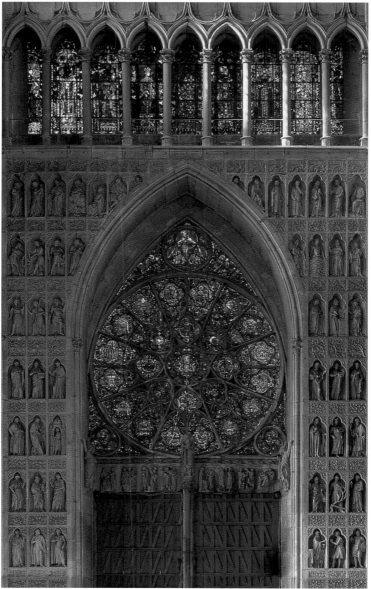

photo © Peter Willi

View looking west from the nave, rose window designed by Bernard de Soissons, with surrounding statues, 13th century

THE NAVE

When you come into the cathedral from the front door, the first space you are in is the entrance section of the nave known as the narthex. This is the part that survived the fire of 1194. Everything else is from a later period. From there, go to the nave, which has six more bays (the space between the columns) before you reach the crossing. At this point the church widens into what are called transept arms. The north transept is to your left and the south transept is to your right.

At the end of each transept is a rose window, just as there is over the western portal. The vaulting of the crossing indicates that the area of the crossing between the nave and the transepts is a rectangle, not a square. Since the reforms of the Second Vatican Council in the mid-20th century, Catholic churches have brought the altar forward into the crossing so that the priest will face the people. When the church was built, the altar was over the center of a circle that set the positions of the small altars behind. There are seven of those small altars.

The immediate impression on entering the church is of a broad, calm and light space. The nave is about a third again as wide as the nave at Notre Dame de Paris. It is built on the footprint of a previous building, and the crypt of the old cathedral under the altar had to be retained as the foundations of the eastern end of this building. The now unknown architects of Chartres took advantage of this greater width to introduce more light to the nave than had previously been thought possible.

To achieve this, they built only a very narrow middle storey (marked by the sets of short columns and arcades known as the triforium) rather than a wide gallery as at Notre Dame de Paris. Note that the ground floor windows are able to let light penetrate into the nave and provide an unparalleled opportunity for stained glass windows to be seen close up. The other innovation was to design the vaults of the roof so that the entire space between the rising arches of the vaults could be filled with double windows with a rose above the two lancets, a feature that would become popular in later buildings.

The lines of the supports of the whole nave can be traced in the clumps of columns along the nave. You can follow the function of each part up from the base. One supports the arch of the bay. Another supports the vaulting of the side aisle. A major one supports a nest of slimmer columns, each of which can be traced

up to one of the transverse or diagonal or arch ribs in the vaults. Up in the vaults, each bay has a rectangular pattern with four diagonal ribs meeting in the center.

The greater width and height of this nave gives it an appearance of lightness and airiness but in fact requires a vastly increased weight of stone vaulting to be supported. This weight was supported by the buttresses, which you viewed outside.

THE LABYRINTH

At the western end of the nave, a labyrinth is set into the floor. This is sometimes hard to see because there may be chairs on top of it. There are two colors of flagstones and the remains of a circular inset in the aisle.

A labyrinth is a frequent feature of cathedrals of the Middle Ages. Architects sometimes put their names in the labyrinth, although there is no sign of the name of the architect of Chartres. The original centerpiece is no longer here: it was taken up during the French Revolution. Look for the circular shape that marks its original location. It depicted Theseus killing the Minotaur and being led out of the labyrinth by Ariadne. Transposed to Christian symbolism, Theseus would represent good, the Minotaur evil, and Ariadne Mary, the patron of the cathedral. Since the labyrinth could be used as a metaphor representing the journey from earth to God and the need to fight and defeat evil along the way with the help of the Virgin, the story of Theseus is a kind of parallel story.

Interpreters of Chartres (among them John James and Jean Villette, whose works are in the cathedral bookshop) point to the significant positioning of the labyrinth in the measurements, proportions, and overall geometry of the ground plan. They relate the shape of the labyrinth itself to medieval notions of numerology and the zodiac. For example, the center of the labyrinth is the same distance from the center of the crossing as is the crossing from the high altar. The center also divides the seven bays of the nave into a group of four and a group of three. Seven is significant, as we have seen, and three and four are numbers corresponding to triangles and squares, which along with circles, are the basic way of deriving important parts of the ground plan such as the shape of the crossing. Four times three is twelve, the number of circles in the labyrinth, including the center. The centerpiece, shaped like a flower, is six-sided and six is the perfect number.

THE STAINED GLASS

Partly because Chartres slipped into obscurity for a number of centuries, its stained glass windows are the best preserved of all such art of the Middle Ages. Stained glass is especially characteristic of Gothic architecture, in which builders dispensed with a great deal of wall in order to let in more light. In France, painted and colored glass windows replaced the painted walls of Romanesque times. As the walls had done before, the windows now featured major church figures and stories from the lives of Christ, Mary and the saints.

Because the windows in the west wall survived the fire of 1194 that destroyed the rest of the Cathedral, we can see prime examples of both 12th- and 13th-century glass in a good state of preservation. From time to time, small parts of these windows have been replaced, but in most cases, the character of the window is perfectly visible and the overall iconography is maintained.

Any one window was probably the work of several artists and certainly the combined work of many specialized crafts people. Unfortunately, no names of the artists have been retained. Chartres today continues to be an important center of stained glass work.

To get an overview of the windows, stand on the labyrinth and look back towards the entrance. You will see the three lancet-shaped windows from the 12th century. In the apse, there is another window from the 12th century, a blue Virgin. As you look high up around the whole cathedral, the windows are of figures of saints and important people in the church. On the ground floor, the windows all around are narrative windows. They tell stories from the lives of Mary, Christ, and the saints. It is not easy to see a sequence in these windows. Often the donors were members of a trade or guild and each may have nominated a particular story. Some windows may also be related to relics and dedications of side altars.

Narratives usually start at the bottom of a window and work up, but the sequence is not always what you would expect. A further complication is that some of the stories have popular legends of the time included in them as well as the more official details from the Bible versions.

The set of 12th-century windows on the western façade deals with the basic story of Christ's ancestry, his Incarnation, Passion, and Resurrection. The rose above deals with the Last Judgment.

In general those on the north side tend to be about passion and death. Those on the south side (the side of the sun) are more about Resurrection. The result is that there are strong narratives within each lower window but not connected sequences between them.

There are three rose windows. If you go down to where the transept crosses the nave, you will see the north and south rose windows. These are both from the 13th century. The north rose deals with Mary and prophecies of Christ. The south rose features the life of Mary.

With up to 30 separate pictures in each window and some 50 windows, the task of seeing everything is overwhelming. This Trail covers only the most remarkable and interesting of them in detail.

The Western Windows

The three lancet windows under the rose survived the fire of 1194. They date from about 1150. The most famous of them is the on the right as you face them, the Jesse window.

The Jesse window or The Tree of Jesse (see Appendix on Biblical terms): Like the other two, it has an intense blue background. Against this blue, the color that first strikes the eye is a clear, pure red. As you look at each frame, you see more colors, especially greens and yellows. Jesse appears in the bottom of the seven pictures of the window, lying on a couch in red robes with a tree trunk sprouting from his groin. Behind the figure of Jesse is a green curtain drawn back to show the city of David, which is Bethlehem and the pre-ordained birthplace of Jesus, his descendant. In the next four frames as you go up, the branches of the tree enfold four Kings of Judah and above them, to complete the lineage, is Mary and at the top, Jesus. The figure of Christ has a halo in the shape of a cross and, like Jesse, is bare-footed. The bare feet signify a prophetic role, in Jesse's case foretelling the coming of the Messiah or events that will follow. Around Christ are seven doves. These represent the seven gifts of the Holy Spirit, which Isaiah names as wisdom, understanding, counsel, knowledge, fortitude, piety, and fear of the Lord. In the Old Testament, these are also seen as attributes of an ideal king, whom Christianity asserts to be Jesus. The figures on half-circles on either side of the central square panels are Old Testament prophets, each carrying a scroll with his name on it. The second top two, going from left to right are Isaiah and Daniel and below Isaiah is Moses.

As sometimes happens with medieval narrative in stone and glass, we move from the description of Christs' ancestry in the right window to the stories of his childhood in the tall central window also known as the Incarnation Window.

The Incarnation or The Childhood of Christ Window: The pattern of the window is checkerboard with three squares in each of nine rows. Nine was to become a much-used number in the mathematics of the new 13th-century building. In this window, the pattern of nine times three is varied only in the topmost image, which gives double space to Mary enthroned with her Son.

The narrative can be read starting at the bottom and usually from left to right in each row, although the sequence does break a bit in a number of places. Thus, on the bottom left, the angel announces to Mary that she will have a child named Jesus. Mary has risen to her feet and clutched her cloak to her neck, obviously surprised by both the messenger and the message. The clutching of the cloak is a standard gesture representing surprise or shock. In the next picture on the right, Mary, with the golden halo, visits her cousin Elizabeth who is wearing red. Elizabeth is pregnant with John the Baptist. In the right-hand frame of that row is the Nativity. As in the sculptures of the Royal Portal outside, the Child is on an altar, not in a cradle, symbolizing the sacrifice he will make for humankind. Above the sleeping figure of Joseph is the star that will guide shepherds and Magi to the scene. In the second row from the left, shepherds with their dogs are given the news by some angels. The next six panels describe the journey and the arrival of the Magi. The final panel of that sequence is the right panel of the fourth row. The left and center panels of the fourth row show the Presentation of Christ in the temple. The three panels of the fifth row from the bottom, reading left to right, depict the Massacre of the Innocents. The sixth and seventh rows are out of sequence, possibly as a result of restorations that favored appearance over narrative, possibly because they rely on Apocrypha. The left panel of the sixth row shows the Flight into Egypt, with Joseph leading a white donkey carrying Mary and Child against a landscape of trees and palms. Next to it, in the center, is a very interesting painting of a city, perhaps in Egypt. The central panel of the seventh row shows the Baptism of Christ. The eighth row shows Christ entering into Jerusalem on what is now celebrated as Palm Sunday. The ninth row and the panels above show Mary enthroned in heaven. She has Christ on her lap and holds the symbols of royal power.

The child holds a book and, with his raised right hand, dispenses wisdom. The mandorla framing Mary is flanked by angels and images of the sun and a crescent moon (see under *Spires* for an explanation of this).

Christ's Death, Passion, and Resurrection: This is the window on the left. The events are told in seven pairs of circular panels, all somewhat crowded with figures and story. It can be read as usual from bottom to top, left to right. The bottom two panels show Christ being transfigured before the apostles Peter, John, and James. The left panel shows the actual Transfiguration. Peter is in white, John is in the middle and is without a beard and James is on the viewer's right. The Transfiguration is represented by white, radiating lines. Christ is speaking with Moses and Elijah. The right-hand panel shows God in a cloud identifying Christ as his Son with Christ talking to his apostles about his Resurrection.

In the second pair, the left panel shows the Last Supper. Christ is the central figure with the cruciform halo. The table is laid with bread, wine, and fish, which is also a reference to Christ feeding a crowd. The right-hand panel shows Christ washing the feet of his disciples, an event retained in the liturgy of the modern church. The third row depicts the betrayal by Judas and the scourging of Jesus. He is tied to a yellow column and the scourgers are laying into him with enormous vigor. The fourth row shows the Crucifixion with Mary, the mother, and John, the beloved disciple, at the foot of the cross. The figure of Christ, which emphasizes the sorrow of death, is probably a 13th-century reworking. The cross itself is green, outlined by red. The red no doubt signifies blood and the green, life.

To the right of the crucifixion scene in the same row, Joseph of Aramithea takes Christ's body down from the cross while Mary and John watch. The yellow-clad figure of Nicodemus is shown using a pair of pincers to take nails out of the dead Christ's feet. The fifth row, on the left, shows Christ being put into the tomb, while the right panel takes up the story of the Resurrection. The women visiting the tomb find it empty. Magdalene tells the apostles about Christ's Resurrection. Next Christ appears to some women, then to some disciples on the road to Emmaus and finally, has a meal with his friends in Emmaus before he disappears back to heaven.

The west rose window: This is an early 13th-century work, dating from about 1215. As happens in the exterior, the western end of the church facing the sunset represents the end of time. The rose depicts the Last Judgment, with Christ sitting at the center of three sets of

12 circles. The repetition of 12 demonstrates its symbolic importance. It is one of the numbers associated with the Virgin and appears in other aspects of the church, which is named for her and holds her tunic as an important relic. Twelve, like seven, is made up of 3 and 4. Since 3 represents the world of the spirit and the Trinity (the idea of three persons making up one God) and 4 represents the earth and the material world, both 7 and 12 as numbers, represent completeness. They are seen to combine both the spiritual and the material.

To the modern viewer, the representation in a series of circles of events associated with the end of all time adds to their drama. The innermost set of circles, which is attached to the second set contains eight angels and the four evangelists at north, south, east, and west. The larger circles forming the second ring contain the 12 apostles. At the top of the circle is Abraham who is taking souls to his bosom. At the bottom, St Michael is using the scales to get a measure of the goodness in each soul, which is one of the principal activities of the Last Judgment. To the right and left of St Michael you can see an angel shepherding the good and a devil prodding the damned. The outer circles show apocalyptic scenes of the Last Judgment with angels blowing trumpets, souls rising from their tombs and coming to be judged.

The Southern Windows

Now go to the other highly prized survival of 12th-century stained glass, which is on the south side – that is to the right as you face the altar and just past the south transept.

The Blue Virgin or Notre Dame de la Belle Verriere: The Blue Virgin stands out from all other windows here by the size of the image of the Virgin Enthroned and by the clear light cerulean blue of the glass on a velvety red background. This window was restored in the 13th century. The figure of the Virgin itself dates from about 1180 and survived the fire of 1194, after which glass workers added detail and some scenes from the public life of Christ, such as the angels around the Virgin flinging up their thuribles and carrying candles. Also added were the six scenes that tell the story of Christ changing water into wine at the marriage feast at Cana. The slight inclination of the Virgin's head, which tends to soften the image, is a 19th-century adjustment made during a later restoration and is not at all in accord with 12th-century thought, which would instead have emphasized power and majesty.

The lower panels of the Blue Virgin stained glass window at Chartres. Panels 1–3 depict the three temptations of Christ; panels 4–9 illustrate the marriage feast at Cana. The unnumbered upper panels are filled by a large image of the Virgin surrounded by adoring angels.

The Zodiac Window matches the signs of the zodiac to the months of the year, and the whole array is surmounted by the image of Christ with the Greek letters alpha and omega, signifying that Christ rules over the beginning and end of time.

GOTHIC ARCHITECTURE OUTSIDE OF PARIS

Legend:
1–6: Donors and onlookers
7. January
8. Aquarius
9. February
10. Pisces
11. March
12. Aries
13. April
14. Taurus
15. May
16. Gemini
17. June
18. Cancer
19. July
20. Leo
21. August
22. Virgo
23. September
24. Libra
25. October
26. Scorpio
27. November
28. Sagittarius
29. December
30. Capricorn
31. Christ

On the bottom row are three temptations of Christ. They give a comic view of the devil's attempts and rebuffs. The horned figure is successively oily, cajoling, friendly, and finally, disgruntled.

Immediately to the left of the Blue Virgin is a pair of windows. The first recounts the life of the Virgin. The second portrays the Zodiac. Both date from the early 13th century and were restored in 1993.

The Life of the Virgin: The story is told in nine rows intersected by a complex pattern of circles, star-shapes, and semi-circles. The bottom four rows and the panel on the left of the fifth recount the early life of Mary as told in apocryphal texts. The upper rows, starting with the one in the very middle, begin with the Annunciation and tell the same story as the Incarnation window. At the very bottom of the window are images of the donors and on the left, vintners. On the right is a Count of Chartres.

The Zodiac window: The same donors are shown again at the bottom of the window. The window matches the signs of the zodiac to the months of the year, with the images identified in words. The zodiac signs fill the right side panels starting at the bottom and the months of the year the left side of the window. Each month is represented by a typical activity of the time. Note that some months are out of order. January is represented by the Roman God Janus, who is opening a door to let in the New Year. Janus is unusual with three heads to represent past, present, and future. February is warming his hands at the fire. March is pruning a vine. May is riding off as a soldier. April is holding flowers. June is mowing grass with a scythe and is wrongly labelled July. July is cutting wheat and is wrongly labelled June. August is threshing. September is picking grapes and crushing them. October is on a barrel of new wine. November, wrongly inscribed as December, is killing a pig. December is having a feast.

The Jesus figure, seated in the very top setting, is flanked by the Greek letters *alpha* and *omega*, signifying the beginning and end of time.

Moving again to the left, you pass four windows that are not stained glass, known as *grisaille* (grayish), then a window of the life of St Martin. You then come to a side chapel with four narrative windows and one grey one with a small image in it. The first of the windows in this chapel covers the life of St Thomas à Becket. The one on its left deals with the lives of Sts Catherine

and Margaret. It is a very interesting example of symbolic narrative technique.

The Story of Saint Catherine: Essentially the story is based on an account in *The Golden Legend* in which St Catherine is tortured because of her refusal to renounce her faith. The hideously ingenious torture ordered by the emperor consists of two wheels studded with sharp nails and knives, each turning in opposite directions as they slowly cut up the victim. Excluding the bottom two sections, the story is told in a set of panels each of which covers four sections of window. Starting from the bottom, in the lower two panels, the story is told in a clockwise direction. In the two panels above that, the story continues counterclockwise. In the top-most panels, the story is told vertically from bottom to top. In other words, the direction of the narrative matches the nature of the torture by the two wheels and finally the triumph over the torture and the entry (at the very top) of the saints into heaven. The story concludes with Catherine urging the Lord to break the torture machine, which an angel does, in the process killing several thousand onlookers. The break-up of the machine is shown in the panel second from the top.

If you wish to further pursue the stories in the many windows, the bookshop has short guides that number the windows and panels and identify the scenes of each story. One is *Guide to the Windows of Chartres Cathedral* by C. Manhes and J.P Deremble.

Reims

Reims is about 93 miles northeast from Paris and can be reached by train, from the Gare de l'Est, in about an hour and forty minutes. If you are continuing by train, the journey to Laon is a further 45 minutes, Soissons is 25 minutes further on and from there, the return to Paris takes an hour and five minutes.

The places recommended here are only a sample of the wealth of Gothic to be found to the north and east of Paris or indeed all around Paris. If you are in a car, it's worth pausing at every town you go through to check what is there. The northeast direction takes you through the famous Champagne district.

The Cathedral at Reims

Location: In Rue Libergier and close to the tourist office. It is well signposted.
Opening Times: 7:30 am–7:30 pm except during ceremonies
Admission: No charge

The cathedral of Reims, like Paris and Chartres, is dedicated to Notre Dame. Building started on it in 1210 after a fire. The choir is the earliest part, having been completed in about 30 years. The nave was started in the middle of the 13th century. Unlike Chartres, Reims has been badly damaged by war, especially in 1918.

This cathedral was used for the coronations of France's kings. Appropriately, it is large, dominating and richly ornamented with sculpture, both outside and in, and with glass. The sculpture generally emphasizes the human and material qualities of figures rather than their celestial significance. In the glasswork, it is interesting to explore how much of the stonework of windows has been hollowed out to make way for glass.

The Basilica of Saint-Remi in Reims

Location: About one mile southeast of the Cathedral of Reims at 53 Rue Saint Simon. Bus A goes from Reims station to the Basilica.
Admission: No charge

This is an earlier building than the cathedral. As part of a former Benedictine abbey, it was started at the beginning of the 11th century. Parts of the north transept and the nave date from before 1050. The choir, the nave, and the western façade were up by the end of the 12th century. Try to identify the various stages of the building and imagine what each period planned as its ideal space.

Gothic churches treat their three or four levels (nave, gallery, triforium, clerestory) differently. Sometimes, as in Chartres, they are distinct zones. Sometimes, as in Reims, they merge more, and vertical elements in the architecture therefore play different roles. However, there is a common tendency for the lower sections to be more earthly, and darker, and to treat the high sections as zones of heavenly light. Earlier buildings such as this basilica and the cathedral of Laon have four storeys; Notre Dame de Paris started with four but switched to three.

GOTHIC ARCHITECTURE OUTSIDE OF PARIS

GOTHIC ARCHITECTURE OUTSIDE OF PARIS

Laon

If possible, don t miss this stop. Laon is about 24 miles northeast of Soissons and its magnificent skyline will live on in your memory.

Laon's Cathedral of Notre Dame

Location: Place Aubry, Laon
Admission: No charge

Notre Dame de Paris is the model for Gothic cathedrals and Notre Dame de Chartres is both exquisite and unusually well preserved. But critics both in medieval and in modern times think that Laon, in Nicholas Pevsner's words, "is the only one (except for Tournai in Southern Belgium) that can give a true idea of what a French cathedral was intended to look like" (*An Outline of European Architecture*). Villard de Honnecourt, a 13th-century architect who travelled about and kept a notebook of sketches and comments, praised its towers.

Like Chartres, Notre Dame de Laon stands out for miles from its slight rise above a surrounding plain. Building began in the 1150s and was mostly finished by 1200, except that it was decided to demolish the choir and create a larger one, which was soon done. The effect of this last rethink was to give the ground plan a very regular shape in the form of a cross and a striking internal symmetry. If you stand at the crossing under the lantern you see four substantial arms each finished with a rose window.

Lanterns were not used in later Gothic buildings, where spires often crowned the crossing and vaulted ceilings made the crossing dark. At Laon, the play of light is quite different. The lantern was planned to be one of seven towers, but only the lantern and the two towers of the western end were built. Even so, Laon gives more of an idea of its original vision than Reims, which was also meant to have seven towers, and Chartres where there were plans for nine. In common with early Gothic cathedrals, Laon has four levels.

The western or main entrance end is a wonder. Whereas the façade of Notre Dame de Paris comes across from a distance as a patterned picture in two dimensions, Laon's façade is abundantly three-dimensional. It almost seems to be in motion, like a merry-go-round. It is instructive to list mentally the devices by which this is done, from the porches and perspectives at ground level through to the eight oxen

standing out on the skyline. The eight represent a miraculous team of oxen that materialized at a critical moment during the construction to give the quarrymen and builders a hand.

Soissons

Soissons is about 20 miles southwest of Laon and 60 miles northeast of Paris. Its cathedral will give you an impression of the relative simplicity of 12th-century architecture compared with the highly decorative Gothic, which is more widely known and admired.

Cathedral of Saint-Gervais and Saint-Protais

Location: Place Mantoue, Soissons
Opening Times: 9:30 am–12:00 noon; 2:00 pm–6:00 pm (5:00 pm in winter)
Admission: No charge

The earliest part of Soissons' cathedral is the south transept, begun about 1180 and finished about 1190. This transept has four storeys and its treatment of these storeys is a lesson in how stone can be dissolved into fine lines that frame light. The basic technique is to place multiple arches between the main piers (defined by the responds that run from the ground up to the ribs of the ogival vault). The ground floor, gallery, and clerestory have three openings and the triforium six. The choir and nave are both more massive, designed to impress rather more than the transept, which is a light, calm space. The choir and other parts of the church were much damaged in the First World War and have been restored.

Beauvais

Beauvais is about 48 miles northeast of Paris. The train leaves from the Gare du Nord and the journey each way takes an hour and fifteen minutes.

What its cathedral powerfully illustrates is the ambition of some 13th-century builders whose great dream was never realized.

If you are a tapestry enthusiast, you may wish to visit the Gallerie Nationale de la Tapisserie (open from 10–11:30 and 2:30 to 4:30 but closed on Mondays). It has both permanent and occasional tapestry exhibitions of considerable note.

Cathedral of Saint Pierre

Location: In the Rue Saint Pierre, close to the tourist information office
Opening Times: 9:00 am–12:00 noon,1:00 pm–5:00 pm
and 2:00 pm–5:30 pm
Admission: No charge

Only part of the Cathedral of Saint Pierre is standing. Started after a fire in 1225, sections of the building collapsed several times and it was never completed. Occasional speculation has it that hubris brought the building down. Beauvais was to be the tallest church in Christendom. When St Peter's in Rome started to go higher, Beauvais added a tower that took it higher. Unfortunately, the tower collapsed. After Beauvais, medieval architects gave up trying to build higher cathedrals.

Perhaps more likely to be at fault than hubris were mistakes, especially in the buttressing. A glance at the buttressing outside the still-standing choir suggests a certain amount of panic leading to extra buttressing. Apparently the building has still not properly settled even today.

What is overwhelmingly evident, however, is that height, and hence the growing weight of stone, was no barrier to the pursuit of lightness. The choir we now see, twice restored after collapses in 1284 and 1573, gains some of its great height from very tall clerestory windows that strive to reach the heights of heavenly light.

Also in Beauvais is:

Église St Etienne

Location: In the Rue de l'Etamine
Opening hours: 9:00 pm–12:15 pm and 2:00 pm–5:30 pm
Admission: No charge

This is a much smaller building than the cathedral and demonstrates interesting features in the history of church building. The nave was built in the 12th century and much of the rest (including the choir) dates from the 16th century. There is a notable Tree of Jesse in 16th-century stained glass.

AFTER THE NAKED LUNCH: IMPRESSIONISTS AND POST-IMPRESSIONISTS

A detail from Monet's Impression: Sunrise, Le Havre

Introduction

A Brief History of Impressionist Art

Although the Impressionist painters are now revered, the art establishment of their time wouldn't show them, so they held their own rebel exhibitions. These comprised eight so-called Impressionist Exhibitions between 1874 and 1886. A decade earlier, in 1873, the Emperor Louis Napoleon had organized a "Salon des Refusés" to show artists who had been rejected by the official Salon. Manet, Whistler, Pissarro, and Cézanne were among the Refusés but their work was generally ridiculed or seen as scandalous. Manet was still spurned by many even after his death in 1883.

From today's perspective, Impressionism can be seen as a creative extension of the traditions of landscape and thematic painting. Manet made direct references to earlier Italian and Spanish paintings. Monet shows a strong lineage from Claude Lorrain and the English painter JMW Turner. Cézanne saw himself as a descendant from, among others, Nicolas Poussin. All acknowledged the inspiration of the French realists of the preceding generation – Corot, Millet, and Courbet. Equally they incorporated the tastes of their time, for oriental art, for example, and for street and café life. Being something of a mutual admiration club, they also greatly influenced one another, ideologically if not technically. Little of this historical continuity or conscientious innovation was recognized at the time. Critics scorned their subjects and their styles, mocking them as "Impressionists." But their work became some of the most popular and bestselling in art history. They made Paris the center of the art world, indeed the ideal city of the western world.

Although they had their heyday more than a century ago, they are still seen as part of the modern era. Manet, Morisot, Monet, Renoir, Degas, Caillebotte, Pissarro, Cézanne, and the rest each had their own style and interests, from the intimate studies of Morisot to the epic projects of Monet, but they had enough rebelliousness in common to hold them together as a group distinguishable from the academic painters of the time and the more adventurous symbolists. Like the realists before them, they

generally preferred everyday subjects – picnics, workers and groups dancing in the parks – but they frequently used models rather than "real" people. To some extent they all became preoccupied with trying to depict the transitory effects of light and, by extension, the way we perceive light and color. Significantly, their first group exhibition was in a photographer's studio in a busy street. They were seen as members of a cultural avant-garde, defended and supported by the avant-garde writers of the time, such as Baudelaire, Mallarmé, and Zola.

These preoccupations are what make them seem modern. By opting for everyday subjects, they brought to an end about four centuries of devotion to subjects drawn from, and combining Christian or classical mythology. Classical values thereafter would be more formal than narrative. By changing the way they painted they presaged the idea that painting is often more about painting than about its ostensible subject matter. They wanted to paint the world as they saw it, but what they painted was shaped by the artists' eye and differs importantly from reality. Their rebellious styles became the watershed for the modern art of the 20th century.

Fashions and markets in art have caused Impressionist painting to be dispersed around the galleries and private collections of the world but their works and their street scenes are still a powerful presence in their home town, Paris.

Profiles of the Artists

Below you'll find brief biographical notes on the Impressionist and Post-Impressionist painters and some who influenced them. For more minor artists, writers and other notables, check the Appendix.

PAUL CÉZANNE (1839–1906)

Cézanne started as an Impressionist, being especially influenced by Pissarro. He fairly soon adopted an analytic and geometric approach, essentially to landscape, which took him away from Impressionism and formed a bridge to the geometric abstractions of the 20th century. He was a rather crusty character and in mid-life withdrew to comparative isolation in his birthplace, Provence. With Gauguin and van Gogh, who also started under Impressionist and realist influences, he is seen largely as a Post-Impressionist pioneering subsequent modernist movements.

CAMILLE COROT (1796–1875)

Corot introduced an optimistic realism to French panting, for which he was much admired by many Impressionists. He was, above all, a landscape painter. He was born in Paris, where he lived for much of his life, and was attracted to the ideas of the Barbizon School who painted the landscape around Barbizon near the castle and forest of Fontainebleau. Corot was one of the first to work at his easel in the open air. He set out to record scenes directly rather than reworking them in a studio. One of his hallmarks is that he mixed colors with white to give them a light-filled quality.

GUSTAVE COURBET (1819–1877)

The first of the Realists and in his day highly unconventional, Courbet was a great supporter of the young Impressionists who in turn admired his capacity to break with academic styles. He had gone to Paris as a 22-year-old to study law but soon found himself attracted to the artist's life. Having grown up in a farming community, he drew on life as he knew it and portrayed people's relationships with each other. He objected to the judgments passed on art by the establishment and built pavilions at the world fairs of 1855 and 1867 to show his own work.

EDGAR DEGAS (1834–1917)

Degas is probably the best-equipped technician of all the Impressionists. His studies took him to academies in Paris and Italy and to the great galleries where he copied the masters of the Renaissance. He drew and painted in classic style for almost 30 years before his painting took the direction that would make him famous. Essentially, he became a painter of a number of themes from ordinary contemporary life. Still very much accepted by the Salon because of his immaculate technique, he took up themes such as the racecourse and experimented with angles and compositions that gave his painting some of the feel of a snapshot. The subsequent themes he developed – people at work, dancers in rehearsal, musicians – continued to be studies of the strains, labor, and unconscious grace or pathos of working class life. He was as acceptable to Impressionist exhibitions as he was to the Salons and

enjoyed considerable success as an Impressionist from the 1880s. Although he lived into his 80s, blindness forced him to stop painting some twenty years before his death, from a stroke, in 1917.

EUGENE DELACROIX (1795–1873)

A Romantic painter much admired by the Impressionists, Delacroix used some of the techniques they would take up as characteristic of their style: divided brush stroking (which leaves the viewer to mix separately applied colors) and colored shadows. Today, he is remembered not only for his dramatic use of color but also for large-scale works on political themes. Ultimately, his health suffered as a result of working from uncomfortable scaffolding and in drafty buildings. During his lifetime, he was a great admirer of the work of Michelangelo and visited England, where he was impressed by Constable. A museum devoted to his work reopens in the spring of 2003 at 6 Rue de Furstenberg.

PAUL GAUGUIN (1848–1903)

Born in Paris, Gauguin associated with the Impressionists but delineated his shapes to make flatter patterning using a very decorative color range. His pictorial style and his attraction to primitive art look forward to 20th-century movements such as the Fauves. Orphaned when his family was already in political exile, Gauguin's guardian's admiration for Delacroix made a big impact on him. Returning to France as a young painter, he was taught by Pissarro and worked alongside van Gogh. Probably his best-known works were done in Tahiti, whose culture and visual beauty captivated him for the rest of his life.

EDOUARD MANET (1832–1883)

Manet perhaps best illustrates how diverse the Impressionists actually were. Although he had a part in organizing the Rejects' Salon and the independent exhibitions of the Impressionists, he was always keen to exhibit in the Salons, sometimes in preference to the independent

exhibitions. Some of his best-known paintings are narrative rather than landscapes or cityscapes. His narratives do not, however, feature the smooth, carefully brushed surfaces of the romantic painters of his century, nor do they attempt any nobility of subject matter. Instead they use contemporary images to make ironic comments on the fashionable and traditional subjects of painting. These reflect both his taste for Spanish artists such as Goya and Velasquez and his affinity with literary men of his time, such as Charles Baudelaire. Like Goya he used a black palette and there is a sense of corruption close to the surface that recalls the poetry of Baudelaire. His later painting of rivers, cafés and gardens after 1870 came closer to the Impressionists, with whom he would sometimes work. He suffered from syphilis over the years, had a leg amputated in April 1883, and died shortly afterwards. He is buried in the Cimitiere de Passy in Paris.

JEAN-FRANCOIS MILLET (1814–1875)

Millet was a realist but somewhat sentimental painter, famous especially for his *Peasants Saying the Angelus*. Millet influenced both Pissarro and van Gogh. Although he was associated with the Barbizon School who favored painting in the open air, he himself painted indoors. He had the reputation during his lifetime of encouraging young painters.

CLAUDE MONET (1840–1926)

Monet determined early in his life to be an artist. By the time he left Le Havre, his birthplace, at age 19, he had already taken up painting in the open air, guided by the local artist Boudin. In Paris he met Pissarro and subsequently many more of what would become the Impressionist circle. He and Pissarro avoided the Franco-Prussian war in 1870 by going to England where he met the influential art dealer Paul Durand-Ruel. Back in France a year later, he set up in Argenteuil, where he already showed the passion for flowers and water that became his eventual trademark. His wife (originally his mistress) Camille Doncieux died in 1879. He moved to Vetheuil and in 1883 to Giverny. In 1892 he married Alice Hoschede, who had been his mistress for ten years. By 1893 he had the garden at his Giverny property redesigned and furnished with the soon to be famous lily pond. Although he travelled a great deal in and outside France, he

focused an enormous amount of his energy on making his garden at Giverny, the subject of his painting of water and reflections. His painting became more and more abstract, expresssionist and, thanks to his dealer and friends, more successful. Cataracts in later life might have influenced some of his color perceptions. Monet today is probably the most admired and expensive of the Impressionists.

BERTHE MORISOT (1841–1895)

Morisot was a French painter and printmaker who exhibited regularly with the Impressionists and participated in their struggle for recognition. A stunning beauty, she was also a woman of great culture and charm who counted among her close friends many key artists and writers. As a 23-year-old, she was exhibited among the painters who had been given the stamp of approval by the Salon. Then, ten years later, in 1874, she vowed never to show her paintings in that officially sanctioned forum again and cast her lot with the Impressionist group. In the late 1860's, she had met Edouard Manet who was to exert a tremendous influence over her work. She modelled for him several times and appears in portraits and as figures in his paintings. Subsequently, she married his younger brother Eugene and their travels abroad were significant to the development of her work. Morisot's work never lost its Manet-like quality – an insistence on design – and her paintings frequently included members of her family, particularly her sister Edna and, later, her daughter Julie. Delicate and subtle, exquisite in color – often with a subdued emerald glow – her work won the admiration of her Impressionist colleagues.

CAMILLE PISSARRO (1830–1903)

Pissarro arrived in Paris from the Virgin Islands in 1855. His painting moved through Realism to Impressionism. He was clearly much valued by other Impressionists as a friend and was even able to work with Cézanne. He encouraged younger artists in the development of the new pointillist style that grew out of Impressionism. He had originally come to Paris specifically to be a painter and was the only one of the Impressionist group to show work in all of the Impressionist exhibitions between 1874 and 1886 and none in the Salon.

PIERRE-AUGUSTE RENOIR (1841–1919)

The son of a tailor and a dressmaker, Renoir began his painting life as a decorator in Paris. He then studied painting and became acquainted with painters such as Sisley, Monet, and Bazille. Politically, he was one of the active Impressionists, agitating for the Salon des Refusés and then independent exhibitions. Artistically, he hankered for classicism and revelled in painting women nude and clothed. These tastes saw him return to the Salon after the first three Impressionist exhibitions. A fair bit of commercial success as a portraitist did not distract him from scenes of Parisian working-class life – essentially of people at play – which are his most impressive works. In common with quite a few painters, Renoir turned his favorite models into mistresses or wives.

A tour of Italy in 1881 convinced him that he had to improve his drawing. He concentrated on figure painting and put aside much of the rapid, suggestive techniques of Impressionism. He and his family settled in Cagnes-sur-Mer in the south of France in 1908. There he painted many breasts and roses and despite severe handicaps with rheumatism, also took up sculpting. He died of lung disease in 1919. The house and garden in Cagnes are now a Renoir museum.

GEORGES SEURAT (1859–1891)

Seurat developed the technique known as Pointillism, in which pure color is put on the canvas in tiny dots, leaving the eye to mix the shades of the image. The technique results in making figures and objects seem very still and solid. His painting style was supported by a study of color theories and optical analysis. Although the style is striking, it did not continue to develop in mainstream European art, which may in part be explained by the fact that Seurat, its leading exponent, died at the age of 32.

PAUL SIGNAC (1863–1935)

Though inspired by seeing Monet's work and meeting him, Signac took up Seurat's Neo-Impressionism, usually known as Pointillism. He had the advantage of coming from a family of established shop-keepers and

was thus able to explore his art from a relatively secure financial position. He showed great respect for his colleagues, was very much a group member and organized exhibitions after their deaths for van Gogh and fellow Pointillist Seurat.

VINCENT VAN GOGH (1853–1890)

Born in Groot Zundert, van Gogh moved to Paris, which was at that time seen as Europe's artistic center, to take up his chosen career as a painter. He lived most of the rest of his unfortunately short and troubled life in France. Van Gogh was influenced by both Realist and Impressionist painters but fundamentally developed a personal style characterized by vivid colors and heavily textured brushing. He was at various times mad, which some see as an indelible aspect of his painting. Certainly his works are immensely energetic and perhaps troubled, but there is quite clear control over texture and composition. The misfortunes of his life may often be reflected in his work but do not control his painting. He died in the hospital at Auvers-sur-Oise at the comparatively young age of 37. A visit to the village enables you to tour scenes that he painted and that are still clearly recognizable.

An Overview of the Trails in this Section

The Impressionist Trails take you to a number of museums – but not to the Louvre, whose massive collections stop at the 19th century. Nineteenth-century French art is largely in the Musée d'Orsay, a beautifully made-over railway station. The Marmottan Monet museum has a collection containing Monet's *Impression: Sunrise,* which gave the Impressionists their enduring name, and works concentrating on Claude Monet and Berthe Morisot. The Orangerie (reopening soon after renovations that have lasted for several years) contains a significant exhibition of the waterlily paintings of Claude Monet, and a good selection of Impressionist and Post-Impressionist work. This is covered briefly in an additional chapter at the end of this section, along with two side trips – one to Monet's garden at Giverny, and one to Auvers-sur-Oise, a small town in which you see the subjects of a number of van Gogh paintings as well as a sound-and-light show on the Impressionists. Twentieth-century art is in the Georges Pompidou Center and is dealt with in the next section.

The Trails are numbered in the order we think would be best. If your time is limited, we've provided starred entries in Trail 1 and 2 at the Musée d'Orsay. This abbreviated Trail will take you one full day, and seeing just those starred entries will give you a good overview of the Impressionists and those who came before and after them. We also suggest that you go on Trail 3, the Musée Marmottan Monet, which will take an additional half-day.

TRAIL 1: MUSÉE D'ORSAY: IMPRESSIONISTS AND THEIR PREDECESSORS

If you view the starred entries only, you can spend a long half-day in this museum. If you see all of them, you may wish to take two days when combined with Trail 2.

TRAIL 2: MUSÉE D'ORSAY: POST-IMPRESSIONISTS

Seeing the starred entries only will take the rest of the half-day you spent on Trail 1, and a longer half-day will allow you to see the works in more detail.

TRAIL 3: MUSÉE MARMOTTAN MONET: MONET AND OTHERS

A visit here will take a long half-day. There will be time to take in most of the works on show. Importantly, you will see *Impression: Sunrise* and a number of works by Berthe Morisot, the woman, artist, and model who exhibited in all but one of the Impressionist exhibitions.

Other Museums and Suggested Day Trips

This section very briefly covers a number of other museums, including the Orangerie, plus two selected day-trips out of Paris: Auvers-sur-Oise and Monet's garden at Giverny.

Island on the Seine, near Rouen

TRAIL 1:
Impressionists and Their Predecessors

Musée d'Orsay

Location: Near the Orsay Metro and RER stations; well signposted
Opening Times: 10:00 am–6:00 pm, later on Thurs., closed Mon
Admission: Euro 7; Euro 5 with discount

The Orsay collection, essentially of 19th-century French work, is housed in a splendidly adapted old railway building, worth admiring in its own right. The museum provides a free ground plan in English and other languages, and you'll find several restaurants inside, ranging from a full-blown dining room in a lovely setting to tearooms and sandwich bars. There are some wonderful views of Paris out of the windows. The Orsay is reasonably generous in the seating it provides in many rooms, useful not only for resting but for getting a more long-range view of groups of paintings. It also provides excellent art notes on cards – look for the racks near main rooms.

On the lower levels are the works of painters who preceded Impressionism and earlier works of painters who became known as Impressionists. The galleries on the upper levels, clearly signposted, take the visitor through a collection of major works by Impressionist painters. Beyond that are the works of the next generation, who gradually became known as the Post-Impressionists and Neo-Impressionists.

This long half-day Trail gives you an overview of the Orsay's very large collection. Before you leave, visit the model of Haussmann's Paris, which is at the back of the building. His Paris was the backdrop for Impressionist life and he made some great improvements to Paris. Sewers were laid. Paris was divided into its 20 arrondissements and its

MUSÉE D'ORSAY: THE IMPRESSIONISTS

citizens mentally prepared for the building of the underground Metro at the turn of the century. He might have had an obsession with planning but it does mean that Paris is probably the world's best signposted and most accessible city.

Please note that the location by room numbers is not rock solid. The museum maintains a consistent pattern but individual paintings may be moved slightly or be taken away for loan or technical work. This Trail begins downstairs.

Before the Impressionists

Like all movements, the Impressionists grew out of the generations that preceded them, partly by breaking from the traditions and beliefs that earlier painters had lived by. In order to understand what the Impressionists drew from tradition – and what they rebelled against – this Trail looks at the work of those earlier painters and also their contemporaries, as well as the work of the Impressionists before they called themselves by that name (that is, prior to 1874).

If your time is limited, focus on the starred entries.

Room 2

Eugene Delacroix☆
Chasse aux Lions (The Lion Hunt), 1854

Delacroix was much admired by the generation of reformist painters that followed him. He is best known for large-scale Romantic works (in the Louvre) but he painted a considerable variety of subject matter using bold and free brushwork. *Chasse aux Lions* is vivid and rapid to the point of being obscure, although there is no chance that he was painting such violent action on the spot. He clearly wants to engage a viewer in the sense of chaos that an encounter with lions would cause. Impressionist painters – especially Monet – would similarly rely on brush stroking and a profusion of bright color to convey atmosphere. The Impressionists' dedication to everyday subject matter owed a lot to the dark-toned realists such as Corot and Courbet who preceded them. Their attachment to color showed their debt to the narrative painters of the Romantic school, Delacroix and Géricault, and the classicist Ingres.

Room 3

Alexandre Cabanel
Naissance de Venus (The Birth of Venus), exhibited in the Salon of 1863

At the same time as Manet's *Déjeuner sur l'Herbe* was being refused for display in the annual Salon of the Academy, this piece of fluff by Cabanel was not only shown but showered with praise and bought by the Emperor Louis Napoleon. Cabanel's nude is a prurient study of a voluptuous body, justified by its would-be classical subject. Venus (Aphrodite to the Greeks) was born out of the sea in one of the great moments of mythology, a moment at least charged with high symbolism. Cabanel's Venus reclines in some sort of languor a short distance above the waves while Cupid babies flutter overhead wondering where to tickle her to wake her up. Apart from its soft erotic content, the best that can be said for it is that it has a pretty sky. Empty reference to classical themes was one of the hallmarks of the so-called Academic painting that the Impressionists rejected.

Room 5

Camille Corot☆
La Catalpa; Souvenir de Ville-d'Auray (Catalpa, Memory of Ville d'Auray), exhibited in the Salon of 1869

Corot, along with some other painters of the Barbizon school – notably Jean-Francois Millet and Charles-Francois Daubigny – broke with the tradition of working in the studio and painted a great deal *en plein air* (in the open air). Despite this, they continued to produce rather dark, smooth-textured pictures that retained the characteristics of studio work. It is probably more accurate to say that they sketched in the open air and completed their work in the studio. This was a method frequently used by Impressionist painters even though they supported working out of doors. Corot makes clear his perceptions of his work by calling his paintings memories of this or that place. To varying degrees, he idealizes the scene that he remembers and had sketched. This group of painters also regularly included peasant figures as real-life figures, which was an implicit rejection of the *Nymphs and Shepherds* style. *La Catalpa* is remembered by Corot as a pleasant country place. This work is not as dark as a lot of his work. The sun glints on the leaves, which scatter across a large part of the painting and between them, sky shows through. Despite their departures from Academic traditions, these painters were exhibited in the Salon.

Charles-Francois Daubigny

La Moisson (*The Harvest*), painted in 1851, exhibited in the
Salon of 1852

Daubigny conceives the landscape at harvest time on a grand scale.
The sun is setting in a huge sky and the peasants continue to
work. Pools of light in the distance mark the end of the day. The
purpose seems to be to confer dignity on the tired workers by
placing them in a spacious countryside. This romantic view of
rural labor, which was also a feature of the contemporaneous
poetry of William Wordsworth, was taking place as the Industrial
Revolution was gathering force.

Room 6

Jean-Francois Millet

L'Angelus du Soir (*The Evening Angelus*), c.1857–59

The Angelus is a prayer said in memory of the Annunciation, when
the archangel Gabriel announced to Mary that she was going to
have a baby. It was commonly recited – and in some places still is –
when the church bells rang at dawn, midday, and dusk. A number
of Millet's paintings ennoble peasant figures and come across as
devotional works. Reproductions are in fact hung in church halls
and schools. This one is a narrative of devout peasant life. The
spire of the church is in the distance, marking the site of the
village. The man and the woman have left the village in the
morning to work in the fields. They have been digging potatoes all
day. Evening has come. The bells of the Angelus ring out from the
village at six o'clock, having rung also during the day at midday.
The peasants pause in their work to pray. They pray but they will
not go home until it is too dark to work.

Camille Corot

Souvenir de l'Italie or *Souvenir des Landes* (*Memory of Italy*), 1872

As a memory, this is probably one that gradually exaggerates the
scale of the scene. A tiny figure of a woman carrying a load on her
head and the buildings of a town on a rise in the distance are the
only signs of habitation. The largest object in the picture is a big
tree that encloses the landscape so that it is not infinitely vast,
though the memory is clearly of empty fields and long distances.
The figure is walking, even though she has a load to carry. There

are no roads. The distance is seen from a walker's viewpoint – in the modern mind, the village would only be a few minutes away.

Room 7

Gustave Courbet
La Falaise d'Etretat après l'Orage (The Cliff at Etretat after the Storm), painted in 1869, exhibited in the Salon of 1870

Etretat was actually a large beach resort not far from Le Havre on the English Channel. It was one of Courbet's favorite places to paint. It offered spectacular cliffs, the sea itself, stormy weather, boats, and fishing – all robust outdoor subjects for painters. The jutting promontory with its arch (actually one of three) attracted Monet as well as Courbet. Other painters and literary figures – including Delacroix – spent time there. Indeed, there might have

Courbet's La Falaise d'Etretat après l'Orage

MUSÉE D'ORSAY: THE IMPRESSIONISTS

been a large party of arty onlookers somewhere outside Courbet's frame. Like Monet, Courbet chooses to show the cliffs and the sea in an apparently wild state. Courbet's painting concentrates on defining the elements of the scene by applying paint smoothly and a little darkly. The very interestingly shaped cliff is an attraction in the painting but no more so than the painting of the powerful waves that create such formations.

Room 11

Puvis de Chavannes
Le Pauvre Pêcheur (The Poor Fisherman), 1881

Puvis de Chavannes was a contemporary of the Impressionists. This room contains quite a few of his works. *Le Pauvre Pêcheur* is probably the best regarded. Apart from the obvious comment in the subject and implicit in the style, the work's muted colors serve this painter better than the flat, light, and often sentimental colors he uses elsewhere. This sort of painting is a long way from that associated with the Impressionists. Impressionists, to begin with, would have been likely to romanticize fishing. They would certainly have given the seascape more presence and perhaps have left out the rest of the family altogether. Puvis de Chavannes preferred to make a social comment rather than look on as a bourgeois outsider. His other symbolist paintings around the room are somewhat coy, even vapid, and do not fairly represent him.

Go to Room 14 to view a selection of the paintings of Edouard Manet before 1870.

Room 14

Edouard Manet
Emile Zola, exhibited in the Salon of 1868

Edouard Manet shows the young and successful writer Zola, who lived from 1840 to 1902, as the admirer and defender of the avant-garde in Paris at the time. He therefore includes two Japanese prints as well as a print of his own controversial work *Olympia* on the wall. On his desk and partly obscured by a quill is a pamphlet about Manet, clinching the portrait as a thank-you for his support for Impressionist painters. Zola's face and the book he is holding

are lit as though he is on stage, but apart from what the viewer may make of various objects in the room, there is no glamour. The painting is dark and flat looking, light colors against black and heavily outlined shadows.

Edouard Manet ☆
Olympia, exhibited in the Salon of 1865

Although it was accepted by the conservative Salon, Manet's *Olympia* excited the same outrage that his *Déjeuner sur l'Herbe* (upstairs) had provoked two years earlier. In both paintings the nude model – one Victorine Meurent – looks challengingly at the viewer. This is not a nude in a classical setting, but a portrait of a real woman, and a prostitute at that. It was this that excited such indignation. The few things Olympia is wearing, especially the ribbon with the pearl around her neck, suggest prostitution, and her hand is over her pubic region. Both she and the cat at her feet are looking out of the picture, perhaps at someone coming into the room. The arrangement and tone of the work are drawn from earlier paintings. The allusions to a painting by Titian (*The Venus of Urbino*) suggest that he is mocking the practice of making nudes acceptable by representing them as myth. In contrast, the allusions to Goya's *Naked Maja* repeat the Spanish painter's insistence on sexual frankness despite the danger of the Inquisition. (Reportedly, the *Naked Maja* was still running into trouble from US authorities in 1930 when Spain put her on a postage stamp – the American postal authorities would not deliver any letters that featured it!)

Edouard Manet ☆
Le Balcon (The Balcony), exhibited in the Salon 1869

Three people are on a balcony looking down on the street. From the left, they are the artist's sister-in-law Berthe Morisot – herself one of the Impressionist painters – Antoine Guillemet, another painter of the time; and a musician called Fanny Clauss. Berthe looks rather cross; Fanny has a dreamy look. In a painting that is essentially in black, white, and green, color is all-important. The three might as well be in front of a black hole. You can just make out someone in the background, probably a waiter, as well as a light in the room and a painting on the wall. But essentially, the white on the figures picks them out against deep shadow and other details of the outside world such as the green shutters and

MUSÉE D'ORSAY: THE IMPRESSIONISTS

Manet's Le Balcon

the highlights of dress. Berthe's fan and the decoration on her neckband are therefore prominent in red. It is not usual to paint shadows in black but the shadows around her neck are. The geometry created by the shutters and balustrades illustrates Manet's formalism, which he passed on to Morisot as a painter.

Edouard Manet
Le Fifre (The Fife Player), rejected by the Salon 1866

A jaunty lad, painted in red, white and black with touches of gold on his buttons, instrument, collar and cap, the fife player stands alone in a grey space. No sky or building behind, no surface to stand on, he appears before us as fresh and confident as his youth can make him. Does he appear before us in a spaceless world because the painter believes he is going off to his death? Note how his gaiters are painted in a few quick strokes, still visible to the eye, and that the splashes have a gleam to them. The disciplined use of color – even his face is presented to us in red, black, and white – allows the gold to give his stance substance as well as vitality. What did the Salon have against this charming work?

Edouard Manet
Pivoines (Stem of Peonies) and
Secateurs; Pivoines (White Peonies) and Secateurs, often hanging side by side, 1864

In one painting, the secateurs are closed and in the other, open and balanced on the table. In the second painting, the flowers are already limp. Being cut has ended their life. The juxtaposing of secateurs with fragile flowers makes this an image of the ways in which gardeners and those who arrange flowers try to grasp the moments of beauty to be had from them, yet their beauty fades even as they are admired. Baudelaire would have liked this symbolism. The forms of these fragile flowers are suggested with rapid, broad brush strokes and made up of a surprising number of colors – light green, dark green, white, pink and grey.

Room 15

Henri Fantin-Latour
Un Atelier au Batignolles (A Studio at Batignolles), painted in 1870, exhibited in the Salon of 1870

MUSÉE D'ORSAY: THE IMPRESSIONISTS

That the Impressionists formed a circle is attested by the number of times they painted one another or were painted together. The *Atelier au Batignolles* – like the one of Bazille's at Rue de la Condamine – illustrates that the group included writers and critics as well as painters. The figure seated at the easel with hair and beard is Manet. Standing behind Manet – appropriately framed by the picture on the wall – is a distinguished looking Renoir, appearing both young and thoughtful. On Renoir's left – holding a pair of lunettes – is the radical novelist and polemicist Emile Zola. Zola was a particularly staunch defender of Manet's work. The tall dandy in the checked trousers is Bazille, who painted his group of the friends in the same year. No one would have expected that this healthy looking man was going to die that year. Peering out behind Bazille – and looking as though he just managed to squash himself into the scene – is Monet. This homage to Manet was satirized in a cartoon of it entitled *Jesus Painting Among His Disciples*. No one today would take this to be a group of rebels. Not only are they dressed quite formally – and apart from Manet and perhaps Monet well groomed – but they are also happy to pose like the board of a bank contemplating a purchase for the board room. It is ironic that their portrait as luminaries of the art world was exhibited at the Salon at much the same time as some of their works were being rejected as outrageous or incompetent.

Room 18

Claude Monet
Le Déjeuner sur l'Herbe (The Picnic), 1865–66

This work was painted a little after Manet's painting of the same name but Monet, who is a member of the same circle, presents no such ironies. The subject is what the title says, a picnic. As such it fits with the enthusiasm of the group for painting scenes of people enjoying their leisure time. Perhaps he had decided to present a different view from Manet's of the lives of artists and their models, but looking at the work leaves you with no doubt that what he was really interested in was color and light. It is a jolly young man's painting of a number of apparently well-to-do, handsomely dressed people having a good time. The white picnic cloth is laid out, the plates and glasses ready. Poultry, fish, fruit, and cake are about to be served; but the eye catches the white of dresses spotted with black, light flecking the trees,

splashes of red and blue on the women's gowns, faces outlined in light. The work was not finished and survives today in two pieces. In order to work on a piece of this size, Monet had a ditch dug in the garden. He was seriously committed to the idea of working outside and not in a studio and of trying to capture light and color as they came before him in the real world. These two preoccupations were to stay with him for the rest of his long career.

Claude Monet
La Pie (The Magpie on the Fence) 1868–69

The magpie shivering on the fence is obviously not the real subject of this painting. The subject is sunlight and shadow on snow. For the shadows, Monet has used blue: he avoided blacks and greys. The roof tiles also give a blue surface that the white trees can bounce off. Snow casts a landscape into very broad outlines but it deadens the visual world as it also deadens sound. The bird therefore brings a bit of life to the scene. Perhaps this is a sign – if any is needed – that this is an early work. In his later work, Monet would find that the effects of light and shadow gave him more than enough drama.

Room 19

Claude Monet
Femmes au Jardin (Women in the Garden), painted in 1866–67, refused by the Salon of 1867

Four women are in a garden. The upper half of the painting is filled with dark trees, the lower half broken into by shadows. White dominates – white dress, buttons, ribbons, flowers – but it is not the same white. The women are all the same woman, Monet's mistress, model, and first wife, Camille – the one whose portrait is in the Marmottan Monet. Her face and graceful body are picked up separately in the four figures.

Pierre-Auguste Renoir
Le Garçon au Chat (Boy with a Cat), 1868

There are plenty of female nudes in Impressionist painting but very few males. This early piece by Renoir is pretty sentimental but the modelling of the body shows off Renoir's skill as a painter. He is

already using the deep blue that he preferred to blacks and greys for dark backgrounds and for shadows. The boy is relaxed and his pose informal. He has his back to the viewer but he does not look like a reluctant model. Renoir – in a long career – would do a lot of figure painting, including many nudes. In this, his emphasis differed from that of his fellow Impressionists. His interest in painting bodies, but without placing them in any significant narrative, probably points to his continuing interest in classical themes. Throughout his career, he continued to paint his nudes in scenes that honor classical values but have none of the mythological and historical trappings that went along with the classical painting of the time. In this context, the cat seems likely to be a deliberately anti-heroic statement.

Manet's Le Déjeuner sur l'Herbe

The Impressionists

Take the escalator at the back end of the building up to the top floor. Here are the paintings that form the heart of the Impressionist movement. Many may seem familiar from reproductions but the reality of paint on canvas is often startlingly different. You will see some of the same artists here as in the Pre-Impressionist section, as the painters of the period progressed through stages in their painting lives.

Room 29

Edouard Manet☆
Le Déjeuner sur l'Herbe (The Picnic), 1865

This work was rejected by the Salon in 1865 and exhibited in the Salon des Refusés in the same year. The content of this painting was shocking in its day, and it is still startling. A naked woman sits with the remains of a picnic lunch nearby while two fully dressed men talk to each other. The model was Victorine Meurat, also depicted in *Olympia*. In a dimmer and more wistful pool of light in the background, another woman in flimsy clothing washes in a pond. No reproduction prepares the viewer for the startling flesh and the very direct gaze with which the woman in the foreground confronts first the painter and now the viewer. Is it a joke that the other woman is dressed, albeit in some sort of gauze? The painting itself is made up of two landscapes. The one with the bather is light and blue; the second with the nude, the men, the neglected bread rolls and fruit is darker. The way in which the light falls organizes the picture. The painting is full of quotations from other works. The group of figures is taken directly from Raphael's *Judgment of Paris*, and the subject from Titian's *Fête Champêtre*.

Edouard Manet
La Blonde aux Seins Nus (The Blonde with Bare Breasts) 1878

At first glance, this might pass for a Renoir. Could Manet be having a dig at Renoir for his style? She is blonde – a hair color often favored by Renoir but quite untypical of Manet's works. The work itself is something of a puzzle. The breasts are very bare for several reasons. One is that the blouse looks as though it has just been torn back. Another is that the features of the face are indistinct so

that there is nothing much to look at except breasts. The third – and rather quaint thing – is that she is wearing a floral hat. Manet used nude paintings to make comments and they were often couched as references to other paintings. He does not paint a nude for its own sake. Rather he hints at or asks why the person is naked and what that means to the viewer. The viewer is left wondering at why this otherwise dressed woman has bare breasts, and why Manet has made her faceless.

Claude Monet
Paysage, Vetheuil (Countryside, Vetheuil), 1879

The surface of this painting is made up of brushstrokes that create forms and shapes. The reeds are upstrokes that end with a knob on top. The clouds are puffs. The hill slopes are built up with strokes that run down, as the slope now appears to do. The tree is made up of clump on clump brushing in the direction of the light. Everywhere, the artist's brush is creating the world that we will see. Note too, how the church tower rises against the pointed slopes of the roof. In Monet's hand, the brush became truly creative.

Claude Monet
Les Coquelicots (Poppies), painted in 1873, shown in the First Impressionist Exhibition in 1874

Here, red poppies run down a hill slope on the left and figures vanish into the flowers which somehow float above the grass. Is it made idyllic by the flowers and their fluttering red presence? To the right, the grassy world turns blue and on the extreme left, there is yellow. It is as though this organization of primary colors gave the red its full vigor and allowed it to remain center stage. The figures of women and children in this green and flowery world add the feeling that the landscape is there to be enjoyed by those who are in it, by the painter and ultimately by the viewer. Note the date in the left corner.

Berthe Morisot
La Chasse aux Papillons (The Butterfly Chase), 1874

Morisot's subjects are often events in family life. Here a woman and children are chasing butterflies and the sense of play is emphasized by the pools of light and the light picked up on blossom, hat and dress. There is some black, which serves to make the white whiter.

Claude Monet[☆]
Grosse Mer à Etretat (Heavy Seas at Etretat), 1868–69

Eight figures stand in the foreground of this painting, on the strand, and are totally dwarfed by the waves. There are other paintings of the same spot in different moods and one downstairs in the Orsay by Courbet that features the same cliff. Putting figures in the foreground as spectators underlines the fact that one of the attractions of a holiday resort like Etretat is that it gives the experience of nature in its grandeur. In the painting, the thrill of the grandeur of the waves is channelled through this group of tiny figures. They can enjoy the terrors of nature without being harmed, imagine themselves in the waves without having to survive in them. There is a link with gardening in that the painting seeks to tame nature or experience nature tamed.

Edouard Manet[☆]
Berthe Morisot à l'Eventail (Berthe Morisot with a Fan), 1872

The viewer's eye is presented with a black figure, face covered, and is carried down to take in the impudent ankle and a flippant shoe. In this portrait, Manet draws on some of his Spanish motifs with the fan and the use of black. The black is made even more intense because the background is also brown. Though you don't doubt the confidence of the sitter, Berthe Morisot, she does not appear relaxed and the suggestion of latent or nervous movement is one of the interests of the portrait.

Edouard Manet
Vase de Pivoines sur Piedouche (Vase of Peonies on a Pedestal), 1864

The surface subject is the fragility of the white blooms. The red flowers stand higher and stronger than the white and the floral decoration of the vase mocks the transience of the real flowers. Some of the white flowers have fallen on to black – the colors associated with the trappings of funerals and death. Manet was a literary painter who worked with literary figures, so he would have readily used these colors as allusions to life and death. The green of stalks and leaves in the arrangement is kept quite dark. Only the pure white and pink flowers are drooping and falling. Thus the painting ultimately becomes one of regret.

MUSÉE D'ORSAY: THE IMPRESSIONISTS

Room 30

Berthe Morisot
Le Berceau (The Crib), painted in 1872, shown in the First Impressionist Exhibition

This is known to be a portrait of Berthe's sister and her sleeping child. The scene is gentle and still but there is something in the mother's appearance that suggests that all is not well. Is it that she is tired, or that the child has been ill? The feeling of gentle watchfulness is accentuated by the light surfaces – the drapery around the crib, the curtain – and the fact that the child's sleeping face is seen only through the protective drapes.

Berthe Morisot☆
Jeune Femme se Poudrant (Young Woman Powdering Herself) 1877

This is a painting completed close to the time when Berthe Morisot exhibited in the Second Impressionist Exhibition. The young woman is in a room full of paintings. There are splashes of red and blue painted in below the dressing table. Otherwise, apart from a black necklace, she is a flurry of white petticoats and pale skin. If a man had been arranging the scene, the woman may have been half naked and washing or perhaps combing long erotic hair. Berthe shows her doing something that women typically do. The activity is single minded. The scene has some of the flurry of a preparation that precedes performance. There is also the anticipation of appearing with a more flawless, smooth and perfumed skin than is natural.

Berthe Morisot☆
Jeune Femme en Toilette de Bal (Young Woman in a Ball Gown), painted in 1879, shown in the Fifth Impressionist Exhibition of 1880

The overwhelming impression is of white – white flesh, white dress, white flowers, white ear rings – white painted on white so that wherever there is color, it seems to have been subsumed into the white. The simple image has been made deliberately complex. The young woman's mouth is tremulous. Perhaps she is not looking forward to the ball. The hasty strokes in the background are charged with an emotion at odds with the idea that the subject is ready for enjoyment and nothing more. She is shown in a rather private way, not predominantly presented as the rather decorative object that she might be expected to be at the ball itself. A

confident woman herself, Berthe has succeeded in painting a young woman who has some self-possession and inner life. Too many of the paintings of young women by male painters leave women no such dignity.

Gustave Caillebotte☆
Raboteurs de Parquets (The Planers), painted in 1875, shown in the Second Impressionist Exhibition of 1876

Three men are planing a wooden floor. The light comes in through the window behind them, striking their backs, their arms and a completed section of the floor. Wood shavings lie on the floor as evidence of their activity. On the right is a bottle of wine and a partly emptied glass. This suggests that their worktime is convivial, an impression that is strengthened because the workman on the right seems to be talking to the one in the middle, while the one on the left is partly turned towards them both. The angle – low to the floor, allowing only part of the window to be in view – compresses the space and concentrates attention on the surface of the floor. Caillebotte relished the geometry of space and delineated figures within space in a hyper-realistic manner.

Edgar Degas☆
L'Orchestre de l'Opéra (The Orchestra at the Opera), c.1870

Most of the picture is a horizontal band of men at work. They are in a theatre but they don't act. In principle, they are invisible to the audience. The back of the bass player indicates this. The position of the painter or the viewer is therefore a bit puzzling. It appears to be so far below the orchestra that the top of the bass intrudes on the ballet dancers above. The cutting off of the dancers about the waist announces the focus of the painting. In the foreground with the bassoon are a friend of Degas and a brother of Mademoiselle Dihau the pianist whose portrait, also by Degas, usually hangs nearby. This is a somber, crowded pit of musicians concentrating on their job without regard for what's going on stage or whether members of the audience can in fact see them. Their sobriety is in very obvious contrast with the bright colors in the thin band of performers above them and to add to the contrast, the performers under the spotlights are brushed in more sketchily and more vigorously than the more conventionally painted line-up of musicians. It is an unconventional piece of group portraiture

illustrating, as Degas often did, the demanding labor behind – or in this case underneath – the bright lights of entertainment.

Room 31

Edgar Degas
Répétition d'un Ballet sur la Scéne (Ballet Rehearsal on the Set), 1874

Of all the works of Degas, those of ballet dancers are most gushed over, but his pictures of ballet dancers are not of glittering performance nights. Although the end result is intended to be an exquisite performance, all light and tulle and floating on points, his focus is usually on the hard work. This rehearsal scene contains four elements that are typical of many of these paintings. First, there is the performer, in this scene holding center stage. Next there are other dancers waiting, relaxing or scratching themselves. Third there is a man: in this picture he has been painted out once and moved a bit to the left. Finally, the scene is viewed from above, as though from a box to the side of the stage, which causes the picture to be composed on a diagonal that vanishes into the darkness at the back of the stage. For the rehearsal, we are without the bright lights or the color of the scenery. The overall toning is in browns. Some of the figures waiting on the side show marked signs of tension or fatigue. The resting figures also seem to be smaller since they are duck-footed rather than up on their points.

Edgar Degas
Petite Danseuse de Quatorze Ans or Grande Danseuse Habillée
(Small Fourteen-Year-Old Dancer or Big Dancer, Dressed), modelled in 1881 in bronze and cast in 1950 from a wax, shown at the Sixth Impressionist Exhibition of 1881

This is a childish figure, flat chested and with skinny legs yet with the inner absorption of an adult, preparing herself mentally for a demanding and disciplined effort. The yellowing material of the tutu and the satin ribbon of the ponytail give the figure a sense of lost childhood, like a doll you might find years later in an attic. This is not the effect of the original. It would have developed since casting, but it does not seem at all at odds with Degas's feeling for the subject.

Edgas Degas
Difficult Poses: wax studies cast in bronze after Degas's death

A large number of these studies are of women in difficult or nearly impossible positions. Certainly their poses would be impossible to hold for very long. (Try!) Apart from a few balletic poses, there are balancing acts, which look like ballet dancers trying things out and a number of studies of someone holding or trying to get something out of the foot. The more relaxed poses are of women bathing or putting on their shoes.

Degas's less well-known fascination with horses is represented in the sculpture cases as well as on the walls. The horses are racehorses and frequently are studies in motion. They illustrate the interesting characteristic of Degas that he studies and achieves forms of beauty and anatomy without feeling any need to idealize the subject.

Edgar Degas
Course de Gentlemen avant le Départ (Gentlemen Jockeys Lining Up)
 1862, redone in 1882
Le Champs de Course, Jockeys Amateurs près d'une Voiture
 (At the Races, Amateur Jockeys near a Carriage), 1878, finished
 in 1887

Each of this pair of paintings is a deliberate mix of industrial activity and recreation. The first rather roughly painted one of jockeys milling about at the start has chimney stacks fuming in the background and, in the middle ground scattered on the hillside, a picnicking crowd. The second focuses more on the jockeys and their horses. The horseman facing the left and another at the edge of the frame stop the general movement to the right of both jockeys. Beyond this center of attention, in the middle ground, is a rather brushed horizontal of spectators, and beyond that, a train and the town. In both pictures, the moment of excitement before the race is what animates the scene, with horses behaving unpredictably and riders turning in their saddles in their efforts to control them. Against this archetypal leisure activity, Degas has in each case painted in an industrial background. This impulse to comment and juxtapose labor and entertainment is a persistent theme of Degas.

Edgar Degas

Dans un Café ou l'Absinthe (In a Café or The Absinthe Drinker),
shown at the Second Impressionist Exhibition of 1876

The combination of the placement and color of the female figure and
of the objects – the water jug on a tray and the light-colored drink –
make the drinker and the drink clearly the central focus of this
work. The figure of the man is darker as is his drink and he is
looking out of the picture. It has been argued that the drink at the
man's elbow is his hangover cure – a mixture of black coffee and
soda – but the way it is placed makes it possible that it is hers, not
his. He does, however, look the type to be in need of regular
hangover cures. The dress of both suggests that they are either down
on their luck or ploughing meagre incomes into drugs. Absinthe was
comparable to the hard drugs of today. Its almost hallucinogenic
effects were warned against, its flavoring substance – wormwood –
had sinister connotations and it was much consumed by the
working class whose tendency during the 19th century to rebellion
was considerably feared by the ruling classes. Public campaigns
against absinthe therefore emphasized its degrading effects and
became another means of urging temperance on the working classes.

There is nothing at all convivial about the drinkers. The woman
seems to be in another world. Impressionist painters may have
pursued the realist taste for putting the lives of ordinary people
into their paintings but each did it in a different way. In Degas's
case, he may be dealing with ordinary people but he shows this
woman locked in an inner world of suffering. She is isolated. She
has dressed to go out. She is sitting alone with her drink, thinking
to herself. She is in a brown, black and dirty white scene. The
white background is of street curtains reflected in a mirror.
Paralleling her isolation is the detachment that the painter achieves
from taking a high-angle view. The central message is that we are
each of us alone.

Edgar Degas

Madame Jentaud au Miroir (Madame Jentaud at her Mirror), 1875

This is a very curious portrait in that the subject has vanished in the
mirror; or if this is not a vanishing act, there is some sort of
transformation. The profile of a subject on the right side is painted
in a fairly standard portrait manner but the rest of the painting –
including the face in the mirror – is rough with rough brush

stroking and very little detail. The look on the face in the mirror is not what you would expect from the face looking in the mirror. Since we must suppose this to be deliberate rather than the result of any ineptitude, we have a puzzle. The label indicates that she was a friend of Degas. She was 21 at the time. Did they share some private joke that we don't know about? Is he predicting how she will age?

Edgar Degas
Les Repasseuses (The Laundresses) 1884–1886

The yawning and stretching ironing woman is clearly an image of the working-class Parisienne – not simply because of her job but also because of the rounded face and snub nose. The subject probably attracted Degas because he could make a picture of a woman not caring much about her looks and not posing for any kind of conventional painting. Even the fatigue is that of someone who is going to stretch and yawn and pull herself together and get on with the job rather than that of the more pampered classes who can stop and rest as soon as they feel a bit tired. Soon, in fact, she will return to the work being done by her fellow worker, the color of whose clothing parallels that of the heat from the stove in the background, used for heating the flat irons.

The surfaces – especially on the main figure – are considerably flattened and the expanse of the ironing table in front is seen from a relatively high angle. The absence of much background detail tends to isolate the more solid dimensions of the yawning head. It looks like an anonymous workspace.

Edouard Manet
La Serveuse de Bocks (Barmaid Serving Beer), 1878–1879

The waitress is serving big pots of beer in a cabaret. The composition could be read as being divided down the middle. On the left, starting from the bottom, the space is filled by bourgeois figures, as can be seen by the top hat and the glimpse of the show they are watching. The actress is in white and cut vertically so that she is only half in the frame of the picture. On the right side of the picture – and again working vertically from the bottom – is a black figure in a worker's or artist's smock. Immediately above that are the chubby pink face, white blouse and golden beer pots of the waitress who also wears a bright earring. The golden beer color begins a diagonal at bottom right that is completed at the top left

Degas's The Laundresses

by the white dress of the performer. Framing the head of the waitress is gaily-flowered wallpaper.

The focus of the painting is therefore almost entirely on the waitress. Only she faces us and is fully visible. Only she enjoys the favor of bright colors – unless you count the half-obscured performer. In essence the female workers are set in high contrast to the mainly – but not exclusively – male and bourgeois audience.

Edouard Manet
Oeillets et Clématites dans un Vase de Cristal (Pansies and Clematis in a Crystal Vase), 1882

Flowers were an essential subject for many Impressionists. Renoir and Monet used them incessantly and Manet frequently. They are a recurring theme in art through the ages. In this still life, Manet actually avoids what we come to expect, his favorite black. Perhaps that is in recognition of the fact that black does

not occur in nature. The shadows are in blues and greens. The background is lilac – a flower color in itself. One of the problems of painting flowers is that they are difficult to paint without looking like artificial flowers. The real thing is beyond the truth even of photographers. To some degree, the Impressionists in general and Manet in this work get around that by making the painting a study in fleetingly applied color. There is only a very general indication of form. By putting the flowers in a crystal vase, so that we can see their stalks, Manet has made sense of the arrangement and given these flowers, which are not usually those associated with formal arrangements, a presence that the blooms alone would not have.

Room 32

Pierre-Auguste Renoir ☆
Le Balançoire (The Swing), painted in 1876, shown in the Third Impressionist Exhibition in 1877

The woman might well be wearing her favorite dress: you might recognize the back view of it in *A Dance at Moulin de la Galette* (in this room). She is one of a group of people on an outing in public gardens. Sunlight dapples the ground under the trees. There might be more light than there should be. The sunlight on the dress disturbed some critics of the day. One even described the effect as "bizarre" and complained that it looked as if the model had "spots of grease" on her clothes. The girl with the blue bows is smiling, apple-cheeked, and has flowers in her hair. The paint is especially thick on the girl and on the ground: the ground beside the girl looks like a section from Monet's late *Waterlily* paintings. The depth of the path is created by pink and white circles on a blue ground. This painting is one of those memorable images of youth that evokes our own memories.

Nearby, there are two portraits by Renoir of women who were known in the French cultural circles of his day. Their personalities are suggested, especially through the use of color. However, we move on to:

Pierre-Auguste Renoir
Etude au Torse, Effet du Soleil (Study of a Torso, the Effect of Sunlight), painted in 1875, shown in the Second Impressionist Exhibition 1876

If anything, Renoir's female bodies became fuller as he aged. This is mainly a study in pink and blue flesh. Again, some 19th-century viewers failed to understand Renoir's use of dappled light. It had rarely been applied to flesh before, and one critic scoffed at the "green and violet spots which denote the state of complete putrefaction of a corpse"!

The background is sketchy and smudged. It comes across as a wilderness. The figure itself seems to be emerging from white drapes around the hips, as though this scene is some sort of everyday *Birth of Venus*. The chief subject − the flesh − radiates. It is firm, bright-skinned, and wholesome like fresh apples and peaches. There is an innocence pictured here. She seems not just good-natured but relaxed and happy. It is as though the sun has cured all ills. This could be Eve in the Garden of Eden − but in a spot where there are neither Gods nor Adams to disturb her.

Pierre-Auguste Renoir
Chemin Montant dans les Hautes Herbes (Path Rising through Tall Grass), 1872–5

This painting belongs to a world when a weekend outing or a summer holiday was a trip to the country that seemed to last forever, and yet was all too quickly over. It is as though it is something in the memory of one of the children in the painting, who could have thus described the scene: "The track seemed to plunge down the hill and vanish in the grass. The trees were planted in rows. There was a red sunshade. All the older people lagged behind and were still a long way back. You could just see them if you looked back. You could see a big poplar too, at the top of the path. The path curved around through the trees and there were tall, colored flowers standing above the grass."

Pierre-Auguste Renoir☆
Bal au Moulin de la Galette (A Dance at Moulin de la Galette), painted in 1876, shown at the Third Impressionist Exhibition of 1877

The Moulin de la Galette was an outdoor venue for Sunday dances at a windmill in Montmartre. A *galette* is a pancake; they used to be made and sold there. The weekly Sunday dance started at about three in the afternoon and would go on until midnight under gaslight. These white gaslights form the upper limit of

Renoir's painting but it is still daylight and sun is filtering through the trees.

A friend of Renoir's and a critic, Georges Rivière, identified a lot of the people in the painting as either friends of Renoir or young women who frequented the dances and whom Renoir persuaded (with some difficulty) to pose. Rivière's account stresses that the women who were persuaded to act as temporary models were simple and honest working girls. Rivière himself is the young man with the straw hat sitting in the right corner with a couple of painters. He is identified as a writer by the pen in his right hand. Of the two women in the foreground, the one in black is the model used in *The Swing* and the one seated in the striped dress is her younger sister. The woman wearing the dress that features in *The Swing* is a Renoir model named Marguerite Legrand. She is dancing with a Cuban painter named Solares.

Renoir evokes the atmosphere and tone of a popular dance place. The dancers are enjoying themselves without any great pretensions to elegance or posturing. As an image, it shows the determination to idealize the qualities of vigor and innocence the painters saw in ordinary Parisians. To the modern viewer, it seems a more innocent age.

The composition, with so many figures moving freely, is an ambitious one. It is somewhat calmed by the almost full circle of lighter colors that can be traced from the gas lamps down to the highlighted dancing couple, across to the striped dress in the foreground, back up through the dapples of light and the seated figure, on to the gleam of the glasses and bottles, the gold of the hats and back to another substantial gas light.

Pierre-Auguste Renoir
Daughter of a Restaurateur from Chaloui

This is a simple portrait, intended perhaps to convey that the daughter of the restaurateur is a simple, pleasant young woman. She is identified as Alphonsine Tournaise (1845–1939). Her table locates the restaurant. Behind are the river, a bridge and a boat. Her simple appearance is given a bit of dash with a red hatband. She is a very relaxed figure in a very relaxed place. What is presumably being evoked is an aspect of the artist's life – pleasant summer days spent out by the river, lunching and wining.

MUSÉE D'ORSAY: THE IMPRESSIONISTS

Alfred Sisley
La Barque Pendant l'Inondation, Port Marly (Boat During the Flood at Port Marly), 1876

Painting a flood suggests that Sisley was a determined open-air painter. The apparent realism of the scene is pinned down by the lettering on the walls. At the time, Port Marly was a semi-rural area along the Seine. Both Sisley and Pissarro painted in the locality. The flood has the advantage that it allows for a simplified composition. The water is divided from the clouds by a line of closely pollarded trees. Cut level at the top, they give a tight horizon and indicate the season. A necessarily limited amount of activity in the boat serves to make the scene still and calm, as sometimes happens when a flood has come to its peak.

Camille Pissarro
Côteaux de l'Hermitage Pontoise (From the Hillside at Pontoise), 1873

This is one of several Pissarro paintings in these rooms that were done during the 25 years he spent in Pontoise. Unlike scenes of country life such as one finds in Monet, Renoir, and Sisley, these are genuine-looking scenes of peasant life. The hunched-over peasant in his baggy pants is probably a genuine figure looking at his vegetable patch while some poultry peck about nearby. The stone walls and stone houses are neither romanticized nor formalized. The steeply sloping fields and the church or tower to the right hem in the scene. Cézanne spent time at Pontoise learning from Pissarro. It is easy to see in this painting the sorts of places Cézanne painted and some of the greens and oranges that he typically used.

Camille Pissarro
Paysage à Chaponval (Countryside at Chaponval) 1880

The conventional horizon line is formed by the zig-zag blue roofs of the village. Note that instead of sky, it is the hillside that encloses the village. The blue of the roofs is picked up by the foreground figure of a girl in blue minding a cow. She too is hemmed in by the tall tree occupying the left side of the canvas. Forms and perspectives are brought out with thick textures that give form – and sometimes chunkiness – to the landscape.

Camille Pissarro☆

Jeune Fille à la Baguette (Young Girl with a Stick), painted in 1881, shown in the Seventh Impressionist Exhibition 1882

The peasant girl in blue seems to be idling in the sun. She is probably minding a cow, an occupation conducive to periods of idling. She could well be the same girl minding the cow in Pissarro's nearby work *Paysage a Chaponval*. It is likely that she is a cowgirl and not a model. She is resting against a background of green and gold, which again suggests some of the origins of Cézanne's palette. Cézanne was a difficult and testy character and Pissarro was one of the few friends patient enough to put up with him. Their periods of time together had a lasting and perceptible effect on Cézanne's use of color and his taste for rustic settings.

Claude Monet☆

Le Déjeuner (The Luncheon), painted in 1873–74, shown in the Second Impressionist Exhibition, 1876

The title alludes to past activities in the garden. There are many signs that the luncheon is over. The bread has been broken and left in bits; the wine has been drunk; the fruit is out; the coffee is finished. The female figures, right background, have apparently finished lunch. Someone has left her parasol and a basket shaped like a handbag behind on the bench. A sun hat is hanging from a tree, like a large flower. They've gone for a short stroll around the garden, leaving the child to play alone beside the table. The abandoned lunch spread occupies the center foreground. The table and its remains of lunch are in shadow, as is the path on which the two women are strolling. The band of sunshine across the picture falls on the red flowers, the roses and the yellow gown of one of the women. The one of the left could well be Camille, Monet's model, mistress, and later first wife. The hat and the rose hanging from the tree help to close the top of the picture and bring the center ground of sunlight and women's dresses well forward. This element of the composition partly overcomes or at least balances the importance of the table.

The layout of the garden suggests the studied care that Monet would lavish on increasingly large and ambitious gardens until his death at Giverny some 40 years later. The flowers have been planned to give a co-ordinated display of color in summer. It is likely that Impressionist paintings – especially Monet's – have played a considerable part in the development of more recent ideas

MUSÉE D'ORSAY: THE IMPRESSIONISTS

about and passion for gardening. This may be a reason why Impressionism – and especially Monet – remains so popular with modern audiences. Florists even today actually sell flowers arranged in the Impressionist manner.

Claude Monet
Les Déchargeurs de Charbon (Men Unloading Coal), 1875

Monet's picture of coal barges being unloaded might be the most frank image of industrial France in the whole Impressionist *oeuvre*. The detail is unrelentingly hard and grimy. A steel bridge stalks across the top of the frame. Through its shallow arch in the distance are tall smoke stacks and squat functional buildings. The coal barge is anchored in green water and is being unloaded across the planks laid from the barge into the riverbank. The planks are kept in stark parallel lines to indicate the repetitive and harsh nature of the work. The three laborers in the foreground, returning to the barge with their baskets up-ended on their heads, seem like stereotypes of laborers, conveying the impression that they will be going up and down all day – or until the job is done. The general coloration is of black coal and dark colors. Given Monet's propensity for having a scene correctly arranged before he painted it, one wonders how he arranged for this painting.

Claude Monet☆
Gare St-Lazare (The St-Lazare Railway Station), painted in 1877, shown in the Third Impressionist Exhibition

Renoir relates that for one of Monet's paintings of Gare St-Lazare, the painter dressed up to approach the stationmaster for assistance. The stationmaster agreed to have one of his engines stand in the station emitting smoke and steam while Monet painted it. Certainly, in this picture of the St-Lazare station, the engine appears to be stationary and releasing steam from its sides. The bridge in the middle distance, lined up with the top of the funnel, is the Pont de l'Europe, which features in several paintings by Monet and Caillebotte. Both the background buildings and the station itself are part of Haussmann's gigantic town planning clearances and building from the 1850s to the 1870s. Although some intellectuals, such as Victor Hugo, objected vigorously to the destruction of old Paris, several of the Impressionists relished romanticizing the new Paris. The overall

composition of the view of the station is fairly unusual in painting because it is almost completely symmetrical. The glass roof gable is in the center and the top of the bridge intersecting with the vertical divides the upper half of the canvas into two squares. The symmetry of the lower part of the painting, below the bridge line, is varied only slightly by the position of the locomotive.

The general tenor of the view is one of comparative tranquillity rather than hissing engines and dangerous heavy objects hurtling along the tracks. The blue smoke from the engine is a clear, tranquil blue. Many of the clouds of steam are as white as clouds in the sky. The buildings in the background are catching the sun. So too are the tracks in front of the engine. The steel roof is supported by very thin columns and held together and framed by girders that look light. The metal work already belongs to that light and decorative use of iron that will characterize the era well into the 20th century, until steel and concrete take over.

Claude Monet☆
La Rue Montorgueil, Fête de 30 Juin (Celebrating June 30 in Rue Montorgueil), painted in 1878, shown in the Fourth Impressionist Exhibition of 1879

Rue Montorgueil is in the Second Arrondissement, off Rue Etienne Marcel between the Rue du Louvre and the Boulevard de Sebastopol. In this picture the flags are out and fluttering. It is a popular occasion and people have been induced to get flags and wave them out of their windows or to hurry into and down the street. There are so many flags waving from the tall buildings that the picture gets a Gothic upward sweep, like a big shout out into the open sky. Up close, the figures are schematic; step back and they are fluttering down the street in a wave of good-humored patriotism. Since Monet couldn't paint this scene quickly, and couldn't have arranged for the scene to carry on for long enough to be painted, this has to be a work largely of the imagination.

Room 33

Pierre-Auguste Renoir and Richard Guino
Le Baigneuse (The Bather) and
Le Jugement de Paris (The Judgment of Paris)

MUSÉE D'ORSAY: THE IMPRESSIONISTS

Late in life, Renoir's hands became so painful from the effects of arthritis that in order to paint at all, he had to have his hands bandaged and a brush stuck in the bandages. Despite this, he developed an urge to sculpt. He resolved the problem by working with a young Italian sculptor, Richard Guino. Renoir would hover near the sculpture indicating, with a stick bandaged to his fist, where the next sculpting motion should be made and Guino would translate the thought. The results most often were of bouncy chubby female nudes in classical settings. Some of Renoir's favored painting subjects were stocky young country girls with big hips and small breasts. He did not move too far away from those images in this sculpture of the bather.

The story of the Trojan prince Paris is at the beginning of Homer's *Iliad*. Paris was asked to choose the most beautiful of three goddesses – Hera, Athena, and Aphrodite. He gave the prize, an apple, to Aphrodite who helped him to abscond with Helen, the wife of the King of Sparta and the most beautiful mortal in the world. This naturally led to both Hera and Athena, who didn't get the apple, becoming his implacable enemies. The pair went into battle on the side of Menelaus and the Spartans.

The works themselves suggest firstly that Renoir was dissatisfied with having to model his very rounded figures on flat surfaces with paint, and secondly, that he wanted to tread overtly into classical territory rather than expressing classical values through pictures of women among flowers. This desire is dramatized by these collaborative sculptures. It is doubtful that the mythological narrative of *The Judgment of Paris* could have appeared respectably in an Impressionist exhibition, because for Impressionists in general, classical subject matter scarcely figured, even though classical aesthetic principles continued to be honored. This difference in subject matter was a key marker of Impressionism. Devotion to classical learning and classical analogy, however, continued to dominate other schools of painting and was common in the literary works of the most ardent admirers of Impressionist paintings. Degas even wrote sonnets containing classical illusions.

Room 34

Claude Monet☆
Meules, Fin de l'Eté (Haystacks at the End of Summer) 1891

Monet pursued the subject of haystacks to study the effects of

light: the subject is treated essentially as an abstraction. There are no laborers or other figures. The forms of the haystacks are defined by light against horizontal layers of sky, hills, trees, and the mown field. The colors he has concentrated on are the complementary blues and oranges. Orange is complementary to blue because it mixes red and yellow, the other two primary colors. There are both blue and orange shades in the haystacks and the shadows are blue. Using complementary colors to represent shadows was one of the noted techniques of the Impressionists. The light here is strong, almost white light.

The next selection is a number of Monet pictures of the Rouen Cathedral. The arrangement and selection of them at the Orsay may differ from time to time.

Claude Monet☆
La Cathédrale de Rouen: Le Portail, Soleil Matinal (Rouen Cathedral: The Doorway in the Morning Sun) 1893

La Cathédrale de Rouen: Le Portail et la Tour Saint Roman, Effet du Matin, Harmonie Blanche (Rouen Cathedral: The Doorway and St Roman's Tour, Morning Effects, Harmony in White) 1893

La Cathédrale de Rouen: Le Portail, Temps Grise, Harmonie Grise (Rouen Cathedral: The Doorway in Grey Weather, Harmony in Grey) 1892

La Cathédrale de Rouen: Le Portail, Soleil Vu de Face, Harmonie Brune (Rouen Cathedral: View of the Doorway in the Sun, Harmony in Brown) 1892

Monet's capacity to become obsessed with a single subject is evident here. The older he got, the more obsessed he seemed to become with repeated views of changing surfaces and depths. His titling suggests, in fact, that light and its effects are his subject. But this is too simple. Change itself has become the subject. Meditations on the meaning of change inevitably challenge the reliability or even the validity of memory. Since change can only be calculated against memory and memories manifestly become distorted, change is a challenge not simply to our perceptions but to our identities. Interestingly, perhaps the greatest writer in Monet's lifetime, Marcel Proust (1871–1922), took the problem of memory as the central subject of his massive masterpiece.

By positioning themselves staunchly as recorders of the moment, the Impressionists are inescapably also recorders of the

past. Thus they give us both the pleasure of recognition and nostalgia for things lost. Aware of this intrinsic contradiction, Monet in particular set out to give a more encyclopedic account by creating many presents for the same subject. Renoir by contrast saw the impossibility of capturing the present and looked around for enduring pictorial values.

Pierre-Auguste Renoir
Danse à la Campagne (A Country Dance), 1883

The scene of dancing in the country persists with Renoir's perception of the country as healthier, more informal and more enjoyable. The man has lost his hat and the girl is a big, lively working girl. She faces out towards us. We can also see the man's face in profile. The girl is wearing golden gloves but the man none. A convivial table is in the background and the tree is a real one. The style of the dancers has some vigor to it – not quite a polka but good fun.

Pierre-Auguste Renoir
Danse à la Ville (*A Town Dance*), 1883

As a companion piece to *A Country Dance*, this work portrays a jaundiced view of the city. The pair are formally dressed, the woman quite expensively. They do not touch. Both wear white gloves. We see the half of the girl's face. The man's face is concealed. The palms behind are potted. The dancers seem from the careful arrangement of their dress to be scarcely moving. The message seems to be that the trappings of elegance come at considerable human cost.

Pierre-Auguste Renoir
Jeunes Filles au Piano (Girls at a Piano), 1892

The setting is the house of a wealthy family. The room in the background has paintings hanging on the walls. The girls are well and carefully dressed. They are however, seen as innocents within this setting, intent on their playing. Their round faces, red cheeks, golden and auburn hair make them recognizable as Renoir models. There is also something of the atmosphere of popular writing of that period, such as Louisa May Alcott's *Little Women,* that idealized such activities and the relationships that were formed by

them. Moments rather than lives are tinged with such carefree happiness. Renoir has captured the moment and presented it to us on the canvas.

Claude Monet
Essai de Figure en Plein Air, Une Femme à l'Ombrelle Tournée vers la Gauche (Study of a Figure in the Open Air, Woman with an Umbrella Turned towards the Left), 1886

This is one of a pair of studies of form and light on a windy day. The woman hovers between field and sky, held down from being blown away by the green umbrella. The wind causes the grass and the dress and the clouds to stream upwards across the surface. The viewpoint is down the hill and she is shielding her face from the wind and sun. Its companion piece, where she faces in the opposite direction, is usually hanging alongside.

You can now proceed directly to Trail 2, which continues with the next rooms in this museum.

MUSÉE D'ORSAY: THE IMPRESSIONISTS

TRAIL 2:
Post-Impressionists

Within the Orsay, Rooms 35–44 move into a period of transition between Impressionism and various painters and groups of painters who were lumped together under the vague title of Post-Impressionists. The three major figures of Post-Impressionism are Vincent van Gogh, Paul Cézanne, and Paul Gauguin. Also well-known are Georges Seurat and Paul Signac. Apart from the very bland name conferred on them by art historians, they have in common a knowledge of Impressionism and Impressionist painters and they further developed some key Impressionist ideas. They are however, very different from each other – as indeed were the Impressionists themselves.

This Trail will take a good half-day or more. It can be seen in conjunction with the previous trail on the second day. If you just wish to get an overview, you can view the starred entries in less than an afternoon.

Room 35

Room 35 at the Orsay is devoted to van Gogh. It covers a narrow band of years from about 1886 to 1890 when, perhaps, despairing at his chances of recovery, he killed himself in Auvers-sur-Oise. If you can get into a vacant chair – after the unrelenting preceding rooms – position yourself to look along the left side of the room as you enter. Notice that in those few years his colors became very vivid and his brush strokes more and more serpentine. The paintings from 1886–87 were painted in Paris, more or less within the Impressionist atmosphere. After that, he left Paris for Provence and then Auvers and was painting well outside any recognizable Impressionist style.

Vincent van Gogh

Fritillaires Couronne Impériale dans une Vase de Cuivre (Flowers in a Copper Vase), 1886 or 1887

This work of van Gogh's uses the thickly laid-on paint and the color separation that several other Impressionists used. (By separation, we mean that the constituent colors of an object are laid down side by side instead of being mixed. This would become the chief preoccupation of Seurat and Signac.) Van Gogh was not using this as a way of conveying impressions of light and keeping the canvas bright – he was using colors to define shapes or forms. The flowers are quite still in the vase. Whereas Impressionist flowers are often shown as though they had reached their peak and are about to drop, these are shown in in their idealized form. The vase is deformed but the reason for that is not clear. The background anticipates things Van Gogh would do a lot more of later. He uses a deep cobalt blue and covers it with some agitated white spotting.

Vincent van Gogh

Le Restaurant de la Sirène à Asnières (The Restaurant La Sirene at Asnières), summer of 1887

Asnières was once a popular village by the Seine and on the edge of Paris. It is now almost an inner suburb. The painters frequented it for relaxation, lunching, and finding picnic-like situations to paint. For van Gogh, this is a peaceful painting. Its horizontal brush stroking is soothing and although the particular interest is not in the effects of light, it is plainly of a warm summer's day when the sun takes a lot of the color out of pale or white surfaces. The shadows – such as on the side of the building next to the restaurant – are constructed of separated complementary colors. Identifying the restaurant by name – in the painting and not just in the title – tends to reassure viewers that the painter is in the same world as they are and that the artist is painting real places.

Vincent van Gogh

Nature Morte ou Roses et Anenomes (Still Life or Roses and Anenomes), painted in Auvers-sur-Oise in June 1890

This much flatter still life of flowers comes from 1890, the year of van Gogh's death. The colors are less vivid. They are bright and decorative in the manner of Gauguin or in the style of the Japanese painting that

was much admired at the time. The principal surfaces – the table and the vase – are both flattened and deformed. The flowers are painted as forms either individually or in groups. One flower has fallen, a detail that brings the flowers a little out of the world of abstraction and into a world of forms composed by line and color.

Vincent van Gogh☆
Mademoiselle Gachet au Jardin (Mademoiselle Gachet in the Garden) and *Dans le Jardin du Docteur Gachet (In Doctor Gachet's Garden)*, painted on consecutive days in mid 1890

The two paintings of the Gachets' garden were done at the end of May and on the first day in June 1890. Mademoiselle is the doctor's daughter Marguerite. Doctor Gachet lived in Auvers-sur-Oise, not far from Paris, and if you go there, (see page 213) you can see where the garden was. Van Gogh has shifted from defining form by color to defining it by texture. The figure of Mademoiselle Gachet is made from extremely thick paint strokes. This subject is a frequent one of the Impressionists, and viewed from a distance, could be taken as a domestic study on a pleasant if somewhat windy day. Close-up, the figure of Mademoiselle Gachet and parts of the garden are thick with paint.

The other view of the garden's edge by its bright orange wall is much darker than its companion. The poplars have become serpentine in the wind and the heavens are violent. The world beyond the wall looks more mundane. Within the garden, the leaves and trunks of plants are drawn with dark outlines as in, say, lead lighting. Before you read too much into the agitation – say of the poplars – it is worth remembering how trees look in a persistent wind. There is considerable realism in van Gogh's landscape.

Vincent van Gogh
Portrait de Docteur Paul Gachet (Portrait of Doctor Paul Gachet), painted in Auvers-sur-Oise at the beginning of June 1890

As well as being a doctor, Gachet was a painter and a collector. (The Gachet collection lies ahead in Room 41.) For all the surface flattening and the brilliance of color, the picture survives as a portrait. Unlike portraits by, say, Picasso, the study still looks like someone you might know. He has a look of professional forbearance on his face that might well have described, in part, his relationship with the unfortunate van Gogh. His coat is painted in

the serpentine manner – in this case, too, to give it the homely rumpled look of a countryman. The two blues of the flat background suggest a hill and the skyline. They are from a most beautiful part of van Gogh's palette, reminiscent of 12th-century stained glass and Limoges enamel.

Vincent van Gogh*
L'Église d'Auvers (The Church at Auvers), painted in Auvers-sur-Oise at the beginning of June 1890

The dark outlining and the deep glowing blue give an effect close to stained glass. To ways of defining forms through color and texture, van Gogh has added motion. The paths and the grass in front of the church take part in an upward motion. The figure on the path is sketched in except for the dress that can be painted as movement. The windows and buttressing of the church are tilted off the vertical and thrust upwards as Gothic buildings are meant to do. The enamel blue from the inside of the church matches the blue of heaven outside. In this vision, the church seems organic. It is common to describe van Gogh's painting as the product of inner turmoil. Perhaps, but we should not overlook its faithfulness to its subject and its spirituality.

Vincent van Gogh*
Portrait de l'Artiste (Self-portrait), painted at Saint Remy de Provence at the beginning of September 1889

Van Gogh's taste for self-portraits is demonstrated by there often being two hanging in this room. The question inevitably arises whether, in this one, he is showing a consciousness of his own deteriorating mental state. The gaze is not remarkably different from that in other portraits but certainly it is more anxious. The texture and agitated surfacing that van Gogh had developed by then undoubtedly make this portrait disturbing. Around the comparatively still face is a turbulent world. A blue background is no surprise in van Gogh but a light blue one is surprising. There is light blue in the background and on the clothing, everywhere except the head. The uniformity of coloring is a statement that the surface is flat even though some detail of the clothing can be indicated by line. It is also a device that isolates the head. Some of the strokes on the background are so circular that they really take the form of the volutes that you often see in architecture.

Vincent van Gogh

Chaumes à Cordeville (Thatched Roofs), painted in Auvers-sur-Oise mid-1890

This work was formerly thought to have been of a similar subject at Monteil. At first sight, the subject seems ideal for van Gogh's turbulent lines and textures. The thatches are really old and sagging, the trees behind wrestling with the clouds. Yet other aspects of the real world are treated quite directly. The content of the vegetable garden is straightforward and unromantic. The nearby rooflines of obviously newer houses are strictly drawn straight lines and triangles. We must speculate from this that van Gogh's painted world is not simply a world of the mind. As so many painters do, he often ferreted out suitable subjects and waited for suitable times.

Vincent van Gogh

La Méridienne or La Sieste après Millet (Afternoon Nap or *The Siesta after Millet)*, painted in Saint Remy in December 1889 and January of 1890

A couple of Millet's peasants are snoozing under a Monet haystack. Their clothing and the straw under their heads is writhing as is the upper sky but the sleeping figures and the grazing animals are still. The flooding sun comes from a concealed source to the right beyond the haystacks. Millet famously idealized the simple, honest, devout peasant. Monet only wanted to focus on light when he painted haystacks. What are van Gogh's quotations trying to say? That hard, honest labor deserves its moments of peace? Possibly, as he was religious. That moments of a summer's day lead us into a dream world? That if you fall asleep in the shade, there are wonderful worlds at the edge of consciousness? (See how, in this picture, the eye travels out into the sunlit world beyond.) Or perhaps that, in the simpler life, there are perfect moments?

Vincent van Gogh☆

Portrait de l'Artiste (Self-portrait), painted in Saint Remy in December 1889 and January of 1890

Here van Gogh used some of the techniques of Impressionism. Brush strokes are used to define shapes; colors are separated into dashes laid down one beside the other; his ginger beard and hair has blue shadows; highlights are in white. The blue-green

background could be found in Monet or Renoir. This is a somewhat anxious face, but it is also the face of an enthusiast. We know from the rest of his *oeuvre* that van Gogh learned quickly and changed quickly.

Vincent van Gogh ☆
La Chambre de van Gogh à Arles (van Gogh's Room in Arles), 1889

The difficulties of viewing this picture arise from trying to figure out what the logic of the viewing perspective is. It can be taken as an honest view of a room that exaggerates the foreshortening. Perhaps that is meant to give it a tunnel effect. Exaggeration comes mostly from the floor lines and the angle from which the chairs are viewed. The "van Gogh" chairs considerably raise the angle of view. The table by the bed is less foreshortened and is also set at an unusual angle for a table in a room. Overall, there does not seem to be a logical position for a viewer who expects a consistent perspective.

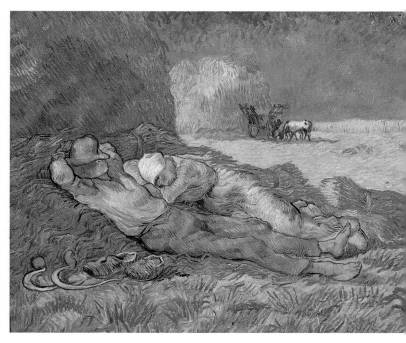

van Gogh's **La Méridienne**

Room 36

Room 36 contains works by Paul Cézanne. Each movement in art, as in philosophy, strikes its own balance between what is permanent or ideal and what is apparent and of the moment. It is a slippery downhill path when artists elaborate one of these aspects at the expense of the other. A lot of French painting and sculpture in the 19th century was in such a decadent state. The elaboration of meaningless classical ideals was one thing that the Impressionists rebelled against.

Paul Cézanne's painting works overtly with the tension between permanence and appearance. (Braque and Picasso carried this interest in permanent form into abstraction.) Cézanne developed his painting styles along with the Impressionists and particularly with Camille Pissarro, who was an honest painter of country and city life. His unromantic perceptions of the country and significant aspects of his palette remained with Cézanne.

There are two points in the room from which to look at these paintings. From the wire below each painting, you see Cézanne's geometric flattened surfaces; from the chairs, you see these abstracted but not yet geometric forms fall into the illusion of space. The message seems to be that objects expressed in their inner form will be composed into a reality by the eye. Cézanne was working deliberately to achieve these effects.

Paul Cézanne☆
Nature Morte à la Boulloire (Still Life) 1869

For this still life, Cézanne has used black, a favorite of Manet's, to put a bit of perspective into the work. The table that hovers without clear support is given a thick angular edge by a black shadow. It otherwise might seem as flat as the background. If you cover your view of the right side of the painting, the rest does look quite flat from close up. The shadow of the pot leaks over the table in a sinister fashion to join other shadows cast by the dangling cloth. The objects on the table are in the round except for the mouth of the jar. It appears tilted forward, perhaps to avoid the need to put another light-colored object against the wall to hold the focus of the painting.

Paul Cézanne
Dahlias, painted at Auvers about 1873

Cézanne's *Dahlias* take us back to his Impressionist days. The subject matter is direct – a vase of flowers composed for its color

and the harmony of its overall composition. It does depart from much Impressionism, however, with its parallels to the hyperrealism of still life in earlier Flemish painting. The brush strokes are essentially defining the shapes of the flowers without any special concentration on their effects of light. The background is neutral – two dark surfaces meeting at a blurred edge. The design of the vase and its oriental style is a significant section of the painting, possibly because as a solid object it matches the solidity of the dahlias. The background flowers and foliage are painted in a more Impressionist manner.

Paul Cézanne
Nature Morte à la Soupière (Still Life with a Soup Tureen), 1877

A distant view reveals several perspectives at work simultaneously. In particular, the tabletop is tilted forward relative to the other objects on it, which themselves do not all occupy the same dimension. The fruits, which should roll off such a tilted surface, are more circular than globular. The paintings in the background fit the eye line of a seated person. The total effect is to isolate each object in its own dimension. The tureen is in the style of many vases used in paintings of the period.

Paul Cézanne
Le Vase Bleu (The Blue Vase), 1885–87

The *Blue Vase* is a telling demonstration of the difference between the close-up and the distant view. Up close, the picture seems to be composed of quite a flat pattern of forms detached from one another. Only two objects – the vase and the plate – overlap. Even the flowers are detached rather than massed. The fruit (are they peaches?) are only slightly modelled by color but the delicacy of their color is finely observed. The gentle blue background offers no comment. The world outside the still life is marked by a vertical in the same color as the table. When you step back from the painting, it acquires a quite comfortable depth of field without any obtrusive distortions. The detachment of various parts becomes more evident even though the space they are set in has become more persuasively natural.

Paul Cézanne
Cour de Ferme à Auvers, 1879–80

The view of the farmhouse glimpsed between two tall almost colorless verticals defies the conventions of composition. The farmhouse and the landscape of trees and sky above it are reminders – both in their color and in their subject matter – of Cézanne's association with Pissarro. Cézanne's scene, however, has no people in it. It is a view of forms, of trees and buildings, not one of activities or of times of day. The colors of stone and of green countryside were to persist in Cézanne's work no matter how formal he became in the analysis of shapes of objects in space. The very intrusive verticals on each side of the foreground are presumably the walls of rather featureless farm buildings.

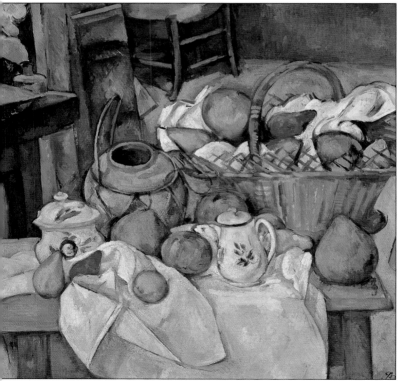

Cézanne's **The Blue Vase**

Paul Cézanne☆
Rochers près des Grottes au-dessus de Chateau-noir (Rocks near the Caves above Chateau-noir), 1904

This is one painting that does not fall into any more of a pattern as you distance yourself from it: it is a tangle of trees and colors. The colors are mostly orange, blue, and green. They are put down in flat patches, each patch presumably marking a change of surface angle in the rock. The tree trunks are columns of differently colored rectangles. The foliage is arranged in geometric patches. Some Cézanne work is seen as a bridge between Impressionism and Cubism, as are works by Braque, Gris, and Picasso. As Cubism was getting under way in Paris, artists still used the analysis of real objects, unlike later developments in 20th-century Abstraction. This is of course a retrospective judgment on Cézanne's work, which did not itself develop into anything like Cubism.

Paul Cézanne☆
Baigneurs (Bathers), 1890–1902 and
Baigneurs (Bathers), 1890–1900

Male nudes were frequent enough in the Academic painting of the 19th century but the reformist painters – from Manet onward – confined themselves almost entirely to unclothed females. As happens so often in both Academic and Impressionist painting (sculpture was different) various forms of ablutions are the justification for the nudity. This is one of a number of compositions on this classical subject and comes across as a celebration of athletic young male bodies. Much of the surroundings are in characteristic blue, orange, and some green tones but the celebratory form of the composition is made by the predominantly white pyramid formed by the clouds and the bathers' upward gestures into it. The pyramidal composition however, is kept various by the postures of the men. One is a seated strong man; one is striking a pose; one is a tough athletic; one is shown leaping enthusiastically into his bathing, another is shivering. In the background are Dionysian figures prancing. The last reference might suggest Greek vase painting.

Paul Cézanne
Achille Empéraire, 1866–70

The subject is identified on the painting itself, on the top – *Achille Empéraire, peintre*. He lived from 1829 to 1898. If we weren't told, we

might think him a theatrical figure, perhaps an entrepreneur. A small figure with a big head and a big chair, he seems on a throne. This might have prompted Cézanne to inscribe his name as one might on a statue of a royal, especially as the name itself is so impressive. The face is very carefully barbered with both moustache and small beard but the care and attention does not hide the sadness in his expression and eyes. The legs protruding from the gown are pitifully thin but the placing on the throne, the decorative fabric, the careful and bohemian dress and the announcement of the subject's profession all count towards giving the strange figure both dignity and presence.

Paul Cézanne
La Femme à la Cafetière (The Woman with a Coffee Pot), 1890–95

The severity of the woman's face is paralleled by many details in the painting. The wall behind is covered with a number of carefully aligned paintings. Beside the coffee pot, a cup on a saucer has a spoon placed in it, dead center. The table is almost without its surface. Perhaps even the shadows have been swept off it. The woman's dress is painted in two shades of blue with symmetrical pleats above the waist, sharp pleats on one side and correctly complementary orange hands in the lap. The hairdo is severe and surmounts a housewife's face. The hand is modelled in planes of blue, red, and white. Having got this far in underlining the severity of his subject matter, Cézanne uses the flowered wall paper on the left, each flower dutifully separate, to indicate that the painting is slightly tilted in the frame. This could be for the same reason that Expressionist filmmakers – decades later – would shoot scenes on a tilt. At a simple level, it takes us out of the mundane but it also denotes the fictional nature of the narrative. Is this his wife? There is a portrait in Room 36 that looks like the same person.

Room 38

This room contains a number of Degas pastels. Some would argue that in an overall analysis, Degas was not an Impressionist, even though he exhibited with the group, and place him instead in another line, perhaps, of gifted draftsmen and social commentators such as Daumier, Goya, and Toulouse-Lautrec.

MUSÉE D'ORSAY: THE POST-IMPRESSIONISTS

Edgar Degas*
Ballet Dit l'Etoile (Ballet Called the Star), painted in 1876–77,
shown in the Third Impressionist Exhibition of 1877

Pastel is a good medium in which to see an artist's drafting and
coloring skills. Some of these pastels are justly among Degas's best-
known pieces. The dancer – lit by footlights and viewed from
above as from a box – has a white, mask-like face only slightly less
artificial than the tutus classical dancers are obliged to waft about
in. The work-a-day elements of the scene are half glimpsed in the
form of other dancers and a headless gentleman standing in the
wings. Juxtaposing the contrived grace of the dancer taking a bow
with the resting dancers and especially the somewhat sinister male
figure is an essential way for Degas to show his detachment. Has
the man already arranged to pick up one of the dancers? Has he
made the arrangement for someone else? Does this mitigate Degas's
own attraction to these girlish workers? Whatever else, this dancer
is all lightness and fragility.

Edgar Degas
Le Tub (The Bath), shown in the Eighth Impressionist Exhibition
 of 1876
*Après le Bain – Femme s'essuyent la Nuque (After Bathing – Woman
 Drying the Back of her Neck)* c.1895

It is interesting to remember that the first known female nude in
classical sculpture was a bathing scene. The excellence of this
drawing is apparent but the ostensible subject is puzzling. In his
sculpture, Degas was able to model nude bodies without recourse
to subterfuge. They are in awkward postures – as in *Le Tub*. There
is something about painting and drawing that demands a
naturalistic justification. If it is not an activity in which the
subject's nudity can be accepted, it begins to fall either into the
category of "nymphs and shepherds" nudes or the depiction of vice
or loose morals.

Room 39

Camille Pissarro
*L'Eglise Saint Jacques à Dieppe (The Church of Saint Jacques at
Dieppe)*, 1901

Pissarro continued until the end of his life to be an honest recorder

of light and shade as definers of forms. His treatment of city life matches his previous treatment of country life. It is straightforward, describing what it sees, and speaking of a painter who takes pleasure in what he sees. The church is shown as its congregation would like to think of it. The street beside the church is calm, a good place for a promenade. It is, on the whole, a sedate picture of some of the things that mattered in the life of the time and were often left without comment.

Pierre-Auguste Renoir
Les Baigneuses (The Bathers), 1918–1919

Renoir always had a taste for painting well-rounded nudes and the rolls of flesh seem to grow with the years. The scene has to be interpreted as vaguely classical. The landscape doesn't seem to be anywhere in particular. There is the regulation group of bathers in the distance and the large blondes are lolling about as though all in the world is sweetness and light. Oddly, the naked pair have hats with roses, too small to be any protection against sunburn. They presumably acknowledge Renoir's noted love of roses. The flesh is the color of peaches and roses and shows no sign of blemish from sun, wind, or earth so the scene could be taken as an idyll. It may equally manifest Renoir's failure to make anything out of the now discredited classical past.

Pierre-Auguste Renoir☆
Gabrielle à la Rose (Gabrielle with a Rose)

This is a work from Renoir's last days at Cagnes-sur-Mer. Like Monet, Renoir spent his final days in the country, frequently painting the garden he and his wife and their gardeners developed around their house in the south of France. The flowers he was most passionate about were roses. (Some of his favorites have been revived by horticulturists and are now more widely grown.) This portrait contains two of his favorite flowers, along with two of his favorite breasts, those of Gabrielle, whom he frequently used as a model. Unlike his nude roly-poly nymphs, Gabrielle is black-haired and has a face colored by the sun. Without any pretext – other than the juxtaposition of roses to skin – Renoir makes the nude convincing.

MUSÉE D'ORSAY: THE POST-IMPRESSIONISTS

Claude Monet☆
Nymphéas Bleus (Blue Waterlilies), 1916–1919

Of the many, many paintings – large and extra large – Monet did of waterlilies in his garden at Giverny, there are few in the Orsay. There is a big collection of them in the Marmottan Monet and two rooms specially designed for them by Monet himself in the Orangerie. With his waterlilies, Monet went into an epic phase where studies of ever-changing flowers, shadows, and reflections eventually became studies of change itself, and hence studies of what cannot be fully captured or understood. The receding waterway is framed by willows dropping into the water. The blue water with green pads and floating white flowers seems to have a defined surface but this is often blurred by some uncertainty about where vegetation ends and reflections begin.

To Monet, waterscapes were studies of the source of life in some of its most beautiful forms. Reflections in water, which are so easily lost with the passing of a cloud or the fall of a leaf, came to symbolize the impossibility of holding on to moments or memories. The paintings are to a considerable degree studies in regret for times lost.

Claude Monet☆
Le Jardin de Monet à Giverny (Monet's Garden at Giverny) 1900

Monet's property at Giverny was large enough for him, using employed gardeners, to cultivate a garden based on mass planting. Unlike many gardeners, his plans left little to chance. The property was, in fact, big enough for him to be able to divert some of the river through the property. In the painting, his house is in the background, reflected in some of this water. The mass planting gives him a broad slash of lilac and white across the canvas, which is enclosed above by willows and towards the bottom by one of the two paths on either side of the bed of irises.

Claude Monet
Le Bassin aux Nymphéas Harmonie Verte (The Waterlily Pool, Harmony in Green), 1899

Japanese painting and *objets d'art* were highly thought of by several of the Impressionist group. Some of the paintings show samples of Japanese art somewhere in the background. What they apparently admired was the capacity of Japanese painting to make

everyday subjects into gracious formal decorations. Monet had a bridge in the Japanese manner built across one of his lily ponds and, as usual, he then fell to painting it repeatedly for years, He undoubtedly also saw something Japanese about the lilies themselves with their floating pads and the way in which the flowers opened almost like an origami work. In this work, we are drawn to a contemplation of the surface of the water. The lilies are in roughly vertical receding lines and the horizontally curving bridge gives that surface a great depth of field. You see the water going a long way back, under the bridge that never comes down into it. The subject is really of beautiful still objects, floating on a very calm surface. It is a meditation. The dominant green becomes as much an element of the meditation as of the bridge itself.

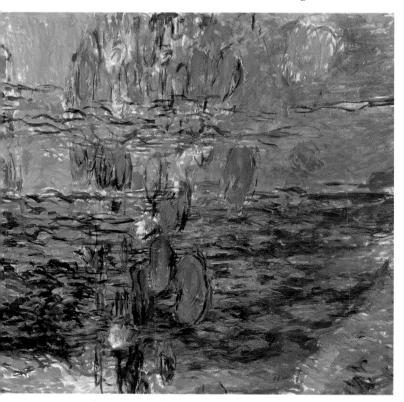

Monet's Nymphéas 1916–19 (see also pages 196–197)
© ADAGP, Paris and DACS, London 2003

Claude Monet☆
Londres: le Parlement Trouée de Soleil dans un Brouillard (The House of Parliament Pierced by Sun in a London Fog), 1904

We now know that the pea-soupers through which 19th-century Londoners groped their way were smog, a mixture of genuine fog and the smoke from their domestic coal and wood fires. The Houses of Parliament were another subject Monet painted several times. He used this as an opportunity to paint a shadowy blue scene pierced by the red of the sun coming through the haze and staining the water. We can't be sure whether the shrouding of England's Parliament suggests some other meaning. It may be a reference to Turner, the great English exponent of color, haze, and water. In any case, the subject clearly places the work in England. Perhaps Monet is bowing to the demands of the market: people like to be able to identify the subjects of works they buy.

Room 40

In Room 40 are works by Odilon Redon (1840–1916), a contemporary of the Impressionists. Redon uses a fresh style, somewhere between Puvis de Chavannes and the more restrained Impressionists. He has persisted with the other preoccupation of French art in the 19th century – symbolism. Paintings in this room show his use of Christian symbolism (the Sacred Heart), pagan symbolism (the Victor's Crown), and eastern symbolism (the Buddha). We do not cover any of them specifically here, however, if you have time, you may enjoy a look.

Room 41

Room 41 contains the Gachet collection. His family gave Dr Gachet's collection of Impressionists and others to the state. (His portrait is among the van Gogh works in Room 35.)

Paul Cézanne
Une Moderne Olympia, painted 1873–4, shown in the First Impressionist Exhibition of 1874

Manet's *Olympia* was exhibited in the Salon of 1865 and is exhibited in Room 14 of the Orsay. Ten years after Manet's *Olympia*, Cézanne's *Modern Olympia* puzzled the critics of the First

Impressionist Exhibition but excited Doctor Gachet, who picked it up for his collection. In the circumstances, we must suppose that it is a parody – or at least a good-humored extension – of Manet's work. The key features of the parody are that Olympia has been given a stagier setting. The gentleman watcher implied in Manet's Olympia is included in the picture in the person of Cézanne. Cézanne, however, is not there as a painter but as the gentleman client. The transaction is set up as a peep show. The elements of the stage for the peep show are clear-cut. The curtains that will later be drawn are now caught back with gold tassels. The ornate table with carafe and the baroque flower arrangement indicate the exotic nature of the show.

Olympia herself is floating on a cloud of drapes and has withdrawn to a more modest posture than she might have been in. The black servant appears to be drawing the sheet over the naked woman. (Some commentators say he is taking it off but that looks unlikely from the flow of the sheet.) This may indicate that the voyeur will soon have to reach for his top hat on the sofa and take off into the night. A further element of parody could be deduced from the rough style of the brushing, which leaves portions of canvas bare. Apparently Cézanne painted it quickly: it was exhibited as a sketch.

Pierre-Auguste Renoir
Portrait de Modèle or *Margot* (*Portrait of Model* or *Margot*), 1878

The idea of a portrait of a model is in itself interesting because it indicates that Renoir is seeing and painting her as herself. Her fresh face and golden hair are framed in dark blue with, it appears, some black. She is paler than his later pomegranate-faced and pink fleshy ladies. Indeed, she comes across as an elegant figure. There is nothing in the portrait to indicate where she is or what station she might occupy in life or even what she thinks of the world around her, but there is a magic in the beauty of the face and the hair.

Camille Pissarro
La Route de Louveciennes (*The Road to Louveciennes*), 1872

A popular place for painting, Louveciennes features in a lot of Impressionist works. Pissarro's muddy snow scene reveals some geometric tendencies. The sharp edges and cubic shapes of the

houses obviously fascinated him as elements of composition. Two trees define the space. The receding road provides lines on which the cubic spaces can plausibly sit. Typical of Pissarro's humanist approach to landscapes and city scenes, there are people strolling down the street – despite the impediment of the snow – and a big sky puts us into an expansive world.

Room 43

This room contains considerable numbers of early works of Gauguin when he still had connections with Impressionist painters and Impressionist thinkers.

Paul Gauguin☆
Nature Morte à l'Eventail (Still Life and a Fan), 1889

The oriental fan, which occupies a central position on the painting above the Cézanne-like fruit, directs our attention to the interests of Gauguin. The curious bell with the serpent-like handles is an orientalizing touch. The difference from Cézanne is the emphasis on arranging the space to accommodate surface patterns of color rather than isolating forms to create solid space. It is interesting to note that the painting was formerly in a Japanese collection and reclaimed by France as part of a treaty at the end of the Second World War. Gauguin uses a quite different palette of colors from the Impressionists, who had something of a love affair with primary colors. Gauguin's colors are clear but softer. His interest is not in the colors of real life but in making color patterns composed in a studio.

Paul Gauguin☆
Les Meules Jaunes or La Moisson Blonde (The Golden Harvest), 1889

Gauguin's harvest scene shows him to be such a decorative colorist that patterns of color virtually overwhelm the scene. The coloration is perhaps closest to the tonings of embroidery threads, and the general tenor of the subject has some of the charm of a piece of embroidery. The moldings of the surfaces as a pattern of rounded shapes parallels the softness of the coloration. There is nothing violent in texture or color: the transparent colors and the idyllic tone might owe something to Puvis de Chavannes. Gauguin was soon to transfer his romantic vision of peasant women in

golden rural settings to the exotic and more overtly magical setting of the South Seas. It is this later work for which he is best remembered, but that lies outside this particular Trail.

Paul Gauguin☆
La Belle Angèle (The Beautiful Angèle), 1889

This image has been constructed to look like a sacred image. We must suppose that the face is reflected in a mirror on the table, but it is also sitting, like a holy picture, on the table. Angèle herself is wearing a cross and peasant dress, which reinforces the idea that we are dealing with simple and intense faith. Behind and to the left is a pagan idol, which may be an attempt to universalize the idea of spirituality. The wallpaper sets the picture in a bower and relates the idea of holiness to nature. The background of the painting is also its surface. It is quite one-dimensional and consists of horizontal bands of color starting with yellow at the bottom through orange and brown to blue. The painting is extraordinarily vivid, appealing for the color alone.

As you pass on to Room 45, note that Room 44 contains some interesting examples of Gauguin's work.

Room 45

Georges Seurat☆
Le Cirque (The Circus), painted in 1890–91, shown in the Salon des Independants 1891

Georges Seurat developed a technique called Pointillism. The Impressionists had realized that the constituent parts of a color could be put separately on a canvas and would at a distance be mixed by the eye. Seurat pushed this perception into a rather dogmatic style in which color was applied in tiny dots all over the canvas. The spacing of the dots indicated shapes, and the shaping of separate colors side by side established tones. The difficulty is that this sort of optical theory doesn't quite work. The paintings remain interesting because they continue to be a set of dots rather than a fusion of them. The net effect of the technique is to make the scene look static and timeless.

The Circus is a highly animated scene and is expertly composed to convey the vigor and excitement of the ring. Yet it is also extraordinarily static. Each element is so etched that it does not

convey a sense of fluid motion. No matter how far you get away from it, the edges remain sharp and the bodies defined each in its own space. Perhaps Seurat has stumbled on a version of the timeless moment, so longed for but never captured by the Impressionists?

Room 46

Paul Signac☆
Femmes au Puits (Women at the Well), painted in 1892, shown in the Salon des Independants 1893

Signac also pursued Pointillism. Even more than Seurat, his works become geometric patterns. The elements of the painting are real shapes but each body and object is modelled in isolation. The figures are like cutouts that have been carefully pasted down on a flat background. Everything seems extraordinarily motionless. The contours of the landscape are seen as an entirely flat surface. Inevitably this raises speculation about the relationship between the mechanics of painting and the subject of a painting. With the benefit of our later knowledge, we would have to say that Signac is paving the way for Abstraction. The bright sunlight colors stay in the mind's eye. It is a memorable painting, but not one that fires the imagination.

Paul Signac
La Boule Rouge (The Red Buoy), 1895

This harbor scene of Signac's works rather better than the *Women at the Well* though it still detaches the viewer from the scene. It helps a bit to squint. The scene is apparently another Mediterranean one in bright sunshine. The uniform tone of the buildings along the harbor helps to diminish the effect of the dot technique. So too does the reflecting of the buildings in the water. The reflections are at first steady and then splayed out across the water to give a sense of quiet motion to the picture. Nevertheless it is still and the viewer's eye is drawn back to the red buoy in the foreground of the painting. Similarly, by the water, when there is little happening, the eye returns to a single object and makes that the subject of interest.

Room 47

In Rooms 46 and 47 there are a number of works by Henri Toulouse-Lautrec who recreates something of the world of performers, continuing the tradition of Degas in portraying theatrical life. He went somewhere down the scale towards popular risqué and cabaret theatre and, by all accounts, involved himself in some of the low life of the day. The pastels in Room 47 show why his ability to create recognizable and exciting images on bold, flat, brightly colored surfaces makes him an important figure in the development of poster art.

Henri de Toulouse-Lautrec
La Danse Mauresque (The Moorish Dance), 1895,
Bal au Moulin Rouge (Dancing at the Moulin Rouge), 1895, and
Jane Avril Dancing, 1892

Even more than Degas, Toulouse-Lautrec was the artist of the working life of Parisian cafés and music halls. Top among his favorites was the dancer known as La Goulue, "the glutton." Her real name was Louise Weber. These paintings were panels to decorate the entrance to her show. Among the spectators at the Moorish dance are Jane Avril, in black dress and hat; Oscar Wilde, on her left in the top-hat; and Toulouse-Lautrec himself, the short figure on her right (he was in fact deformed). Toulouse-Lautrec's paintings have the freshness of drawing, partly because he is so gifted in capturing movement and typical postures, partly because he paints only what is necessary to the action and leaves the rest of the cardboard or canvas bare. He also adopts the cartoonist's device of caricature. Wilde is a case in point, as is the demonic pianist. Even more surrealistic is La Goulue's long-necked male companion at the Moulin Rouge, where La Goulue is colorfully mooning the top-hatted patrons. The front view of Jane Avril in action contains all these classic Toulouse-Lautrec devices: fine attention to the portrait of the pale, sharp-featured beauty, fantastic skill in capturing movement, a quickly sketched background with the cardboard left bare, and mocking caricatures of the onlookers.

Henri de Toulouse-Lautrec: Four Portraits
Louis Bougle, 1895
Justine Dieuhl, 1891
Paul Leclerq, 1897
Woman with Black Boa, 1892

MUSÉE D'ORSAY: THE POST-IMPRESSIONISTS

Portraiture was a favored form among Impressionists and Post-Impressionists. They depicted one another, their relatives, their friends, and their patrons or supporters. Toulouse-Lautrec was avid in his sketching of acquaintances and his invitations to chance acquaintances to pose. By all accounts, he worked quickly with very thinned paint and included only what he thought necessary to capture the expression of the person.

This completes the Orsay Trail. It has concentrated on the Impressionists but you've also seen the paintings that preceded this movement as well as those that came after. The next Trail allows you to enjoy more wonderful Impressionist paintings.

TRAIL 3:
Monet and Others

Musée Marmottan Monet
(Academie des Beaux-Arts)

Location: 2 Louis Boilly (16th arrondissement), Metro La Muette. Follow the signs through the park. Some reasonable restaurants can be found back at La Muette.

Opening Times: Open from 10:00 am to 6:00 pm, closed Mon.

Admission: 6.50 Euros, 4 Euros discount

Website: www.marmottan.com

The Marmottan Monet enables you to get to know significant works by Monet and Morisot and a little more about some other Impressionist artists. *Impression: Sunrise*, the work that gave its name to the movement, is here. Take your time. This is a half-day Trail, but it could take longer.

The museum is comfortable and informative. There are well-placed seats from which to view the paintings. The hanging is thematic rather than purely chronological, which allows you to make new connections and comparisons between works. The lighting has been skillfully designed to do justice to the works.

On the way around, you will have the opportunity to watch a short informative documentary about Monet and his garden at Giverny.

We recommend that you go first to the last room, where there is a feast of Monets. To get there, turn left at the entrance and go downstairs and walk through the galleries to the last room. Comments start from the entrance to this room and move back through the galleries.

MUSÉE MARMOTTAN MONET

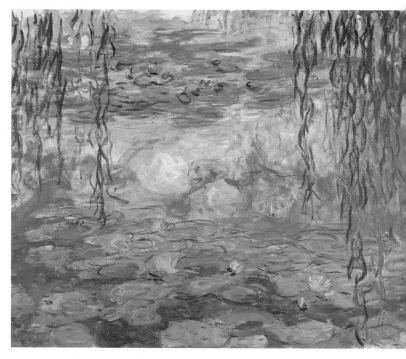

Monet's **Nymphéas**
© ADAGP, Paris and DACS, London 2003

Claude Monet
Nymphéas (Waterlilies), 1914–17

This work shows clouds and reeds reflected in the pond, on which there are floating pale blue lily pads. The device of putting the sky under and within the water is a clear statement that the waterscape contains the whole landscape. Through the water, you enter the sky. The desire one has when looking up to woolly clouds or flying over them, to be able to sit in them and bounce around like a child seems to be almost realizable on earth. The delineation of the water surface by the lily pads seems simple but you would have to have painted a lot of water before you could do it with such apparent ease. The upside-down nature of the image is because the reeds are upside down. Otherwise, it could almost be taken as a view from the bottom of the pond. Here the painter is the illusionist.

Claude Monet
Iris Jaunes et Pourpres (Yellow and Purple Irises), 1924–25

This painting of irises on long stems overhanging the water is, in some aspects, a messy painting. Perhaps it expresses the painter's despair, which must have been more or less constant, that art cannot even imitate, let alone exceed, nature. The iris flowers flutter in the air like giant insects, but below the long leaves gather somewhat angrily and the surface of the pond is obscured and stirred. It is a painting of happy things, yet it is not a happy painting.

Claude Monet
Nymphéas (Waterlilies), 1914–1917

Basically this is a painting of a clump of reeds or reed-like growth reflected in a surface indicated by a few floating lilies. You notice that like many canvasses, the corners and some of the edge are not painted on; the painting itself is not complete and in some way parallels the transience of the subject matter. The very vigor of the reeds is an entirely straightforward statement of the fecundity and riotousness of watery places.

Claude Monet
Nymphéas (Waterlilies), 1917–1919, a long work

In a very sketchy canvas, we find the painter focussed on water and impatient with the landscape beyond it. Although there is much attention given to laying down, either singly or in mixtures, a very wide range of colors, the total effect is one either of extreme impatience to get the basic job done or frustration that these changing lights and forms on and under the surface of the water cannot actually be captured. It almost comes across as a mid-20th-century action painting in which the subject and the agent become one on the surface of the canvas. As we gaze at the water rushing past, we can see fishy things, tadpoles, and eyes forming out of what might actually be a flurry of brush strokes. In this sort of painting it is possible to capture accidental effects not quite intended by the painter but allowed to remain and take their place in the overall sweep of the work.

Claude Monet
Le Bateau (The Boat), 1887

By 1887, Monet was already at Giverny and embarking on his

MUSÉE MARMOTTAN MONET

extraordinary exploration of "water landscapes," as he sometimes called them. While the boat helps to tell us that we are looking in the water, the interest is in the murky and threatening depths full of writhing weed ready to entangle. The boat gives the image a placid touch.

Claude Monet
Nymphéas (Waterlilies), 1916–1919

The weeping willows hang like opening stage curtains, an effect underlined by the frame acting as a proscenium arch. They open on something of a Swan Lake, a fantasy in pink and white with perspectives receding into wonderland. Start close up to the painting and step back bit by bit, being careful not to trip over the seats. The flat surface falls into a perspective created by color gradation and the massing of simple lines – to wit, the dark squiggles of the willow and the plate-shapes of the lily pads. This is an immensely tranquil and enchanting scene, taking its tones from the whites, yellows, pinks, and pale greens on the surface of the water rather than from the framing darkness of the willows.

Claude Monet
Nymphéas (Waterlilies), 1916–1919

Five red waterlilies are sitting among ten or eleven lilac pads on green-reflecting water. If wisteria blooms at the same time as waterlilies, it is wisteria that is reflected on the water's surface and then appears to be falling through it. Perhaps this is an allegory of Monet's universe – the bright flames of paradise in the flowers, the precarious floating islands of the world, the dank and menacing depths ready to swallow it all up.

Now move to the middle room, where you will find a group of five paintings on the wall to your left. The hanging of the group illustrates the thematic arrangement of hanging in the gallery overall. All the paintings are of Giverny. In the center is one of the Japanese bridge that Monet had built at Giverny in response to the enthusiasm for Japanese art at the time. On each side of the bridge painting are views of the house seen from the rose garden, and a willow tree seen at different times of the day – one in a red dawn or sunset, the other in a violet evening. Start on the left.

Claude Monet
Weeping Willow, 1918–1919

The scarlet trunk and branches of the willow come from those fairy stories in which the trees of the forest reach out and pluck at the body of the fleeing heroine. Here, the tent of leaves suffused with the gold of the sunset creates a haven. The view of the tree is an Expressionist one, set inside the tree's canopy, trying to attribute some kind of natural force to the tree, perhaps some kind of consciousness. The paint is applied thickly with heavy brush strokes, seeming to reflect turmoil in the mind of the artist that is then reflected in his subject and his way of working.

Monet's Weeping Willow

MUSÉE MARMOTTAN MONET

Claude Monet
Japanese Bridge or The Waterlily Pond, 1918–1924

The overall effect is of a somewhat dark and abstract work. The paint is thickly applied. A lot of darkish foliage frames the subject. The subject itself is sketched in as an element of composition. A longer look does show a perspective of lilies below and beyond the bridge but in essence we are probably looking at one of the many episodes in another of Monet's obsessively pursued subjects. Paintings of the Japanese bridge appear over a period of almost 25 years and, like the rest of Monet's art, move from forms of realism to forms of abstraction.

Paintings likely to be hanging on other walls in this room include:

Claude Monet
Le Pont de l'Europe, Gare St-Lazare (The Bridge at St-Lazare Station), 1877

The highly dramatic diagonal of the railway bridge may well symbolize the destruction railways caused to city and countryside. Now, advocates of public transportation and enthusiasts of steam and electric traction make something romantic of railways, but many in the 19th century saw steam, steel, and soot as instruments of the devil of the Industrial Revolution. This is altogether a more threatening view of railways than in many of Monet's other works, including the one next to it. Apart from the great force of the bridge, the detail of the painting focuses on the railway yards with steam, locomotives, and workmen. It is a bleak scene of reddish brown ground scored by black lines and inhabited by black figures and machines. The smoke – especially in the foreground – is discolored. It floats up out of nowhere, echoing thereby the infernal imagery used at the time about industrial machinery. The buildings of Paris, by contrast, are simply opening up a target for the bridge to thrust through.

Claude Monet
Train in the Snow or The Locomotive, 1875

The train that has stopped in the snow to take on passengers is apparently the one Monet caught regularly from his house at Argenteuil. Despite the red-eyed monster glare of the lights – and indeed the suggestion of the red maw at the front – the view is

certainly less menacing than its neighbor. The diagonal of the train is not so marked, and in comparison with the bridge, the train itself is a smaller part of the whole picture. Vanishing perspectives of a wooden fence and trees claim more space than the train. Even the dirtiness of the train's smoke is mitigated by the general dirtiness of the sky on snowy days. The fact that the train is stopped for people to get on and off underlines the utility of the machine and its relationship to the people of the city. For all that, as a snow scene, it is a far cry from the snow-covered romance of rural landscapes, including Monet's own.

Claude Monet
Impression: Soleil Levant (Impression: Sunrise), 1873

This painting became immediately famous when it was first exhibited in 1874. It divided critics and gave the Impressionists their name. The painters who exhibited together in 1874 called themselves "the Company of artists, sculptors etc" but a jeering journalist named Louis Leroy seized on the name of this painting and called them "Impressionists." "A sketch for wallpaper," he wrote in *Le Charivari*, "is more accomplished than this painting." The insult stuck but it soon became so glamorous a label that the painters themselves insisted on its being used to describe them as a group, even though they did not have all that much in common.

The scene is the old harbor of Le Havre on the Channel coast where Monet spent his childhood. Ports and river mouths mixed two of Monet's preferred scenes – water and industrial sites. Monet said of this view from a hotel window that it is "only an impression and is instantaneous." Asked for a title, he answered, "Write down *Impression*."

The subject can be read simply as a seascape. On the other hand, the ambiguity of forms and the layers of meaning we ascribe to common objects can suggest other narratives. The scene, over which the blood red sun is rising and staining the water, is ambiguous. The sky, though explicable as a dawn sky, is also somewhat apocalyptic. The horizon of grey shapes, a mixture of ships and docks, raise masts and piers in the form of crosses and forests of dead trunks standing in a muddy shore. The brilliance of the light flung by the sun on the water is counterbalanced by the blackness of the boats. They could as well belong to people trawling a river for corpses, as in Dicken's *Martin Chuzzlewit*, as to people boating in a peaceful dawn. The harbor industry – a dark, satanic one – intrudes between the meeting of sky and sea. The sun

is painted as a solid intense object staining the sea, as would fire or blood.

Well before Monet, the English painter JMW Turner had created highly impressionistic works. The freedom and sketchiness of Monet's work is often to be found in watercolors and sketching. This, however, is oil painting, which the Academic painters of the period used in a very studied way, certainly not as an apparently rapid sketch of a moment.

There is plenty of technical evidence that the painting was in fact put together quickly. Consider the number of colors and their lack of gradation. There are patches where the white of the prepared canvas shows through. The objects and their reflections don't match exactly. Brush strokes are used to give a quick indication to the eye of the direction of a surface.

If this work was exhibited today unsigned, undated, and unknown, it could be accepted as modern and probably not as a simple seascape. Monet was to pursue the sort of thing he was doing here for the rest of his career, apparently painting nature but also pursuing it as a metaphor.

Claude Monet
Cathédrale à Rouen, Effets de Soleil, Fin de Journée (Rouen Cathedral, Effects of Sunlight, End of the Day), 1892

This Gothic cathedral must have overwhelmed Monet, like everyone else. He painted many versions of it (see Trail 1 in this section) in an attempt to set down the effects light has on a basically white limestone building with many decorative arches, columns, and knobs. The encrustation of Gothic decoration is paralleled here by a very thick application of paint to achieve an effect of light. The towering mass of the building from the ground is emphasized by making it break out of the frame at the top and by the quite noticeable inward lean given to the façade. The people in front who are minimally suggested also serve to make the building dominate the space. The stone is made so that it seems to have absorbed the sun. The coloration of the building is actually based on the complementarity of blue (one of the primary colors) and orange (made by mixing the other two primary colors, red and yellow). Thus, shadows are blue, as is the sky and some of the people, while the toning on the stone and also on others among the people is in orange. Above and beyond technical skill, Monet is trying to capture inside a frame the soul

of the cathedral and the spirit of builders who themselves were obsessed with light.

Walk back into the first room to the stairs you came in by. Begin with the paintings on the wall at the foot of the stairs and move from left to right.

Claude Monet
Londres: Le Parlement (The Parliament: Reflections on the Thames), 1899–90

Rather than a landscape or a cityscape, this is another expression of Monet's longing for water. A disturbed sky is seen transformed into glittering water below. The building is painted over with green as a bundle of reeds. The water here is the bright surface of life; the reeds are the dark places. Known already from his cathedral paintings to be an insightful interpreter of Gothic buildings, Monet has treated this one as though it should be outlined and then effaced. On the other hand, the main tower of Westminster is shaped like a crown against a halo of light in the sky, which suggests its authority.

Claude Monet
Nymphéas, Effet du Soir (Waterlilies, Evening Effects), 1897–98

This painting of waterlilies could be seen as a work that presaged Monet's obsession with the waterlilies. The surface of the water rather than depths or reflections forms the basic surface of the painting. As usual, elliptical lily pads create a depth of field. The focus of the painting is two lilies in bloom, so generously set on a field of blue and green that they enjoy the full spotlight. The painting then is a serene study in the delicacy of white flowers tinged with yellow and pink. The work conveys a hint of the regret that beauty cannot ever be entirely captured. Their delicacy is also their fragility. Their moment of beauty, like so much of nature, is transient.

Claude Monet
Promenade près d'Argenteuil (Promenade near Argenteuil), 1873

This classically composed picture, with its receding corridors of flowers, experiments with color division, a technique that would later be developed in a more formal way by Seurat. The yellow and mauve of the right foreground demonstrate the technique at its freshest. The painting is, however, as much a study of wind as it is

MUSÉE MARMOTTAN MONET

a study in color. The sky is agitated; the woman's dress is blowing out stiffly; the couple appear to be hanging on tightly to their umbrellas; the leaves of the trees are glistening as they move in the wind; the red flowers are blown into massed color and the shadows of clouds move across the green field. For all that, it is an idyllic scene, perceived as though through a window by someone undisturbed by the wind.

Edouard Manet
Jupiter et Antiope d'après Titien (After Titian), 1856

This is a silly painting but interesting in that it shows that *Olympia* and the *Déjeuner sur l'Herbe,* both of which are in the Orsay, were not Manet's first attempts at revisiting the subjects of classical painters. If it is a parody, which the rough brushwork suggests it might be, its shafts are not much more penetrating than those of the Cupid hanging from the tree. Unlike Manet's later nudes, this would almost certainly have created no scandal for its subject matter, though it would have been criticized for the technique. At this time, so long as women were in classical scenes, they could be naked. Some of the characteristic Manet brushwork is already here.

Edouard Manet
Portrait de Berthe Morisot Etendue (Portrait of Berthe Morisot), 1873

This portrait of Berthe Morisot, herself a considerable painter of the Impressionist group, was painted a year before she married Manet's brother Eugène. Manet painted her frequently. Who would not want her for a model? She was a great beauty and judging from her writings, an intense woman, fond of opinion and gossip. Manet's taste for black against white pinpoints her intensity and style. Her hair is slightly messed, her eyes challenging, her gaze bold and lips slightly upturned at the corners. Her dress is perhaps carelessly glamorous. She knows how to dress yet does not need to pay too much attention to the detail because she can rely on her beauty. The reclining posture, the black bow around her neck and the steady gaze have a little of the Olympia in them.

Gustave Caillebotte
Rue de Paris – Temps de Pluie (Street in Paris – Rain), 1877

This is a study for a painting now held in the Art Institute in Chicago and very close to the painting in its general form, although details such as the features of faces are not in the study. This probably indicates that Caillebotte's real interest was in the geometry of the streets and buildings rather than the people stepping up to the foreground. In fact, they look more like models placed in a diorama than people walking in the rain. Caillebotte seems to welcome the broad boulevards and industrial features of the new Paris of the 19th century. He shows them all with a kind of hyperrealism. Perhaps he is drawing close to Surrealism. The low position of the artist's eye – somewhere near the level of the gentleman's knee – throws the building into exaggerated perspective. The straight lines of the pavement look as though it is ready to march down the straight lines of the boulevards. The umbrellas have sharply defined ribs and regular patterns of light and dark segments. It is often hard to see what Caillebotte had in common with members of the Impressionist group – and indeed it is sometimes hard to see what they had in common with each other – except that he was, like them, painting the Paris of his day.

Pierre-Auguste Renoir
Claude Monet à la Lecture (Claude Monet Reading), 1872

This portrait is not in the same mold as those where the subject is posed, waiting for the artist. Although it is not unique to Impressionists, it is nevertheless typical of them that Renoir would choose to have his subject doing something everyday and of the moment, like reading the newspaper. He is in a transitory place, still dressed in coat and hat. You intuit that it is the portrait of a friend because the ambience suggests familiarity. He has come in, not taken off his coat, lit a pipe, and settled in with the paper. To modern eyes, far from being any sort of bohemian, he looks a very serious man with a beard, black hat, and pipe.

Pierre-Auguste Renoir
Portrait de Madame Claude Monet, 1872

Renoir's familiarity with Monet is again on show with a portrait of Monet's first wife Camille (Camille Doncieux). It is a portrait of a beautiful, black-haired, dark-eyed woman set in lilac and gold. The lilac tone continues in the blue shadows of the wall. The gesture of the hand held near to the throat carries a slight suggestion of

nervousness or discomfort. So too does the fact that her eyes are not meeting those of the painter or the viewer. Unlike many of Renoir portraits, it is not of a rounded, robust face and figure but a pale figure on a muted, almost melancholy ground. The tinge of red on cheek and bottom lip heightens her pallor: the warmth has gone out of her. Camille died seven years after this portrait was painted.

Pierre-Auguste Renoir
Portrait de Julie Manet, 1894

Another of Renoir's "friends and relations" portraits. The subject, this time, is Julie Manet, the daughter of Berthe Morisot. Julie was her mother's favorite model. Renoir paints her as a very pretty sixteen-year-old. She looks both beautiful and wholesome with masses of reddish hair. There is nothing in the background to distract you from her, but she does look rather detached. The brushwork is vigorous enough for the viewer to be aware of it – especially in the hair and the neck of the dress but also on the parts of the face where the light falls.

Paul Gauguin
Banquet de Fleurs (Banquet of Flowers) 1897

At the same time as Renoir was painting his portrait of Julie Manet and Monet was painting scenes where light would be the focus – in effect while the Impressionists were still fully engrossed in their styles – Paul Gauguin had left France for Tahiti and was revisiting the joys and mysteries of the flat surface. There is a mixture of Japanese-influenced flower painting and Cézanne-influenced mangoes next to the vase. Both of these resemblances however go in the one direction – towards creating a flattened tapestry-like surface on which real or imagined flowers provide deliciously colored patterns. The clear reds compose the picture and the blue shadows of the bowl and fruits anchor it. The blue is picked up in the top right.

Berthe Morisot
Au Bal (At the Ball), 1875

Many of Berthe Morisot's paintings in public galleries are of young women or children. Although this is an attractive painting of an

attractive young woman, it really does look awfully as though she is all dressed up and no one has asked her to dance. If not that, she may be hoping some unwanted suitor will not see her there half hidden behind the fan and looking as bored as possible. Or is she reflecting on the inanity of social life? It is an unsettling work. You don't know – and will never know – what the story is, but you know there is one.

This painting is a good introduction to more works by Morisot. Return to near the entrance, turn left and go up the stairs to the Morisot room. On the wall there is summary of the main events of Berthe Morisot's life (or revisit the Profiles of the Artists in the introduction to this section). When you go into the room, your first impression is that she mostly painted young women and children, often at leisure. The one male figure in the room is her husband Eugène Manet, brother of the painter Edouard. The notes below cover a selection of the paintings that are usually displayed in this area.

Berthe Morisot
Au Bord du Lac (Lakeside), 1883

A child has turned her back, but the woman looking at her focuses our gaze on the child, too. In the green background, a number of figures promenade but the child and the woman give you the feeling that they have slipped away from the crowd and are enjoying themselves on their own. The child's curiosity is nicely caught in her stance. The turbulence of the sky is paralleled by the turbulence of the brushing. In turn, brushing is used to suggest different surfaces in the large area of green between the foreground and the promenaders. Manet's influence on her work is observable. His black is used by Morisot with touches on dress, hair, tree trunks, and figures in the distance.

Berthe Morisot
Portrait de l'Artiste (Self-Portrait), 1885

Berthe Morisot was about 42 or 43 when she painted her own portrait. She does not see herself as the glamorous figure she undoubtedly was. She shows herself as a painter of rather imperious manner. She has given herself greying hair and has dressed conservatively. Much of the brushing is savage and peremptory and a lot of the canvas is left unpainted. She might be

MUSÉE MARMOTTAN MONET

suggesting that her own career as a painter has been less satisfactory than she would have wanted it to be.

Berthe Morisot
Le Cerisier (The Cherry Tree), 1891

The girl on the ladder is Berthe's daughter Julie, whom Renoir painted. The one below is her niece, so it is another family scene. Julie is about 13 and not yet the sophisticated model she would later become. Her dress is bursting with light from a not-easily-identified source above. The white of the dress is made up of a wide spectrum of color. The light is more subdued on the second figure but continues through to the bottom of the picture. The detail of the cherry tree against the sky, top left, has a touch of the sort of agitation that brings van Gogh to mind.

Berthe Morisot
Eugène Manet et sa Fille dans le Jardin de Bourgival (Eugène Manet and his Daughter in the Garden of Bougival), 1881

The scene is in the garden of a holiday villa. Young Julie is playing with a model of a street or station on her father's lap. The garden is a summer garden with many surfaces catching light, much of it suggested by very rapid brush strokes spread around folds in garments or the outlines of the child. The left side of the canvas is partly bare and shows the reddish ground with which Morisot had prepared the canvas. The child is absorbed in play. Her father is content to be with her but looks as though his thoughts are elsewhere. The dark and relatively undifferentiated area is associated with the male figure and the bright light and dancing flowers with the child.

Berthe Morisot
Roses Tremières (Exotic Roses), 1884

The seat in this work is empty. This is curious for a painter who so often put young people into her images. It is the summer after the death of Edouard Manet to whom Berthe owed so much as a painter. The empty seat may refer to his absence. His early death naturally would have haunted her.

Berthe Morisot
Eugène Manet à Ile de Wight (Eugène Manet at the Isle of Wight),
1875

This was painted very soon after Berthe's marriage to Eugène when they were holidaying on the Isle of Wight. It is a true holiday picture where all the fun and interest is outside. At the open window, Eugène becomes the viewer. He is twisted around in his chair as though he has just heard something from outside where there are people and boats on the water. In the painting is a succession of horizontals created by a window seat, a row of pots, a row of red flowers in the pots, a fence, and a window frame. Between them, they enclose a scene of a girl looking out at the boats on the harbor. The scene is then framed vertically by white curtains with the brown of the window showing through and merged with the browns and whites of Eugène's figure and clothing. One of the boats at the right edge of the curtain is a steamer. The funnel is lined up with the edge of the curtain and the smoke disappears into it like a smudge. Here, a narrative painter is putting down clues and leaving it to the viewer to make the story, but its essence is there in the colors of the outside world, which are bright and filled with light. In contrast, the colors indoors are less varied.

There is another room of pastels of varying subjects that show Morisot's gift for drawing and composing. You may wish to view these before leaving this museum.

Other Museums and Suggested Day Trips

Other Museums

Musée de l'Orangerie
(Opening after renovations in 2004)

Location: Jardin des Tuileries, near the Place de la Concorde (site of the Revolution's guillotine) at the other end of the Tuileries Gardens from the Louvre

Opening hours: Normally between 9:45 am and 5:15 pm daily, closed Tues. Check for any changes after reopening by ringing 01 42 97 48 16.

Visiting this museum will take about half a day. For several years, the Orangerie was closed for refurbishment and the Walter-Guillaume collection of Impressionist and Post-Impressionist paintings toured the world.

It is a smallish but terrific collection, representative of a wide range of painting of the period, and its prize is the gigantic waterlily paintings by Monet exhibited in underground galleries especially designed for them by the artist himself. When it re-opens, it is a must.

We have explored the themes of Monet's waterlily paintings in earlier Trails in this section. The very scale of the paintings and their display testifies to his intention to create an epic series that celebrates the intensity of a moment and captures transient beauty. Take up a few vantage points and meditate on them.

The matching building on the opposite side of the gardens – the Jeu de Paume – is used for temporary exhibitions of contemporary art.

Musée National Gustave Moreau

Location: Rue de La Rochefoucauld (9th arrondissement) Metro Trinité
Opening hours: 11:00 am–5:15 pm Mon.-Wed.; 10:00 am–12:45 pm,
2:00 pm–5:15 pm Thurs.-Sun.

Gustave Moreau, whose paintings are exhibited in this museum north of the city, is an acquired taste. He left a large collection of his works to the state. His works are of Biblical and mythological scenes; the most famous is *Jupiter and Semele.*

Musée National Eugène Delacroix

Location: 6 Place de Furstenberg in the 6th arrondissement. Metro Mabillon
Opening hours: 9:30 am– 5:30 pm, closed Tues.
Admission charge: Discount fee applies to all on Sunday

Eugène Delacroix, whose works we will also see in the Louvre in section 4, worked in this museum until his death in 1864. Here you will see portraits, including one of George Sand, and other works such as *The Entombment of Christ.* This charming museum is set in the left bank area of St-Germain-des Près, where you'll find many cafés and restaurants.

Musée Auguste Rodin

Location: 77 Rue de Varenne, Metro Varenne
Opening hours: 9:30 am–5:45 pm, closed Mon.; but opening hours
Oct.–March are 10:00 am–4:45 pm

The Rodin museum displays the work of this great French sculptor in a wonderful setting – a large and serene rose garden. Here you will see his famous works such as *The Thinker, The Gates of Hell* and many others. Indoors, other famous sculptures, such as *The Kiss,* are arranged in chronological order. Rodin died in 1917 and lived and worked here for nine years before his death. Of these three museums of individual artists, the Rodin is the pick for both its collection and setting.

Side Trips

Auvers-sur-Oise

This is a small town about an hour northwest of Paris, accessible by car or train. Allow for an hour's drive or take the train leaving from the Gare St-Lazare or the Gare du Nord in the direction of Pontoise.

Van Gogh spent the last period of his life in Auvers, during which he painted many scenes in and around the town. Other painters, including Cézanne, also painted at Auvers. His *Farmyard in Auvers* is in the Musée d'Orsay. Pissarro lived nearby and several of his paintings are of landscapes close by in Pontoise.

Many of the sites are now signposted and all are within easy walking distance. The chateau offers an excellent multimedia account of Impressionism, with many novelties such as a simulated train ride through Impressionist landscapes and a 3D movie show that takes you up to van Gogh's suicide. The chateau is open from 10:30 am to 6:00 pm (7:30 from April to September) and closed on Mondays. The entrance charge to the chateau is 10 Euros, and is well worth it.

You can lunch, drink, and dine in recreated restaurants within the multimedia show. If you don't eat at the chateau, the other choices are limited – maybe a picnic in the van Gogh park in the middle of town.

The main attractions of the walk through town are views of the church whose image by van Gogh hangs in the Musée d'Orsay, the still recognizable steps going up from the street, and the site of Doctor Gachet's garden, which he also painted.

Monet's Garden at Giverny

The Musée Claude Monet is at Giverny, a small village over 50 miles northwest of Paris on the way to Rouen. You can go by car or train and may choose to make it an overnight trip. The train goes from Gare St-Lazare to Vernon, after which there is a short bus trip to Giverny. Check train timetables for trains before noon and return trips in the evening. It is closed in winter, but from April through to October the gardens are open every day except Monday, from 10:00 am to 6:00 pm. You will have to pay 5.5 Euros for house and garden, although children and students pay less.

The visit will add life and context to Monet the man, his work, and his preoccupations. Monet set up his house and garden at Giverney in 1883 and it was his home until he died in 1926. The garden beds,

OTHER MUSEUMS AND DAY TRIPS

stretches of water, waterlilies, and bridges built to be painted, his house, his dining room, his studio – all were part of his visual plan. He diverted water for waterscapes and had a squad of gardeners awaiting his command. (Some even had to wash the lily pads before he set out to paint them.) The Japanese bridge, paintings of which you will see at the Marmottan Monet, has been rebuilt since his day.

Close to the studio are the formally laid out garden beds. In the far corner, a tunnel takes you through to the Jardin d'Eau, a part of the garden that has been cut off by the road. The garden varies greatly with the seasons – spring bulbs, early summer roses, and the dahlias and sunflowers of late summer each make the garden their own.

Nearby, at No. 99 Rue Claude Monet is the Musée Américain, with similar opening times. There is a separate entrance charge of 5 Euros, but discounts are available. Here you will find a collection of American painters who came to France at the height of the Impressionist movement and worked in styles that are clearly influenced by various strains of Impressionism.

This ends the Impressionist and Post-Impressionist section. It is time now to turn to some of the collections of modern art in Paris.

ART AND ANTI-ART: THE 20TH CENTURY

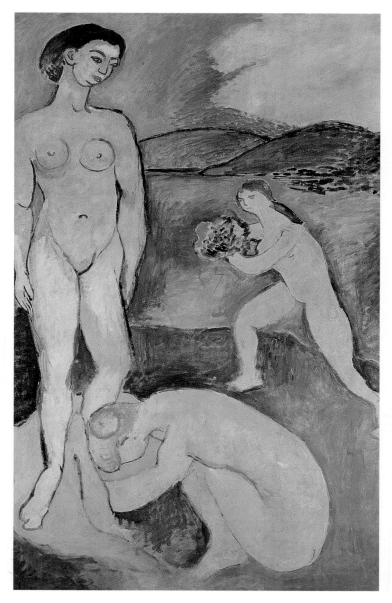

Matisse's Luxe, 1907
© Succession H Matisse/DACS 2003

TRAIL 1:
Modern Art in the Pompidou Center

The art of the 20th century, at least through to the 1960s, is most commonly referred to as modern art, so you find it in the imposing Museum of Modern Art – also known as the Pompidou Center – and in the smaller Museum of Modern Art of the City of Paris. There are also a couple of collections dedicated to individual artists who lived and worked in Paris, which you'll find described at the end of this section.

Paris has a considerable and eclectic array of modern art. Some movements are quite well represented, as are some individual artists. Some are French, although many are not. In the first three decades of the 20th century, Paris was seen as the center of western art. At the same time, however, art had become a world-wide commodity, with the result that a great many of the moderns are in private and public collections outside France, and especially in the United States, for by the middle of the century New York had become the capital of modern art. Finding a representative sample of modern art in Europe is hard work. The Pompidou nevertheless has an excellent collection, so we focus on it in this Trail.

Modern art embraces many movements and many ideas of what art should be about, including the idea that it should be shocking or meaningless. The movements succeed one another quite rapidly and sometimes launch themselves by attacking the ideas of their predecessors.

The three great Post-Impressionists, Cézanne, Gauguin, and van Gogh, set some of the major modern movements in motion. Cézanne was greatly admired by nearly every school and especially the founders of the various forms of geometric abstraction that arose in the 20th century, starting with Cubism. Gauguin was followed in spirit by movements, such as Fauvism, interested in simplifying forms and exploiting color. Van Gogh's approach gave rise to various forms of

MODERN ART: THE POMPIDOU CENTER

Fauvism	**Early 20th century**	**Matisse, Gontcharova, Braque, Jawlensky, Larianov, Chabaud** The Fauves (from the word meaning wild animal) show the lasting influence of Gauguin and van Gogh. The painting's surface is treated as almost two-dimensional. Colors are powerful and personal, shapes are simplified. The most notable of the Fauves, Henri Matisse continued to be one of France's greatest artists throughout his long life.
Abstractionism	**From early 20th century**	**Mondrian, Malevitch, Kandinsky, Kleé, Robert and Sonia Delauney, Léger** Many forms of abstract art flourished in the 20th century. In its purest form, abstract art makes no obvious reference to the observable world, but many forms fall half-way between abstract and figurative images.
Expressionism	**From early 20th century**	**Rouault** Expressionism generally denotes painting that emphasizes the artist's subjective view. It expressed in images a state of mind, religious feelings or social comment, often with a simplicity of execution. In the second half of the century, artists such as Jackson Pollock painted in Abstract-Expressionist style.
Cubism	**From 1907**	**Picasso, Braque, Robert Delaunay, Gris, Léger** Admirers of Cézanne developed an increasingly one-dimensional geometric style. Probably one of the best known artists of the century, Picasso changed styles often, but mostly painted figures as his subjects. His changing styles can be followed in the Pompidou and in the Musée Picasso.
Dada	**From 1913**	**Duchamp, Arp, Grosz, Hausmann, Picabia, Arp** Dada questioned the nature of art, in part by exhibiting found objects. Most Dadaists moved into Surrealism when it announced itself as a movement in 1924.
Surrealism	**From 1924**	**de Chirico, Ernst, Miro, Magritte, Dali and the photographer Man Ray** The word surrealism was coined by the poet Apollinaire and popularised by Andre Breton in his 1924 Surrealist Manifesto. Many Dadaists joined the movement. Surrealist painters drew on the subconscious to create unreal worlds, frequently in a heightened realistic style.

The principal movements in modern art.

Expressionism, which heightens the emotional content of painting via disturbing subject matter, distortion of images and violent textures and colors. By 1906 all three artists were dead and the art of the 20th century would soon progress far beyond their imaginings.

About Using the Modern Art Trail

In order to accommodate the character of modern painting, this Trail describes movements and some typical works within a movement rather than describing individual works as in other sections of this book. It concentrates on the Level 5 galleries in the Pompidou center – art from 1905–1960. We've chosen this approach for this section for several reasons:

- It allows you to get a feel for the movement and its major artists and to see how the general ideas are exemplified. The Trail does point out specific works in each room that are particularly representative of the movement or the direction of any particular artists.
- Collections of modern art in general tend be more fluid and changeable than those of other eras: exhibitions are regularly reorganized and parts of them sent out to other museums for temporary exhibitions. If we were to concentrate on individual works rather than the general movement, you might be disappointed to find that the described work had been removed temporarily.
- Unfortunately, the gallery's moving around of works makes it difficult to specify what room a painting might be in. As far as possible we have followed the same chronology that the Pompidou usually follows. Where room numbers are given, they are those that applied in late 2002. (In that year most of the Surrealist work was on tour. You'll see that we've been unable to specify a room for these.)

We suggest that you use the Trail in this way: read the general introduction to the artistic styles you will encounter in a particular room, and then, as you approach a painting or sculpture, read about the artist's particular approach.

MODERN ART: THE POMPIDOU CENTER

Pompidou Center (Centre National d'Art et de Culture Georges Pompidou)

Location: Place George Pompidou. The closest Metro is Rambuteau, and the Hôtel de Ville station is also within walking distance
Contact details: 01 44 78 12 33
Opening Times: Museum and exhibits, 11:00 am to 9:00 pm daily (except Tuesdays and May 1), Brancusi Workshop, 1:00 pm to 7:00 pm weekdays only
Admission: 10 Euros; reduced admission: 8 Euros. The ticket can be used on the same day for all the current exhibitions, the National Museum of Modern Art, and Brancusi Workshop. Free entry to the museum for those under 18 years of age and to the exhibitions for those under 13 years; and free entry to the museum for everyone on the first Sunday of every month

The Trail should take the better part of a day: about five hours plus breaks. Drinks and snacks can be had within the Center or immediately outside in the busy Beaubourg quarter.

Level 4 and the special exhibitions of the Pompidou attempt to deal with contemporary art, from about the 1960s through to the present. This is a challenge to any gallery anywhere and French artists have not been the movers and shakers. This Trail does not attempt to cover these more recent works.

FAUVISM, PRIMITIVISM AND CUBISM: LEVEL 5, ROOMS 1–5

FAUVISM

The artists that would later be called the Fauves (meaning, roughly, primitive and innocent) were initially inspired by the way Gauguin and van Gogh had used strong color and simplified forms that clearly broke with any attempt to represent reality as we see it. For that reason African and Pacific Islander "primitive" arts appealed – clearly laden with symbolic and religious meaning but with scarcely any attempt at realism. To these artists, "primitive" art was close to nature and unaffected by civilized decadence – a kind of pure art to which the west had to return spiritually.

The artists of the period were already very conscious of the impact that photography was having on visual art. Painting could

no longer amaze people by showing them aspects of reality in a frame. But it could still give a pure form of pleasure, via forms and colors, and work with symbols that link the viewer to the hidden and cosmic realities of their world.

The presence of several Russian artists (Alexej Jawlensky, Nathalie Gontcharova, and Michel Larionov) is a reminder of the many links French art of the period has with other countries in central and eastern Europe as well as Spain and the US. Although Fauvist paintings were first exhibited in Moscow, key artists moved to Paris, and generally stayed there, and the movement itself is seen as essentially French. Paris was the center of the art world and would remain so until World War II.

PRIMITIVISM

Primitivism is also called Cézannism, due to his enormous influence. Unlike Matisse, who stayed with Fauvism and developed it into a personal style, Georges Braque, Andre Derain and the Delaunay couple, Sonia and Robert, had a comparatively brief period as Fauves, from about 1906 to 1911. Both Braque and Derain painted a number of landscapes at Estaque in the brilliant colors of Fauvism but they were already much moved by Cézanne's approach to landscape and the human figure. Room 2 contains the primitivist paintings of Braque, Picasso, Robert Dalaunay, and others. Their progress to a revolutionary break with the past – which became known as Cubism – is traced in Rooms 3 and 5.

CUBISM

The fathers of Cubism are Georges Braque and the Spaniard Pablo Picasso, who spent the most influential part of his career in France. The godfather is Paul Cézanne and whose work was the subject of a retrospective at the Autumn Salon in 1907. The twenty-something Fauves – Georges Braque, Andre Derain (1880–1954), Maurice de Vlaminck (1876–1958), Raoul Dufy (1877–1953), and others – were knocked out by the way Cézanne analyzed not just buildings but natural features into geometric shapes. To them this not only made the world seem solid and timeless, in direct contrast to the Impressionists, but linked the observed world to a set of basic universal shapes and thus brought together the tangible world and the world of the mind. Picasso and Braque traded and discussed ideas frequently. They developed ideas together: both were putting material

elements and fragments of words or music into their pictures between 1911 and 1913, and this collaboration extended up until the start of World War I. Here was something that no representational art, and certainly not photography, could achieve. Here was a truly modern, scientific perception of the world that had no need for the classical symbolism of academic painting. These young painters were not yet Abstractionists, but they were having the kind of thoughts that would later be promulgated in abstract art. As had happened often before in the history of art, the tensions between abstraction and figuration were pulsing into the foreground.

HENRI MATISSE 1869–1954
Nature Morte à la Chocolatière (Still Life with Chocolate-Maker),
 c.1900 Room 1
L'Algérienne (Algerian Woman), c.1909 Room 2

Matisse is represented by paintings that span his long career. The work here illustrates some of the preoccupations of the period: the simplification of forms; the treatment of the picture as a two-dimensional plane; and colors that break sharply from reality. Despite the imputation of naiveté, Matisse and other Fauves were very consciously, according to their own writings, developing the ideas of Post- and Neo-Impressionism. In particular, Matisse was developing the simple and bold forms and colors of Gauguin, having already worked in the divisionist manner of Signac. Matisse continued throughout his career to use figurative images. His curved lines had more and more the freshness and quickness of drawings while the masses of colors were simplified, sometimes to monochrome. Fauvism, said Matisse, used color that did not reflect reality and as a result had a stronger effect.

Three more Matisses, from much later in his career, are in Salle 41. Matisse, one of the century's most popular painters, persisted with figuration throughout the many movements that his long life spanned. In *Le Rêve (The Dream)* from 1935 we see the same bold line and beautiful color that we saw in Matisse as a young Fauve. What he did over time was simplify – use fewer colors and economize his line so that figures became more and more imposing.

GEORGES BRAQUE 1882–1963

Grand Nu (Large Nude), 1908 Room 1
Les Usines du Rio-Tinto à l'Estaque (Rio-Tinto workshops at Estaque),
 1910 Room 3
Le Viaduc à L'Estaque (Viaduct at Estaque), 1908 Room 3
La Terrasse à L'Estaque (Terrace at Estaque), 1908 Room 3
Cinq Bananes et Deux Poires (Five Bananas and Two Pears), 1908 Room 3
Femme à la Guitare (Woman with Guitar), 1913 Room 5
More Braque pictures are in Room 5

Braque was not long a Fauvist but is considered, along with Picasso, as one of the fathers of Cubism. His *Grand Nu* in Room 1, develops and extends Cézanne's parallel hatching technique. Braque's landscapes at Estaque look like simplified imitations of Cézanne. The same range of ochre and green colors is used and the forms of the landscape are noticeably angular and solid. The same critic who had christened the Fauves was further affronted by the idea of reducing buildings and landscapes to geometry and cubes. By 1911 Braque has reduced his color schemes to shades of brown and, like Picassso, is pasting bits of objects, such as newspapers, on to his painting.

Braque's *Five Bananas and Two Pears* demonstrates some of the transitions taking place. Shadows, and hence light, still have a role even if the shadows are sharp geometric areas. The colors have strayed somewhat from realism but are still plausible descendants of those favored since the Impressionists. The dish and the fruit are arranged like an exercise in geometry rather than as anything you might see on a dresser or table. The title is laconic – a rejection of the classic still life in favor of a provocative literalism. On the other hand, the objects are recognizable elements of the familiar world, painted to please. Cubism, however much it reworked the visible world, did not leave it for abstractions whose meaning must be sought entirely within the work.

The works here by Braque (*Woman with a Guitar*) and Picasso (*Violin, Portrait of a Girl*) made between 1911 and the outbreak of war are among the most ambitious and also the most approachable of Cubist paintings. They are confident of their techniques, which by now include a great mixture of materials pasted on to the painted surface, and their pleasure in building up simple and everyday elements into a complex image comes through. The image creates its own world within the frame and there is an undeniable pleasure to be had simply from looking carefully over each detail to see what it is and how it connects to its companions.

MODERN ART: THE POMPIDOU CENTER

Georges Braque's Le Viaduc à L'Estaque

PABLO PICASSO 1881–1973

Jeune Fille au Chapeau (Girl with Hat), 1821 Room 1
Nature Morte (Still Life), 1912 Room 3
Femme Assise Dans un Fauteuil (Woman Sitting in an Armchair), 1910 Room 3
Buste de Femme (Female Bust), 1909–1910 Room 3
Fillette au Cerceau (Young Girl with a Hoop), 1919 Room 5
Le Violon (The Violin), Room 5
Room 7 is devoted to Picasso's later work (1943–1971)

For much of the 20th century, the name Picasso stood for striking innovation in art, and he remains one of the best-known and most respected artists of all time. Though he was born in Barcelona, much of his public working life was spent in France. His work spans the visual arts: painting, sculpture, graphic arts, and ceramics have all been affected by his output and visual imagination. Generally speaking, his work falls into distinguishable periods, such as his early so-called Blue period, and probably most famously, his Cubism.

Influenced strongly by Cézanne, by 1907 Picasso began to turn the human figure into flat, geometric planes and to paint faces that resemble carved heads from Africa. (There are a couple of traditional African sculptures in the room to help you make the connection between geometric western art and the bold, spiritual "primitive" art that so enchanted 20th-century artists. By 1909 he was fragmenting figures into geometric patterns that look like diagrams of crystals. Essentially, Cubism consists of taking objects apart, simplifying the fragments into geometric shapes and reassembling them in patterns. Colors are simple and flat, sitting on the two-dimensional surface rather than attempting to express emotion or contribute to the illusion of light. But Picasso, as he liked to, kept well ahead, so his Woman Sitting in an Armchair from 1910 treats the figure as the point of departure for an arrangement of rectangles that suggests a human figure only in the major outlines.

OTHER ARTISTS AND THEIR WORK

Fernand Leger's *La Couseuse (The Seamstress)* in Room 3, from 1909, retains a strong figure but emphasizes the planes that go into its construction and mutes the colors to a virtual monochrome. Another Spaniard who settled in Paris, **Juan Gris** (1887–1927), in his *Le Petit Déjeuner (The Breakfast)* from 1915 assembles the

elements of a breakfast – coffee pot, newspaper, furniture, room, bowls and so on – but gives them the clarity of detail and unreal juxtaposition of surfaces that surrealists and futurists would favor. The **Henri Laurens** (1885–1954) piece *Bouteille de Beaune* (Bottle of Beaune) shows how well Cubist ideas adapted to sculpture. The arrangements of simple shapes and assemblages that the painters had already introduced to their canvases provided natural inspiration for artists working in three dimensions.

GEORGES ROUAULT (1871–1958)

Room 6 is devoted to Rouault, probably because he is hard to fit into any category other than his own. He is perhaps best known for his religious painting of the 1930s and 40s. His work at the beginning of the century relates him to Fauvism (technically) and to Expressionism (with its darker content) but, like Matisse, he develops a style of his own and basically stays with it. Two nudes, *Fille au Miroir* (Girl at the Mirror) from 1906 and *Nu de Dos* (Nude from the Back), from 1910 illustrate his practices of using color emotionally and outlining solid forms in dark colors. The first, however, with its livid flesh colors and stockinged legs and unconcerned nudity, suggests prostitution. The warmer colors and solid flesh of the second, by contrast, express admiration for the human form rather than exploitation of it.

The elements of Rouault's subsequent progression to religious art can already be seen in these early works. His subject matter is committed and he paints with the black outlines and vivid colors of stained glass – he did in fact study with a stained glass window restorer before moving to study with Gustave Moreau where he would meet Matisse and other (soon-to-be) Fauves.

Rouault's social commitment can be seen not only in the relatively straightforward image of oppression in *Jeu de Massacre* (Massacre Game) but also in his circus studies: *Polichinelle* (Punch), *Clown au Tambour* (Clown with Drum) and *Acrobate* (Acrobat). Often the poorest of all performers, and like the itinerant players of earlier times, a marginal group, circus people become figures of grace and givers of joy under the spotlights – and a metaphor thereby for the spirit that is common to all humanity.

Pablo Picasso's The Enameled Saucepan
© Succession Picasso / DACS, 2003

DADA

Dada (Room 8) is the first outbreak of the particularly 20th century idea of anti-art. Walk into the room and you will be struck immediately by the extent to which it uses ready-made and irreverent objects such as a urinal or a bicycle. The name itself is derived from baby talk and both the publicity and the works of the movement set out to deny conventional ideas of art. Conventional art is inspired by ideas of beauty and meaning and is made by people gifted in their craft. Dada is banal, ready-made, and subverts meaning. It is mainly assembled and usually absurd. If it appears to mean something, the artists themselves are likely to scoff at the interpretation. It aims to shock viewers and deride traditions.

Dada as a movement had a quite short life, having started in Switzerland in 1916 and reaching its end – in Paris at least – early in the 1920s. Its ideological positions, however, persist throughout

the entire century, in literature as well as in the visual arts. In fact, one of its literary adherents, the poet Guillaume Apollinaire, seems to have coined the word Surrealism, which is not only the name of a major movement in art but also a concept that entered the common language to mean something incredible, absurd, and dream-like. (Dada leaves out the dream.)

The fact that Dada spans the years of World War I might be used to explain its absurdity and tendency to nihilism, but it is not an overtly social or political movement, except within the art world. On the contrary, it could be criticized for its disengagement from the first great catastrophe of the 20th century – a self-indulgent, inward-looking exercise in dilettantism. Perhaps that's all it was for some of its adherents, but its importance to artistic thought even today is considerable. The 20th century had to find a fresh set of symbols – academic art had continued to use the symbols of the classical world of Greece and Rome and the Realists and Impressionists still honored beauty, nature and painterly technique as ideals in art.

MARCEL DUCHAMP 1887–1959
Hat Rack, 1917 Room 4
Fontaine (Fountain), 1917 Room 4

There are several more works by Duchamp in Room 4, and more of his work is displayed in Rooms 8 and 9.

The leading French exponent of Dada calls his pissoir a fountain, but a fountain traditionally is an artful work designed to enhance leisure and confer elegance on nature. A urinal is a mass-produced "found" object whose elegance of line is over-ridden by its undoubtedly banal purpose, at best a useful object. Certainly it has an uncontested place in a museum, but not among the exhibits and, being unplumbed and too exposed even for French tastes, no longer useful. So is art something that has no use apart from being looked at, that can be exhibited provided you have a name and a story to go with it, that turns up unexpectedly, that comes out of everyday life, that looks good in spite of itself, that has the mass-produced qualities of 20th-century craft, that cannot be explained in the standard terms of art criticism, that the artists themselves cannot explain? Such questions went on being asked by artists such as Andy Warhol throughout the century. But the fact that they come so readily to mind when you look at the work might indicate that such works are as much literary as visual, often depending on

titles, word-plays, and jokes. Another Duchamp work in the room – *Hat Rack* – contrasts the plainness of the title with the undoubted spider-like elegance of the object, this time somewhat closer to a craft work but not the craft of the artist who presents it as ready-made, and no longer useful, since it has made it to an art exhibition.

OTHER DADA ARTISTS AND THEIR WORK (ALL IN ROOM 4)

The Cubists had introduced assemblage into their frames with bits of paper, card and cloth. Dadaists loved assemblies: witness **Jean Arp**'s (1886–1966) *Trousse d'un Da*, an artist's kit of much-loved driftwood and **Raoul Hausmann**'s (1887–1971) *Spirit of our Times* or *Mechanical Head*, which makes a robotic figure from a milliner's tools. Arp is looking for objects that bring art in touch with nature. Hausmann is using an old craft to presage the future – and indeed the textile crafts are now virtually roboticized.

Hausmann's *Portrait of the Artist* and **George Grosz**'s (1893–1959) *Remember Uncle Auguste the Unhappy Inventor* testify to the spread of Dada to Germany where it would have a longer life than in Paris. In these, the human and autobiographical content is dominant within the Dada assemblage techniques. Hausmann's is a reminiscence of his earlier activities in the Dada movement. Grosz gives an ironic portrait of a half-flesh, half-manufactured man apparently ready to slit his throat. Grosz would progress to more mordant social commentary as his native Germany (he became an American citizen) descended into crisis and hell.

Elsewhere in the room **Francis Picabia**'s (1879–1953) *Tabac-rat* sits between the Cubism of the past and the abstract minimalism of the future. The few words on it suggest a sort of obscure concrete poetry so isolated in a large and fragile space that it is only a background whisper.

ABSTRACTIONISM

The middle rooms of Level 5 represent the art of the period from the end of World War I to the 1950s. In spite of the catastrophes that beset Europe, Paris continued to be the center of western art. The United States would not assume its cultural dominance until the 1950s.

Much of the ideological trench warfare of this period is waged over the opposition between figurative and abstract art. From today's perspectives this is no longer a clear-cut opposition. A long

view of the history of art might set abstraction and figuration as fixed ends of a spectrum with many intermediate points. Ancient Greek and Christian art, to take two European examples, both have periods of greater or lesser abstraction and figuration. In the case of Christian art, this opposition is argued over with just as much intensity as the aesthetic ideologues of the 20th century invested in their positions.

In essence a purely abstract work has to communicate with its own internal properties – shapes, colors, textures, and so on – whereas a figurative work refers to and interprets the world outside itself. But in many respects both ends of this apparent spectrum meet. Colors and shapes have explicit cultural meanings for us – a golden circle is a sun, a crescent the moon, blue is sea and sky, green and ochre are the earth, and so on. Flags are ready-to-hand examples of abstract shapes with symbolic content. The reverse can be said of figurative works – painters arrange recognizable objects in compositions that can be enjoyed for their abstract messages. Eventually throughout the century, and often within the work of one artist, various kinds of abstraction and of figuration overlap.

In the Pompidou collection, the extreme end of Abstractionism is illustrated by a number of Geometric Abstractionists, whilst figuration is best represented by various Surrealists. (The very terms, however, suggest that both kinds of art have a major common thread in that they reject realism.)

Key Abstractionists in the Pompidou are the Dutch group de Stijl, of whom Piet Mondrian is the best known, Kandinsky, Léger, Brancusi, Duchamp, Kupka, Picasso, César, and Robert and Sonia Delaunay. Of various origins in Europe, all of these gravitated to Paris during their careers.

FERNAND LÉGER 1881–1955
La Noce (Wedding), 1911 Room 9
Le Réveil-Matin (The Alarm), 1913 Room 9
Contrastes de Formes, 1913 Room 9
Femme en Rouge et Vert (Woman in Red and Green), 1914 Room 9

In Léger we already see a paradox of the Cubist movement, that it lasted only a few years but had an enormously far-reaching influence. Léger, as we saw in a 1909 work (*The Seamstress* in Room 3), painted the monochrome arrangements of geometric forms that characterized the Cubism of Braque and Picasso. From

1911, he was already branching into a specific form of abstracting subjects, which focused on mechanical shapes and used color also to compose these shapes into patterns. Léger's transition into mechanical forms, christened "Tubism" at the time, was a deliberate move into what he saw as the future. The Italian Futurist movement (which would have an important role in Surrealism) had already proclaimed the idea that machines such as cars, planes and ships were beautiful forms in their own right and an ideal subject for art. Later generations would see them as such icons of the modern world that they would put them into exhibitions without any intervention of art. Of course, there were also artists who continued the romantic tradition of seeing machinery as the prime element of an oppressive industrial world.

ROBERT DELAUNAY 1885–1941
Une Fenêtre (A Window), 1912
Formes Circulaires (Circular Forms), 1912–13
La Ville de Paris 1910–12

SONIA DELAUNAY 1885–1979
Contrastes Simultanés, 1912

Before World War I, the French painter and his Russian-born wife were painting with the idea, also hinted at by Léger in, for example, *Contrastes de Formes*, that abstractions could be based on color as the principal element. Thus, with Sonia's *Contrastes Simultanés* and Robert's *Une Fenêtre (A Window)*, both from 1912–1913, color and shape are used to create a sense of movement, a quality distant from the static works of the Cubists. The colors themselves are of a brilliance that reminds us of strained glass and hence help the work to stand on its own without need of great explanation. Sonia remained a resolute Abstractionist during her life, whereas Robert was inclined to try out various styles, at the same time keeping to his bright colors and fairly geometric forms. *La Ville de Paris* is an example of his figuration from this pre-war period. The figures are seen as through a prism, in characteristic Delaunay coloring, but they are figures nonetheless with many references to classical paintings – three graces set against a cityscape. The poet Apollinaire in fact praised it as a return to "the great Italians." However true that is, it is also a fact that painting could no longer deal in apparently realistic forms. This was becoming the province of photography, as

MODERN ART: THE POMPIDOU CENTER

narrative would become the province of cinema.

The highly attractive painting of the two Delaunays, between the wars is represented later in the Pompidou collection as well as in the Museum of Modern Art of the City of Paris. It varies from strictly abstract work exploiting circular forms to monumental figuration.

VASSILY KANDINSKY 1866–1944
Landschaft mit Turm (*Landscape with Tower*), 1908 Room 10
Improvisation XIV, 1910 Room 10
Dans le Gris, 1919 Room 10
Mit dem Schwarzen Bogen, 1912 Room 11
Jaune-Rouge-Bleu (*Yellow-Red-Blue*), 1925 Room 26

Arbre Rouge, with its one recognizable shape and dominance of color, is in the manner that the Russian expatriate Vassily Kandinsky developed and made his own. We see Kandinsky deeply entranced by rich massed color in *Landscape with Tower*. In 1910, with *Improvisation XIV*, he suggests that figures and real forms, such as the tree, are principally subjects for understanding how color can be freely patterned. Essentially a descendant of the Fauves with his love of color as an expression of interior emotion, Kandinsky became more abstract as he filled his canvases with shapes drawn from organic life forms but not in any representational or symbolic sense – see *Dans le Gris* and *Mit dem Schwarzen Bogen*. Many Abstractionists, and Kandinsky was one of them, believed they were penetrating the hidden and elemental forms behind appearances. Within the boundaries of its frame and from its flat surface, the painting speaks for itself. Kandinsky is also shown in Rooms 16 and 26 (see the section on the Bauhaus school).

Two of the most engaging workers with abstraction are the sculptors Constanin Brancusi and Alexander Calder. The first is found in Room 16 and the second in Rooms 20 and 41. In Room 19 Pierre Bonnard exemplifies the persistence of figuration.

CONSTANTIN BRANCUSI 1867–1957
Muse Endormie (*Sleeping Muse*), 1910 Room 16
Le Coq (*The Rooster*), 1935 Room 16

Brancusi was born in Romania and worked in Paris. His atelier has been recreated by the Pompidou, outside the entrance in Rue Rambuteau. (The museum ticket gains you free entrance.) It

contains the works he bequeathed to the National Museum of Modern Art. Of the works exhibited on Level 5 (Room 16) both the early *Sleeping Muse (1910)* and the later *The Rooster* (1935) demonstrate his meticulous abstraction of figures. The metal is highly polished, the wood carefully crafted. Each reaches for the essence of its subject. The sleeping head relaxes into its own weight and its few serene lines. The rooster stretches towards the sky and its space is jagged with its crowing.

ALEXANDER CALDER 1898–1976

Calder was an American attracted frequently to the stimulating environment of Paris in the 1920s and 30s. Best known for his mobiles, Calder brings a great sense of good humor to his arrangements of wire and metal pieces. By all accounts, he could sketch with wire and pliers much as others do with paper and pencil. His work is uncomplicated and unpretentious, but it is hard not to get lost in the contemplation of its grace, humor, and movement. Calder has an outdoor sculpture at La Défense, whose great arch can be seen from the Arc de Triomphe at the head of the Champs Elysées.

PIERRE BONNARD 1867–1947

Pierre Bonnard maintained throughout his life many of the values he derived from Gauguin and from Japanese art. A colorist of charm and a lover of female nudes, Bonnard contrives by means such as overhead views to flatten the space of the picture and expose the interaction of vertical, horizontal, and diagonal lines in its composition. Traditional subject matter serves many of the same ends as more abstract works. Room 19 contains a number of his intimate scenes.

OTHER ARTISTS AND THEIR WORKS (ROOMS 10 AND 11)

In the vein of Léger's mechanical imagery is **Francis Picabia**'s *Udnie*. The Parisian Picabia (1879–1953) took part in a number of movements, first and briefly Cubism. *Udnie* is an example of his work as one of the very first and doctrinaire Abstractionists. The name of the painting is taken from that of a Spanish dancer, but this knowledge adds virtually nothing to an understanding of the painting, unless you take the compositions of more or less receding diagonals and some of the spinning shapes to represent the

movements of a dance. It's probably more faithful to see it as a complex assembly of abstract shapes derived from Cubism but pushing abstraction into color and movement. In the World War I period, Picabia, with his *Arbre Rouge* (Red Tree) and the Czech-born **Frantisek Kupka** (1871–1957) with *Plans Verticaux* (1912) embody two more directions for Abstraction.

A similar view of painting took a different form in Geometric Abstraction, which tended toward severity where Kandinsky tended toward the lyric. Geometric Abstractionism was born in the period around the World War I. Kupka's *Plans Verticaux 1 (Vertical Planes)* dates from 1912 and the major Dutch movement de Stijl was launched in 1917 by **Piet Mondrian** (1872–1944) and **Theo van Doesburg** (1883–1931). See their work in Room 14.

There is nothing much in any of these geometric abstractions to tie them to reality. Lines, squares, rectangles, primary colors (or black and white) and unforgiving titles, such as *Vertical Planes* (Kupka), *Composition in Red, Blue and White II* (Mondrian, 1937), and *Composition X* (van Doesburg) mark them all. From the same period the Russian **Kasimir Malevitch** (1878–1935) offers no more enlightenment in *Croix Noire* (Black Cross). The artists deliberately wanted to confront their public with what they saw as the fundamentals of art, the values always present in any kind of art, here presented in their "pure form." Some degree of abstraction is inherent in the art of any period. Qualities such as balance, harmony, dissonance, composition, underlying form, movement, repose, and so on are integral to the discussion and understanding of any painting. What we have to do as viewers is maintain our attention without the added (but perhaps distracting) richness of figures, narratives, and symbols. Mondrian himself towards the end of his life – he had been in England and had moved to the US – thought his work needed to be more expansive. *New York City 1* (1942) is a sample of the result – an idealization of the city's grids and towers.

The rather aggressive ideology of much Abstractionism resulted in equally strong defenses of figurative art. In retrospect, these are very loose terms covering many different and overlapping styles, but they remain a rough guide to artists' thinking. Of course, individual painters, as well as movements and groups oscillate between the poles. Malevitch, for example, painted a plain black square (*Carre Noir*) towards 1930 and three years later a child-like figure in a basic landscape in *L'Homme Qui*

Court (*Running Man*). Picasso too, quickly departed from the geometry of Cubism to explore successive ways of seeing the human figure: different profiles presented simultaneously, figures in the manner of African art, flattened figures, rounded figures, classical figures in Mediterranean settings, and figures in surrealist landscapes.

BAUHAUS

Abstraction continued to be a major concern of 20th-century painting, with painters developing both the minimalism of Mondrian and the lyrical movement and color of Kandinsky. Abstractionism also entered directly into modern landscapes and living spaces via the teachings about art, architecture, and design of the Bauhaus. This was a school and workshop founded in Germany in 1919 by the architect Walter Gropius. Although the Bauhaus was closed by the Nazis in 1933 (Fascist art reverted to a frigid variety of imperial classicism), its influence on 20th-century aesthetics was immense and is still with us. Essentially, the unadorned geometry of typically 20th-century buildings and interiors is a legacy of the kind of thinking crystallized at the Bauhaus. We should not, however, blame the Bauhaus for so much of the rubbish that was eventually built in our cities. The Bauhaus renounced ornament and stressed function. It was enough, indeed it was imperative, that the form of a building, a town plan, or a piece of furniture should derive its strength from fulfilling its purpose, but part of that purpose was to be aesthetically satisfying and thereby socially satisfying. So the abstract qualities of objects remained as important as they had been to the makers of the Parthenon. What changed were materials (which had become much more flexible) and purposes.

PAUL KLEE 1879–1940
Der Hirsch (*The Deer*), 1919
Pfeil im Garten (*Arrow in Garden*), 1929
Rhythms, 1930

The Bauhaus was a multimedia school in which painters were especially important. Paul Klee, a Swiss painter, was there for ten years up to 1930. The Pompidou has a good number of paintings from the Bauhaus period of both Kandinsky and Klee. For Klee, literal reference to the visible world was a distraction from the possibilities of imaging spaces and forms within them. Simple basic

forms – squares, lines, circles, triangles – and clear colors are used in paintings such as *The Deer* and *Arrow in Garden* to create a mix of natural and abstract objects assembled into imaginary landscapes. *Rhythms* shows Klee in purely abstract mode, experimenting with texture and reducing colors to focus on balances and hand-drawn lines.

OTHER ARTISTS AND THEIR WORKS (ROOM 26)

Kandinsky went to work and teach at the Bauhaus in 1922 and stayed until it was closed, when he moved to France. Kandinsky's *Auf Spitzen (On the Points, 1928)* and *Akzent in Rosa (Rose Accent, 1926)* express his utopian view that fundamental natural forms such as points, lines, and flat geometric surfaces are sufficient elements for compositions that express universal relationships. **Joan Miró** is also displayed in this room.

SURREALISM

The Pompidou Center has an instructive sample of Surrealist work – enough, in fact, to have mounted a special travelling exhibition in 2002. Many figurative painters did not belong to groups or subscribe to manifestoes. Of those who did, the Surrealists are the most notable and influential. Major surrealists are Giorgio de Chirico, Max Ernst, Joan Miró, Rene Magritte, Salvador Dali and the photographer Man Ray. Surrealism was both a literary and artistic movement. The word was coined by the poet Guillaume Apollinaire and popularized by André Breton in his 1924 *Surrealist Manifesto*. Breton had been closely associated with Dada; indeed the same spirit of rejection – of convention, of logic – characterized Surrealism. Most significantly for its times, Surrealism opposed itself to rationalism. Surrealist writers experimented with automatic writing, allowing words to come spontaneously, without judgment. The focus on everyday objects as objects also of artistic interest would re-emerge years later in Pop Art. In the early days of the movement Surrealists exhibited as a group and conducted polemics in their magazines. The movement attracted artists from Europe and America to Paris, further confirming the city as the cultural capital of the western world.

GIORGIO DE CHIRICO 1888–1978
Portrait Prémonitoire de Guillaume Apollinaire, 1914

De Chirico is a fundamental figure in Surrealism, which was, one could say, born out of a coupling of his work with Dadaism – André Breton being the matchmaker. His *Portrait Prémonitoire* gives us a full account of de Chirico and of Surrealism. Essentially, objects and figures are sharply defined against geometric landscapes so that each is isolated from the other like a display of sculpture. The viewer must read each item carefully for its meaning and symbolism and then ponder their connection.

In the background is a portrait in profile of the painter, drawn to resemble the profile of an emperor on a coin. The profile is framed by a window and has a white dot on the forehead – an assassin's-eye view. This work was reportedly first called *Target Man (Homme-cible)* but was changed to *Premonitory Portrait of Guillaume Apollinaire* when the poet was wounded by a bullet in 1916. Was the painting originally about Apollinaire? The other two objects – a stele on which are carved a shell and a fish, and a bust in the ancient Greek manner of Orpheus – associate it certainly with music and poetry. The sunglasses can be taken to symbolize blindness, and perhaps the often doom-shaped foresight of the seers of ancient mythology. The presentation of the portrait as a shadow outline and the tilt of the background can be taken as indirect references to the developing arts of photography and cinema, which irrevocably changed the century's ideas about visual art. So the painting works as a double homage to the poet and to de Chirico's own Mediterranean background (he grew up in Greece). It is, however, shadowed by darker symbols such as those one sees in dreams or that lurk in the subconscious mind: the poet is a target, figures and objects are disembodied, sharply delineated, ambiguous, bizarre, threatening.

For all its innovation, Surrealism shares the literary elements of the academic painting of previous centuries, which it both refers to and rejects. De Chirico's theme remains relevant today and may come as something of a mental relief after rooms full of abstractions, which eschew questions of relevance.

SALVADOR DALI 1904–1989
Hallucination Partielle (Partial Hallucination), 1931
*Lion, Cheval, Dormeuse Invisibles (Invisible Lion, Horse, and
 Sleeping Woman)*, 1930

A Catalan painter who spent much time in Paris, Dali probably did much more than the founders of Surrealism to make the movement a scandalous success. He managed this both by his behavior and his painting. Along with Picasso and much later Andy Warhol, Dali understood that art could be a branch of entertainment and that, for an artist, entertainment meant provocation. This is not, however, to denigrate Dali's art, which was not only provocative but also thoughtful, skillful, and very influential. Dali especially delves into the unconscious irrational world that was just beginning to be investigated by psychologists. The character of this world can be dream-like, overwhelming, ambiguous, bizarre, and monstrous. Ideas and images come together as in nightmares by free association, as in *Partial Hallucination* with its six images of Lenin on a piano. The heads glow, the notes of music become ants, the seated figure is some kind of medical orderly and there is perhaps a regular household outside the half-open door; but inside the room the irrational reigns. In *Invisible Lion, Horse, and Sleeping Woman*, the central figure is a series of metamorphoses between the two animals and a woman such that the figure is none of the three. The landscape is, as we would say today, surreal – vast, empty, and inhuman despite the figures, and dotted with architectural elements. It is the sort of landscape that would become standard in science fiction illustration. Dali would evolve these landscapes to evoke paranoia, most famously in Hitchcock's *Spellbound*.

OTHER PAINTERS AND THEIR WORKS

The German painter **Max Ernst** (1891–1976) moved to Paris in 1919, already a Dadaist and an admirer of de Chirico. He was in the US during the 1940s and was briefly married to art patron Peggy Guggenheim. His *Ubu Imperator* (1923) is an ironic commentary on figures of authority and power – a mixture no doubt of father figures and political potentates. The image is large and seemingly invulnerable but is balanced on the point of a top, which presumably must keep spinning to stay upright since it has no other support than its own activity. The heavy armory is contrasted to the tiny hands raised in a don't-blame-me gesture suggestive of the rhetoric that sustains tyranny.

The photographer **Man Ray** (1890–1976, real name Emmanuel Rudnitsky) was an American in Paris from 1919. A close friend of Marcel Duchamp and a dedicated Dadaist, Man Ray worked the boundary between painting and photography, largely to challenge

Giorgio de Chirico's Portrait of Guillaume Apollinaire

the presumption that photography could only be realistic. *Le Violon d'Ingres* (*Ingres' Violin*, 1924) is a back view of a nude Parisian beauty, Kiki de Montparnasse, with the sound-holes of a violin drawn on her body. The classical perfection of the model's body and her turban relate the image to the 19th-century French painter Ingres, whose *Turkish Bath* of teeming nudes with headresses is in the Louvre. The title, however, is also a pun. Ingres loved playing the violin and the phrase came to mean a hobby – in Man Ray's case, either photography or nude women.

Rene Magritte (1898–1967) led the Surrealist movement in Belgium. He is possibly best known for his *Modèle Rouge* (Red Model), which shows a pair of boots turning into feet against an anonymous background, by implication questioning where one ends and the other starts. Magritte explicitly exploited the literary side of Surrealism as a comment on painting in *Querelle des Universaux* (*Dispute about Universals*). Here, instead of images, the words foliage, horse, mirror and cannon (or canon – the French is the same) are written on rock-like shapes around a white star. Should we supply our own mental images for these words and shapes thus creating a surreal landscape of our own imaginings and fears?

Joan Miró (1893–1983) was introduced to French Surrealists by his fellow Catalan, Picasso. His painting, however, is considerably more abstract and fantastic than most other Surrealists. An admirer of Paul Klee's painting, Miró goes in a similar direction with his fantastic and child-like landscapes and compositions. *La Sieste* (*Siesta*) could, as the name suggests, be a human form resting under a blue sky in which a few objects swirl in the wind, or it could be a selection of chance images seen in a half-waking state.

TRAIL 2:
Other Museums of
Modern Art

A second excellent collection of modern works can be seen at the Musée de l'Art Moderne de la Ville de Paris. Like Level 5 of the Pompidou, this museum focuses chiefly on modern art to 1960. You will see more of each of the movements from Fauvism to Abstraction, a good number of works by Sonia and Robert Delaunay, the work of Pierre Bonnard, some large figurative works by Henri Matisse, and Raoul Dufy's gigantic homage to power, *The Electricity Fairy*.

For the most part it features French painters involved in Fauvism, Cubism, Dada, Surrealism, and Abstractionism. It also has a number of works from the so-called School of Paris – artists who lived and worked in Paris, such as the Italian Modigliani and the Russian Chagall.

Musée de l'Art Moderne de la Ville de Paris

Location: 11 Avenue du President Wilson in the 16th arrondissement. Metro Iena or Alma Marceau

Opening Times: Open 10:00 am–5:30 pm (6:45 pm on weekends). Closed Mon.

Admission: 7.62 Euros (full price), 6.10 Euros (discount), 3.81 Euros (youth) Free for seniors. The museum contains a low-priced restaurant.

In this museum, the Fauves are represented by Matisse and early works of Braque, Derain, and Robert Delaunay. Matisse's later work, from the 1930s, is exemplified by simple, dancing figures that explore line and mass rather than color. The Cubists paintings feature both Picasso and Braque, while works of Léger and Robert Delaunay demonstrate the movement to abstraction that accompanied Cubism. The work of the Delaunays is especially well represented; you'll see works by Robert,

who moved between figurative and abstract imagery; and Sonia who stuck to a colorful Geometric Abstraction. Georges Rouault's transition from secular Expressionism (*Fille*, 1906) to bold but contemplative religious works (*Crépuscule*, 1938) is clearly illustrated.

Two French painters who worked somewhat outside of art movements – Pierre Bonnard and Édouard Vuillard – are represented by characteristic works. Early in their careers, from about 1890, they identified with a group self-styled "the Nabis" (a Hebrew word meaning prophets) who sought to create beautiful images based chiefly on rich color. Each subsequently developed personal styles without allying themselves further to movements. Deliberately decorative in their painting and interested also in other decorative arts, their work has influenced modern design.

Upstairs in the museum is one of the world's biggest paintings: Raoul Dufy's *La Fée Électricité* (*The Electricity Fairy*). This huge work was commissioned in 1936 by the Parisian Power Distribution Company for an International Exhibition in the following year. Its heroic view of its subject is a reminder of the excitement and optimism that new technology once engendered.

Musée Picasso

Location: 5 Rue de Thorigny (3rd arrondissement) Metro St Paul
Opening Times: Open 9:30 am–6:00 pm. Closed Tues.
Admission: 5.5 Euros, 4 Euros (discount)

Espace Salvador Dali

Location: 11 Rue Poulbot, Espace Montmartre (18th arrondismseent) Metro Abbesses
Opening Times: Open daily 10:00 am–6:00 pm.
Admission: 6 Euros

Two individual artists can be followed up in the Musée Picasso and the Espace Salvador Dali. Picasso was a very productive artist, sometimes cynically so, and the Picasso Museum accordingly is a large collection that illustrates the many styles he experimented with and his great skill even when he was churning stuff out and playing to the market. Dali's art is less well represented in the Espace Salvador Dali, but his capacity to combine art and showbiz (which would later become almost a necessity for artists) is always enjoyable.

SECTION 4:

WORLD ART IN THE LOUVRE

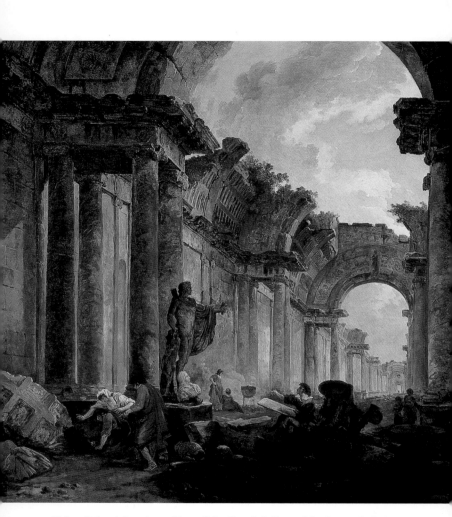

Hubert Robert's Imaginary View of the Grand Gallery of the Louvre in Ruins

Introduction

Cézanne said "the Louvre has all we need." Indeed, it contains so many treasures of art it is hard to know where to begin. If you don't want to be overwhelmed by one of the world's biggest galleries, you must learn to treat it as a collection of galleries within the one institution. It would take months to get through the lot, and it is foolish to even contemplate it. In this section we feature two Trails. The first focuses on the art of ancient Greece and can be managed in a good half-day. The second looks at Italian and French painting and requires a solid day. Medieval art in the Louvre has already been covered in Trail 2 of Section 1.

Of course this leaves out many interesting collections. The Egyptian collection, for example, is fascinating and excellently presented, but it is more about what archaeology reveals of life in ancient Egypt than it is about art. The collection of *objets d'art* is endlessly fascinating, as are the collections of art from the ancient Middle East and Orient – which can be further supplemented (an audioguide included in the ticket price) at the Musée Guimet. The Department of Prints and Drawings contains thousands of works, including gems by Mantegna, Durer, Michelangelo, Rubens, Rembrandt and Millet.

Charts of the three floors are shown in this section, and plans are also available at the Information Desk near the entrance.

The Louvre itself is vast and handsome. Begun as a fortress in Merovingian times and expanded by various kings, it was not occupied by French royals until the 16th century. Then, after Louis XIV left the Louvre for Versailles in 1674 the royal collection was set up in the Louvre, which was gradually designed as a gallery and greatly improved in Louis XVI's time by the painter and master of King's collection, Hubert Robert. The French Revolution decided that it should be a museum for the people and added many confiscated works to it. During the 19th century the run-down palace was restored and enlarged. This was the beginning of the series of grand projects to rebuild and expand the museum, which continue to this day. One of the most controversial works of the late 20th century was the glass pyramid which now crowns and lets light down into the splendidly organized entrance gallery below.

There are three wings of the museum – Denon, Sully and Richelieu.

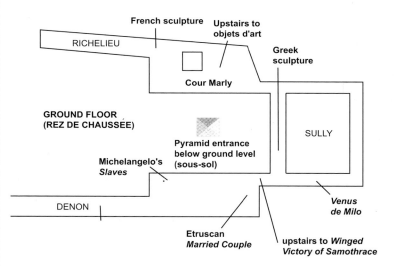

Ground Floor of the Louvre

For upper floors, see page 264

TRAIL 1:
Greek and Etruscan Art

The Louvre

Location: Entrance from Rue de Rivoli or the Tuileries garden. Metro Louvre, Palais Royal

Opening Times: Open 9:00 am–6:00 pm (9:45 pm Mon., Wed.), closed Tues.

Admission: 7.50 Euros. Reduction to 5 Euros applies after 3:00 pm and on Sundays

The Louvre has one of the most notable collections of Greek art outside Greece. Greek antiquities start on the ground floor of the Denon wing.

The first rooms you enter are labelled Pre-Classical and start with Cycladic Art in Room 1a. This display area is converted from the old stables of the palace. It contains eleven cases of art from around 3000–2000 BCE.

The period from about 700 BCE to 480 BCE is known as the Archaic period. It produced probably the most attractive marble statuary to survive in original form. Much classical statuary was of bronze and other recyclable materials and is known only through the marble copies that originated mostly in Roman times. The chart gives an overview of the various periods: the Louvre's collection is presented chronologically so it is useful to follow it.

Room 1a

Cycladic vase identified as Kandela 2200–2700 BCE

This is in the first case as you enter. The artists of the Cycladic islands reached a very high standard in working marble and stone, using tools of emery, blades of obsidian, and some sort of lathe. Like most *objets d'art* through to classical times, it probably had a religious use. The holes in the handles suggest that it might have hung in a tomb.

GREEK AND ETRUSCAN ART

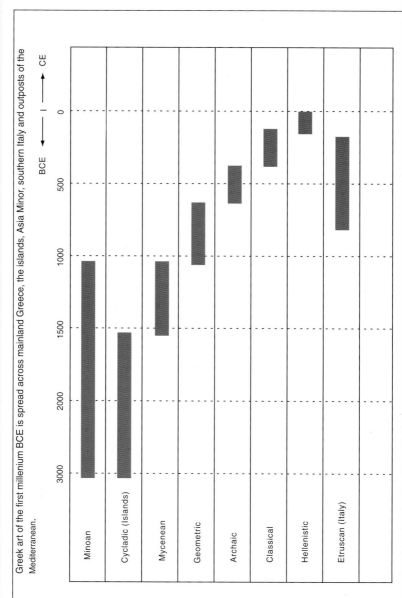

Greek art of the first millenium BCE is spread across mainland Greece, the islands, Asia Minor, southern Italy and outposts of the Mediterranean.

Cycladic figures, marble violin-shaped figures, from 3200–2700 BCE, spade-shaped figures, from 2700–2300 BCE

There are two general shapes among the figures in the case behind the vase. The so-called violin shapes are thought to have been human figures and to have had features painted on them. The figures could be limbless torsos, probably female. The spade shapes could be heads and shoulders. The driving force behind these representations is abstraction. Could this be because they are gods or creatures from another world? Their makers left no written records and we have no way of resolving such questions. Their charm suggests however that they were never meant to be evil.

They exist at the same time as much more developed figures, of which there are also examples in this room. See, for example, the case to the right.

Cycladic Figures: Groupe de Syros, marble, 2700 BCE–2300 BCE

Cycladic figures developed in this manner are usually female. Some were probably recumbent but some are seated. Their main aspect is frontal. The odd shape of the head might mean there was a head-dress or elaborate coiffure that would have been painted on, along with the missing features. The crossed arms with the shorter upper arms indicate that the sculptors adhered to a common set of proportions. They are often presumed to be of goddesses.

Beside these in a case by itself is a head.

Cycladic Head, marble 2700 BCE–2300 BCE

This head, from a four-foot statue from Keros, has carved ears as well as a nose. The slight tilt sideways of the head gives it is quizzical look now that was probably not present in the painted original. In its present state, it suggests the abstraction of Modigliani or the giant figures of Easter Island.

Nearby, to the right, in a case alone is a gold jug.

Gold Jug, c.2200 BCE

The clean and elegant shape of this jug justifies its being attributed to Cycladic workmanship and the preciousness of the

metal makes it irresistible. It was probably used – among other things – for ritual offerings of fluids known as libations. The wings on the sides of the spout suggest the form of a bird. The bird form is echoed in the much later pottery jars with upturned spouts in the case against the wall to the right. The handle is riveted on and artfully decorated with chevrons. Such work must have been prized beyond the Cyclades and been an object of trade and prestige on mainland Greece. Like the sculptures, this artisanship appeals enormously to the modern taste for its simple, clean lines.

Vases in Minoan Style, 1400 BCE–1200 BCE

The Minoan art of the island of Crete from about 3000 BCE was distinct from other Greek art and dominant in its region, but by the end of the second millenium BCE it came under the influence of the mainland empire of Mycenae. The case with a large vase decorated with an octopus also contains a smaller vase with two goats and a palm tree as the principal motifs. The latter is also decorated with fish. Both vases illustrate the freedom of Minoan decoration. Lines and shapes are sketched on with assurance. The form of the animals is adapted readily to the shape of the surface.

In the case to the right, on a top shelf, you'll see:

Bull Rhyton, Minoan

The bull is a persistent symbol of Minoan art. The term Minoan refers to the legendary King Minos who kept a minotaur (half man, half bull) in a labyrinth until it was killed by the hero Theseus. Bulls feature in many sacred and sporting contexts in noted Minoan paintings from Knossos and on vases and precious objects. This bull is a rhyton – that is, a vessel from which fluid was poured at rituals. The original would have been painted to make it even more handsome.

Room 1d

As you move into Room 1d, there is a small bell-shaped pottery work in a case on its own.

Idole Cloche, terracotta, c.700 BCE, from Thebes

Thebes was in central Greece where the art was often more rustic than that of the coasts and islands. This curious object comes from a period between the end of Minoan and Mycenaen and the beginnings of Classical work. The period is characterized by geometric decoration that includes more figures as the centuries pass. It is taken to be a goddess and experts say that the shoes might indicate that it is Artemis, the huntress, but obviously not in her fully athletic guise.

In the same room, you'll see, standing in its own case and a bit broken:

A Loutrophore (The Analatos Amphora), attributed to the Painter of Analatos, 690 BCE, from Attica

The vases of the geometric period are very appealing. This is a noted one attributed to the Painter of Analatos. In most cases, the naming of vase painters is a modern categorization based on a noted work. A few vase painters, however, are known by name because by the late 500s BCE they were signing their work. The centerpiece of this is a procession of chariots drawn by two horses, both of which are shown. The charioteers have big eyes and funny noses. The horses have thin legs and bodies with lavish manes. The spaces around the chariots are filled in with what looks like abstracted landscape symbols – wavy lines for water, cactus-like shapes for vegetation and inverted Vs, possibly for land. Between the highly ornate handles are, from the top, sphinxes, rosettes, dancing couples and a zig-zag. The sphinxes are drawn to emphasize the form of a stalking cat, the wings laid back on the body, the legs sinuous and springy. The dancing couples – the male dark, the female in patterned dress – are dancing to a flute player as they would on many, many vases to come.

To the left, against the wall, you'll see one of three large jars in a group.

Jar from Crete, terracotta, 675 BCE

The images on this very large storage jar are from the so-called orientalizing period that overlapped the end of a geometric period. They indicate the artistic exchanges that took place between the Greek world and the civilizations of Egypt and the Middle East, for example in the use of animal and figurative motifs. The legendary motifs on the jar are griffins in the upper row and below, a circle of images of a young man falling under or perhaps off a winged horse.

GREEK AND ETRUSCAN ART

Back in the top row is an image of possible sexual harassment from ancient times. A naked man is making a grab at the pubic region of his female companion who is still dressed. Headdresses – which may be wigs – have an Egyptian flavor to them.

Moving further up the room towards Room 1e is a less than life-size cylindrical female figure on a pedestal.

La Dame d'Auxerre (The Lady from Auxerre), limestone, 640 BCE, probably from Crete

She is said to be from Auxerre simply because her first museum home was in Auxerre. She actually probably comes from Crete and is therefore said to belong to a Daedalic style (Daedalus was the legendary designer of the labyrinth at Knossus). She wears an elongated bell-shaped skirt that is decorated with patterns of squares within squares. She has prominent feet, a long face, elaborate curls, a belt that nips in the waist and breast and nipples glimpsed from under her clothing. She has a cloak over her shoulders, one arm glued to her side and the other – with very long fingers – against her breast. The experts discuss the meaning of the gesture but agree that this, as with most monumental art of the period, almost certainly has religious meaning. She may herself be a goddess or she may be being offered to a god or goddess. The patterns on the dress and the features would have been painted.

A little further on, again in the middle of the room, is another female figure, this time life size.

The Kore of Samos, marble, 570–560 BCE

Female figures are clothed and called kore (plural korai); male figures are nude and called kouros (plural kouroi). Fragments of both can be seen displayed around the Samos Kore.

The Samos Kore was dedicated to Hera (a goddess of nature who married Zeus on Samos) by an obviously wealthy person known as Cheramyes. His dedication naming himself and Hera is written from bottom to top along the vertical hem of the garment falling in front from waist to ankle. The overall shape is pretty much that of a column but the sculptor has made an enormous amount out of the lines of the drapery. She has similarities to figures at Chartres (see Trail 5) in her three garments. Although the figure is column like in outline, it does not seem heavy.

Towards the back of the room on the right, you'll see:

Head of the Rampin Rider, head marble, body a plaster copy,
c. 560 BCE, from the Acropolis of Athens

Before the building of the classical Acropolis whose ruins are those
we see today, Athens had temples and other buildings in the Archaic
style. The Persians destroyed the older Acropolis in 480 BCE. The
Athenians buried all the smashed pieces that they thought valuable
and they remained there until German, French, and English
archaeologists dug them up in the 19th century. One got away with
the head of a horseman, which had been separated from the torso.
This is the head you now see. It shows the famous Archaic smile,
and the exquisitely detailed work on the hair and beard that was
characteristic of the style. Traces of red paint are visible. The
original of the body is in the Acropolis museum in Athens.

To the left of the Rampin Rider is a black figure vase.

Black Figure Vase

The vase typifies the iconography of Greek vases through its various
periods. The majority of vases are either black figures on red
backgrounds or (later) red figures on black backgrounds. Both styles
gave the painters scope to experiment with drawing techniques and
subject matter, often with more freedom than could be exercised on
public sculpture. Vases might also give an indication of the style of
Greek wall painting, apparently also copious but now almost entirely
lost. The front of the vase depicts a scene from mythology: the birth
of Athena. The goddess is born fully dressed and armed. Zeus is
superintending the birth. Ares, the god of war and carrying a shield,
is behind the newborn, watching. The museum label speculates that
the other two figures might be Poseidon, god of the sea, and
Amphitryon, who was cuckolded by Zeus to produce Herakles. On
the back of the vase is Dionysius, god of revelry and ecstasy, with a
goddess and accompanied by satyrs, those randy creatures of the
woods who are part human and part goat.

A little further on in its own case, is:

Athlete, bronze, c.470

This athlete has just won an event or series of events and is making
a libation to the gods in celebration. By comparison with Archaic

marbles, the pose is more active, the musculature more delineated, the body more detailed. The buttocks are particularly powerful. It is really noticeable that the face exudes quiet confidence rather than pride. The hair is less of a detailed feature than in Archaic statuary but it is still patterned and remains a distinct item of decoration. The famed bronze charioteer at Delphi has a similar expression.

If you can resist Coptic art, in Room 3 on your right, proceed ahead to Rooms 4–15. Otherwise, at least have a look at the 5th-century view of Mary, in the center of a case on the right. She is spinning and suddenly startled by the appearance of the archangel Gabriel with the news that will change her life. Note also how completely the early Christian world has left Greco-Roman art behind.

Next we encounter works of the Classical period, from 480 BCE–400 BCE. This is the period of the Parthenon in Athens. With it is work of the 4th century, as well the period known as the Hellenistic period, which is usually dated from the death of Alexander the Great in 323 BCE to the Battle of Actium in 31 BCE. Much of the art of all three of these periods was either destroyed or dispersed by the Romans or in recent times by the activities of archaeologists, museums, curators, and collectors. A very large proportion of the famous statuary of this period was in bronze, which was destroyed and re-used. The gigantic works of Phidias, who superintended the building and sculpture of the Acropolis, were made of gold and ivory on a wooden superstructure and inevitably plundered once the works lost their sacred significance. The two centuries teemed with sculptors of note. Among those whose names have come down to us are Phidias, Polyklitus, Alcamenos, Skopas, Myron, and Praxiteles. The problem for viewers today is that the greater part of the work of these sculptors is known only through marble copies made in Roman times. There was obviously a substantial market for these copies because these statues – some good, some dreadful – are scattered around the museums and collections of the world. At the time, they probably had the status that reproductions have now.

Scholars take notice of these works because they can deduce trends in the history of Greek art. Over the centuries they have often been highly praised and provoked further imitation but the fact is that art tourists do not generally cross the world to see reproductions. Still, they are the nearest we can get to the work of these periods and some are impressive in their own right.

The copies are in Rooms 14, 15, and 16. They are beyond the collection of slight fragments from Olympia and the Athenian Acropolis.

Room 14

Copy of Polyklitus'
The Athlete's Torso of 430 BCE

Copy of Phidias'
Apollo of 460 BCE

Copy of Polyklitus'
A Wounded Amazon of 440 BCE

Of these three, Polyklitus seems to fare best at the hands of the copyist. *The Athlete's Torso* is a balance between the real and the heroic. The curve that runs right down the front of the torso is a firm statement of the line that the sculptor is following and on which the body will be harmonized. In general, it appears that the sculptor of the high Classical period would have still emphasized clean lines and the total geometry of the figure, though obviously he is also exploiting the athlete theme to show the play of muscle and sinew in the body and enhance his design. The copy of the Phidias *Apollo* makes it look a softish figure. Both this copy and the copy of Polyklitus' *Wounded Amazon* have allegedly superior versions elsewhere. Indeed the copyist of the Polyklitus piece signed his name (Sosicles) on the copy in Rome.

Room 15

Here you will find copies of statues of Persephone and Athena whose originals were by Phidias, an Ares copied from Alcamenos, and a marble Athena copied from a bronze statue in Piraeus.

The Persephone is known as the *Kore Albani* because the version in the Villa Albani is said to be better. It is attributed to the workshop of Phidias and is in the wet T-shirt style. The enormous Athena called the *Minerva Ingres* is a copy of one of Phidias' gold and bronze constructions of 440 BCE. In marble, it is a massive, stately figure, with much of the effect coming from the highly worked drapery from which only the right leg protrudes. The statue of Ares known as the *Ares Borghese* is a copy of a work by Alcemenes. The figure is relaxed, with its weight carried more on one leg than the other. The anatomical features are still fairly abstracted, evoking memories of kouroi. The original bronze of which the marble Athena is a copy can be seen in Athens in the Museum of Piraeus in Athens. Once you have seen the bronze, the copy holds precious little merit.

On the left side of Room 15 is a large Athena called Pallas de Velletri opposite the copy of the Phidias Athena.

Room 16

This is full of copies of works by Praxiteles, the most celebrated Greek sculptor of the fourth century BCE. It is probably the characteristics of Praxiteles' sculpture that many – including a legion of Roman copyists – associate with Classical Greek sculpture. In fact it is a comparatively softer, dreamier kind of sculpture than Greek sculpture at its Classical peak. We will view two world-famous pieces.

Aphrodite de Cnide (Aphrodite of Knidos), marble, copy of a statue from 350 BCE

The *Aphrodite of Knidos* was Praxiteles' most famous statue in ancient times. The copy owned by the Louvre is a torso. There is a complete figure – also a copy – in the Vatican Museum in Rome. The height of the copy in Rome is over six feet, more than life size. This is said to be the first statue in Greek art of a completely nude female. It seems that Praxiteles, commissioned by the Island of Cos to make an Aphrodite, offered the islanders both a draped and a nude version. Cos took the draped version and the nude went to Knidos. The nude version was a huge success. It was often copied during Roman times and had many descendants, of which the celebrated Venus de Milo about 200 years later was one. The convention of depicting a bather in order to depict a nude persists well into the modern era in painting, photography, the popular press, and advertisements. The torso alone shows that this is a figure of many softened curves rather than any firm geometric rendering of a figure. The breasts are those of a youthful figure but the hips are more mature and have an amplitude that would facilitate childbearing. The erotic has not obliterated the reproductive. Why it was so popular in ancient times is perhaps much the same puzzle as why its close neighbor in the Louvre is so popular today.

Venus de Milo or *Aphrodite de Melos* marble, c.100 or 125 BCE, from the Island of Melos

This is an original, but by now anyone could be forgiven for wondering if they are looking at a copy of a copy. The Aphrodite of Melos is a clear descendant of Praxiteles' Aphrodite of Knidos. The S-curve of the body derives from Praxiteles and the face and the

body are in the fourth-century BCE style. Why is this statue so popular with modern tourists? She is a backdrop to countless photos of female companions and is an image that has launched a thousand advertising campaigns. The same tension of youthful breasts and generous hips is present if not even more exaggeratedly so. The left leg forming part of the "S" is so thrust out that the figure would probably have had to be balanced by the missing left arm. How the drapery was held up in that position is a bit of a puzzle. Perhaps the idea was an explicitly erotic one and it was in fact falling off. The head refers back to the features and hairstyles of Classical figures but the ambiguous positioning of the drapery is something more likely to be found in Hellenistic than Classical sculpture.

Go back along the gallery, past the Parthenon fragments, and straight into the room labelled Etruscan Art.

Etruscan Art

This Trail finishes with the small and exquisite selection of work from Etruria. Until the Latins made it part of their Roman empire, central Italy was controlled by the Etruscans. This people established a federation of city-states and traded extensively around the Mediterranean, especially with Greek settlements. What we know of the Etruscans is fragmented, partly because much of their culture was absorbed into Rome. Their surviving art, principally from tombs, is vigorous and distinctive and their former territories have yielded enormous collections of Greek vases either imported or made by local potters. Of particular interest is:

Terracotta sarcophagus of a man and wife, late 6th century BCE from a tomb in ancient Caere

The funerary statue of a married couple is the pearl of the collection. The coffin is made in the shape of a couch on which the life-size couple rests as though at a feast. According to funeral conventions, they are shown as they were or might have been at the peak of their lives – robust, handsome, outgoing and affectionate. Their smile – known as the Archaic smile since it appears also in Greek sculpture of the Archaic period – represents virtue, though happiness in our sense of the term is also present in the closeness and ease of the couple. The fine detail of drapery and decoration is characteristic of Etruscan work.

Bronze miniatures, various periods

Behind and to the left of the sarcophagus is a case of small bronzes that demonstrate the striking freedom of much Etruscan art. In contrast to the domestic realism of the couple, these miniatures show the Etruscan sculptors' taste for elongation and distortion.

Terracotta plaque, late 6th century BCE, from Caere

Also from a tomb in Caere are some fragments of painting which give a little sample of Greek and Etruscan style in painting. A being from another world is carrying off a woman – perhaps the soul of a dead person, perhaps a character from Greek or (the fairly similar) Etruscan myth.

Portrait of a man, 3rd century BCE, from Fiesole

This later bronze head shares its style with late Greek and early Roman sculpture where it is clearly intended to create a likeness of an individual. Even so, it is restrained and to some degree idealized. Later Roman work would become much more detailed and apt to probe the psychology of the subject.

Also on the ground floor beyond the Etruscan collection is some Italian sculpture, including the celebrated *Slaves* of Michelangelo (see the diagram of the Ground Floor, page 246). The fact that Michelangelo's intended adornments for the tomb of Pope Julius II were not completed has given them a unique strength in that the classically inspired figures seem to be integral to the marble from which they are emerging. The admiration of Renaissance artists for the art of the Classical and late Antiquity periods is here well exemplified.

We are nearing nearing the end of this Trail. There is, however, one remarkable work that you must not miss. Take the grand staircase (*Escalier Darv*) up to the next floor (1er étage). Towering over the staircase is:

Winged Victory or *Nike of Samothrace,* marble, c.180 BCE
(although the museum label dates it at about 100 BCE)

This *Winged Victory* is justly famous for its great vitality. Being a creature of mythology perhaps connects it to the Classical past and the Hellenistic flamboyance of the drapery and pose are a perfect match for the symbolic meaning of the figure. It was sculpted, apparently, to celebrate a victory of the sea-going state,

but it manages to express the joy rather than the arrogance of victory. The swirling garments reveal most of the body, which is thrusting forward with the ecstasy earned by an athlete and the imagined thrill of flight. The treatment of the breasts is an object lesson in how to make a fusion of a woman and a bird convincing.

GREEK AND ETRUSCAN ART

TRAIL 2:
Italian & French Painting

P ainting in the Louvre is divided into three regions: French, Southern European, and Northern European. Each school is hung chronologically to show its development (which is not to be confused with improvement). As in many museums, only part of a huge collection is on display, with thousands awaiting a purge or a shift in fashion. The largest group, naturally enough, is French painting, but the universally avowed excellence of the Italian group makes it the gem in the crown. There is too much to take in properly in one visit. To make a visit manageable, this Trail focuses on the sequence of Italian painting from the 14th to the 16th century and on sections of the French collection, especially the 18th and 19th centuries.

Italian Painting

Italian and Spanish painting, and some of the giant French canvases are on the first floor of the Denon wing. (Denon, a director of the Louvre in the early 19th century, was responsible for collecting much of the earlier Italian painting.)

Just as France was pre-eminent in architecture, sculpture, and stained glass for several centuries, so Italy led Europe in painting and architecture from the 14th to the 16th centuries. It was during this period that many Italian philosophers and artists developed a passionate interest in the ancient worlds of Greece and Rome, amidst whose remains they lived. Later historians of the period depicted this as a renaissance, or rebirth, of interest in antiquity, but others see it as a continuation of medieval thought. For our purposes, the term Renaissance and its various sub-divisions are not helpful. What sticks out is that painting over these centuries continues to be largely religious and is increasingly attracted to forms of realism. By and large this reflects shifts in the thought and taste of the major patrons of art, the

ITALIAN AND FRENCH PAINTING

church and the ruling class, but artists were seen as contributors to these changes.

Many of the prizes of the Louvre came through royal collection, especially by François I and Louis XIV. Some survive from booty in the Napoleonic wars (though most had to be returned), but most come from assiduous buying in a market where England, Germany, and the US were big players. Fashions are reflected in the balance of the collection. Curators of the Louvre saw the value of what were once called "primitives" – that is, painters before Leonardo and Raphael, but they, along with many, failed to collect much from the now popular 18th century.

Italian painting	**1200s**	Cimabue
	1300s	Giotto, Simone Martini, Pietro Lorenzetti
	1400s	Pisanello, Gentile da Fabriano, Fra Angelico, Masaccio, Lippi, Piero della Francesca, Uccello, Mantegna, Bellini, Cosimo Tura, Antonella da Messina, Botticelli, Ghirlandaio, Perugino, Leonardo
	1500s	Michelangelo, Raphael, Correggio, Rosso, Fiorentino, Titian, Tintoretto, Veronese, Caravaggio
	1600s	Guido Reni, Gentileschi
	1700s	Tiepolo, Guardi, Canaletto
French painting	**1600s**	de la Tour, Poussin, Lorrain, Le Brun,
	1700s	Watteau, Boucher, Fragonard, Robert, David
	1800s	Gros, Ingres, Gericault, Delacroix, Corot

The Italian paintings are on the "first floor" (Americans call this the "second floor") of the Denon wing. (See next page.) The Mona Lisa is in the Salle des Etats.

THE SPIRIT OF THE MIDDLE AGES: THE 14TH CENTURY

Several painters working within key medieval conventions introduced what would become an Italian preoccupation with representing the human figure.

Cimabue 1272–1302

Maestà: Madonna and Child in Majesty Surrounded by Angels, c.1270

Cimabue's *Maestà* marks the starting point for the great centuries of Italian painting. A Florentine, Cimabue fathered the most influential school of all. He was working within a tradition that dates back to the art of Byzantium, which focused on the metaphysical attributes of an image. The Virgin is the "Queen of Heaven," indicated by the throne and the gold background. The child, though smaller and in need of maternal support, is an upright figure with his right hand stretched out in the gesture representing teaching. Angels, half-human, half-bird, are arranged symmetrically to support the royal throne. Aureoles proclaim the sacred status of the beings. Perspectives are tilted to make a frontal picture. Clothing consists of the ageless draperies associated with Classical times. Like the drapery of medieval statuary, its folds are partly decorative and partly used to model the body underneath. The faces have the almond eyes, long noses and bow-shaped mouths that we will continue to see through the centuries of Italian painting. The bodies, too, despite the flattened space, look rounded and solid. To the church it was important to have figures that counterbalanced the stern and often pitiless judge who ruled in paradise. Thus God in the human form of Jesus was gentle, merciful, and sacrificial, and Mary, his Mother, was able to speak to her son on behalf of people.

Giotto de Bondone 1267–1337

St Francis of Assisi Receiving the Stigmata, c.1330

Giotto studied and worked with Cimabue. He too was a Florentine with a large workshop and an enduring influence. Like many Italian painters after him, Giotto was especially adept at telling a story in a series of significant scenes without words. The stories were all the more convincing because they seemed to be happening

ITALIAN AND FRENCH PAINTING

to solid-looking people in real space. In the story of St Francis receiving the stigmata, Giotto is again going over the life of St Francis he had painted in a great series of frescoes at Assisi. In the main scene Christ descends from a golden sky with six wings and a bare torso. He uses the four wounds in hands and feet to project rays that pierce corresponding places in St Francis' body. Aware of the sacredness of the gift, and perhaps taken by surprise, St Francis is on his knee at the foot of the mountain near Assisi. He dwarfs the two chapels in the landscape, and the trees on the mountain frame him in defiance of perspective. In modern terms, the scale of objects and their relationships are entirely surreal, yet the scene is convincingly taking place in St Francis' world. The folds of his

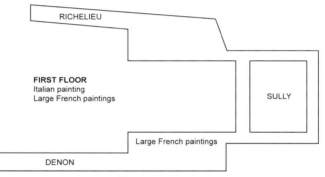

RICHELIEU

FIRST FLOOR
Italian painting
Large French paintings

SULLY

Large French paintings

DENON

Italian painting 16th - 17th century Italian painting 13th - 15th centuries

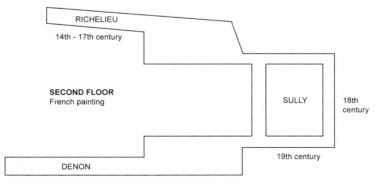

RICHELIEU

14th - 17th century

SECOND FLOOR
French painting

SULLY

18th century

19th century

DENON

habit fall realistically, the face has the intensity of a mystic's, and there are shadows on the mountain and behind the figure. Above all the moment is dramatic – he is in the act of receiving the stigmata that would proclaim his holiness.

The three scenes below are also from the life of St Francis. On the left, Pope Innocent III has a vision in which St Francis builds a church. In the middle, the Pope receives the statutes that St Francis proposed to regulate his order of monks. The inside of the room is drawn in perspective. On the right, St Francis preaches to his friends the birds. They line up to listen attentively as a couple of latecomers fly in from a golden sky.

Simone Martini 1284–1344
Christ Carrying the Cross, c.1340

Simone Martini was one of the major figures of the Sienese school. A turbulent crowd emerges from a less than life-sized Jerusalem set against a gold sky. The figures with haloes – Mary in dark blue, John behind her and Mary Magdalene with the long hair remonstrating and wailing – are agitated. Jesus carries the cross with a bit of help. Others are doing their job or getting in a few taunts. A couple of children get in close for a good look. Christ looks back with distress at the soldier blocking his mother's attempts to reach him. The bright colors and sun-washed background relieve somewhat the horror of the scene, which is plainly that of a man to be crucified and a crowd controlled by arms rather than any lesson in redemption. With few exceptions, the other paintings of this period, hung nearby, from the schools of Venice, Siena, Bologna and Northern Italy, seize on significant and dramatic moments in sacred narratives.

IN SEARCH OF REALISM: THE 15TH CENTURY

The painting of the 1400s continues to be predominantly of religious subjects but also shows an interest in portraiture and classical mythology. This change probably indicates some growth in demand among patrons for secular subjects.

Fra Angelico 1400–1455
The Martyrdom of Saints Cosmas and Damian, c.1440

This work sets a gruesome account of the martyrdom of Cosmas, Damian, and their three brothers in what looks like a medieval

ITALIAN AND FRENCH PAINTING

landscape, a setting commonly used by his predecessors but usually avoided by his contemporaries and successors. Two of the decapitated martyrs have fallen, a third has lost his head but is still kneeling, with blood spurting from his neck. A fourth awaits the executioner's imminent blow and a fifth stands before the onlookers, bound and blindfolded like the other victims. The matter-of-factness of the slaughter makes it all the more horrifying. The story line appears to be derived from the *Golden Legend*. Cosmas and Damian were twins from somewhere in or near Syria. They earned their haloes by supplying medical and veterinary services for free, later becoming the patron saints of physicians. Their unwillingness to renounce Christianity caused the Roman proconsul to attempt a series of ways to execute them until, finally, he managed to have the two doctors and their three brothers beheaded. The aim of the painting is to tell a traditional story as it might have happened, but the figures are in medieval dress. It is a scene of realism and drama. Color is used to make both the land and the sky recede into a vast distance. The otherwise separate groups are tied together by the red and blue semi-circles formed by the figures' clothing and underline the isolation of the yellow figure.

Pisanello 1395–1455
Portrait (of Ginevra d'Este), c.1437, and
Piero della Francesca 1422–1492
Sigismondo Malatesta, c.1451

These two portraits have some striking similarities as well as differences. Both are in profile and hence do not engage with the spectator. Piero's *Sigismondo Malatesta* is made yet more remote by his plain black background, pudding-bowl coiffure and perfect complexion. The rigid posture and calculating expression readily fit our conception of the ruler of an Italian city-state (the Malatestas ruled Rimini) and presumably were approved by the subject. By contrast, Pisanello's fetching young lady is all curves and flowers, with her upturned nose and faint smile. The idealized setting evokes pleasant gardens and tapestries in the high Gothic manner.

Paolo Uccello 1397–1475
The Battle of San Romano, c.1450

Uccello's *Battle of San Romano* is one of three painted to adorn the palace of Cosimo dei Medici in Florence. The other two are in the

Uffizi in Florence and in London. The paintings celebrate a victory of the Florentines over the Sienese in 1432. This part of the battle scene shows the cavalry being pushed back. Horses are rearing and backing into one another and the knights' lances are raised as they find themselves unable to advance. The scene has the rich but muted colors and finery of large tapestries but is also one of powerful figures struggling with confusion. Uccello's famous interest in the geometry of the painted surface, including the illusions created by drawing in perspective, are here exercised in the foreground so that we are placed in the heat of battle rather than being given an observer's view. The confusion gives Uccello scope to draw horses and warriors from various angles and to give depth to the milling crowd. The forest of lances very firmly defines the space of the picture as geometric and hence indicates the means by which the painter has created his illusions of depth.

Giovanni Bellini 1430–1516
Calvary, c.1465, and
Andrea Mantegna 1431–1506
Calvary, c.1460

Two crucifixions, one by the Venetian Bellini and the other by Mantegna show marked shifts in ideas circulating in the same region of Italy at about the same time. (Mantegna's painting was for the church of San Zeno in Verona in the Veneto region where he did most of his work.) Both also illustrate what is meant by 'realism' in discussing this period. Although much detail consists of idealized versions of real forms, human and natural, the whole is meant to depict the significant events of a greater spiritual world shaped by the designs and works of gods and devils.

Bellini's is the later work by a few years. He uses the more conventional backdrop of an Italian landscape to frame still, standing figures. The central figure of Christ is represented, as it so often is on crucifixes, as much at rest as in agony. The figures of Mary and John are secondary only by virtue of their darker coloring against the darker part of the landscape. In other respects they are more imposing – solid human figures in the poses of classical statuary. Gestures are spare and drama absent but, perhaps because of the restraint, Mary's face and right hand are very expressive of grief and despair.

Mantegna's is an exceptionally ambitious work. It attempts to be

ITALIAN AND FRENCH PAINTING

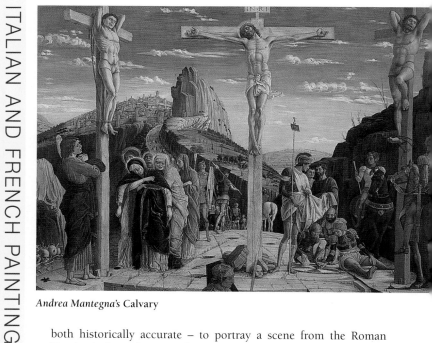

Andrea Mantegna's Calvary

both historically accurate – to portray a scene from the Roman Empire in Jerusalem – and to capture the very moment of death itself. The background is a triumph of fine detail and perspective, and the figures in the foreground are a compelling blend of the artist's pity for the victims of the drama and his passionate interest in the style of ancient Rome. Mary is so stricken with grief that she has to be held up. John has no fear of being identified with his master. The Roman soldiers gamble to divide the loot, watched by an elegantly posed officer and a couple of impeccable horsemen. The three crucified figures are studies in nude anatomy and the pallor and postures of death.

Andrea Mantegna 1431–1506
St Sebastian, c.1480

St Sebastian is one of Mantegna's most daring works. The ancient world is evoked by a ruin, a practice that became common in coming centuries. The city in the background is fantastical. The figure is that of an athlete stoically maintaining a relaxed pose,

weight taken by one hip, the right leg slightly forward. That he is posed as a Roman statue is indicated by the pedestal he is standing on and the broken-off foot of a statue beside the pedestal. The dark and mean faces of the executioners contrast with the pale face of the martyr looking to heaven.

Andrea Mantegna 1431–1506
Wisdom Triumphant over the Vices, c.1502

In this painting Mantegna exploits the other source of stories for patrons seeking variety from religion – classical mythology. Obviously, these justify ancient-world settings and costuming, but the lines between the two worlds blur in many ways: craggy mountains, hilly landscapes with winding rivers, piled up clouds framing sky-borne creatures, rounded arches partly in ruin, garlands, figures in timeless drapery, winged infants (either cupids or angels), semi-naked figures holding statuesque poses. At the same time, there is nothing in the total effect of the mythological scene to match the heroic power of the same painter's *Crucifixion*.

Cosimo Tura 1430–1495
Pietà, c.1480

Cosimo Tura's *Pietà* (1480) comes from another regional school of Northern Italy, Ferrara. Similar in many ways to Mantegna, the Ferrarese painters added an expressionist tone to their sculpture-like figures and geometric spaces. The limpness of the dead Christ is much emphasized, as is the horror on the faces of some of the women. The whole composition, crammed into its lunette, is an array of contortions, from the twisting lines of the drapery to the tilted heads, dismayed features and despairing hands.

Antonello da Messina 1456–1479
Christ at the Column, c.1476
Portrait of a Man ('Il Condottiere'), 1475

With these works Antonello da Messina steps into what can be called straight realism. Christ is now seen as a man suffering and with features rather like those of the man in the portrait, who is thought to be a military figure. Both are in dramatic close-up.

Vittore Carpaccio 1455–1526
St Stephen Preaching in Jerusalem, 1514

Here we see evidence of a taste for clear images and narrative developing in Venetian painting. Both the city and the group of figures have a mix of classical and oriental detail that might be expected from the cosmopolitan Venetians. On his pedestal, Stephen is obviously posed like a statue, but so too is the figure beside the pedestal. The narrative, however, is not the dominant element of the painting. Certainly, it gives it a focus but the panorama of the city and the wealth of the costuming are just as important.

HIGH RENAISSANCE: THE 16TH CENTURY

Leonardo da Vinci 1452–1519
Mona Lisa, 1503–6, also called *La Gioconda*, in the Salle des États

Along with the *Venus de Milo*, this is the Louvre's most sought out piece. Signs point you towards it from any number of unlikely points in the museum. There is often a crowd around it, so you may have to be patient to get an unimpeded view. Apart from admiring what is unquestionably a splendid painting, it is worth pondering why it is so famous, especially when so much other splendid painting surrounds it. One reason may be that Italian painting of this era has long been the benchmark of greatness and there has been a desire to identify the greatest of the great. The usual contenders are Leonardo, Raphael, and Michelangelo, and the Louvre has always had Leonardo. Not just the *Mona Lisa* but a number of his other fabulous paintings. Further, unstinted admiration for Leonardo is not just a modern phenomenon. His contemporaries and successors raved about his painting too, and thought that his inventing and other activities were an unfortunate distraction from his art.

The *Mona Lisa* came into the Louvre's possession via the French king François I, whose palace at Fontainebleau, used by many including Napoleon, makes an agreeable day trip from Paris. François shifted his official residence to the Louvre but his art collection stayed at Fontainebleau for another century, until it moved to the Louvre in 1674. François was keen on Italian artists in general and managed to attract Leonardo to France, where he died, according to legend, in the king's arms. Leonardo seems to

have worked over his paintings a lot – or at least to have taken a long time to finish them – and he probably arrived in France with several in progress, including the *Mona Lisa* and the *The Virgin, Child, and St Anne*.

We can add to this long-standing celebrity of the painting the fact that it is a portrait rather than a religious subject. The historian Giorgio Vasari wrote, not long after Leonardo's death, that the subject was the Lady (hence Mona, meaning "lady") Lisa Gherandini, the wife of the Florentine Francesco del Giocondo (hence its other name, *La Gioconda*). Since *gioconda* also means cheerfull, the name is taken as a reference to the subject's smiling, agreeable face. But we don't know for sure that Vasari was right, and we can see from the faces in *The Virgin and Child with St Anne* and *St John the Baptist* nearby that smiles are pretty standard – in fact they can be traced back to the angels of medieval sculpture. Nonetheless the *Mona Lisa* smile has intrigued generations.

We cannot know how accurate this is as a portrait, but knowing Leonardo's other work, especially his drawings, it is fair to assume that it is the result of meticulous observation of the subject. The seated figure, hands resting in front and eyes engaging the viewer, would become a classic portrait pose much admired and adapted. Leonardo's capacity to achieve finely detailed figures that fit effortlessly into their visual space was part of his genius as a painter. And he was absolutely clear about the nature of portraiture: "A good painter," he wrote, "has two subjects of primary importance: Man and the state of man's mind." The state of mind, he said, is suggested by "gestures and movements of parts of the body".

Typical of Leonardo is his placing of a solid figure against a vast fantastic landscape of rocks, mountains and receding roads and rivers. Great panoramas were fairly common in the backgrounds of Italian painting (see Mantegna's Jerusalem, for example, behind his *Crucifixion*) but Leonardo seems to have wanted wild backdrops that perhaps represented the whole of the earth – man-made landscapes, great lakes and rivers, towering remote mountains – thus universalizing the figures in the foreground.

Leonardo da Vinci 1452–1519
Virgin and Child with St Anne, c.1510

This painting has a similar background of blue peaks and foreground of brown rock with figures. The figures are much more embedded in the landscape than is the single figure of the *Mona Lisa*, no doubt

ITALIAN AND FRENCH PAINTING

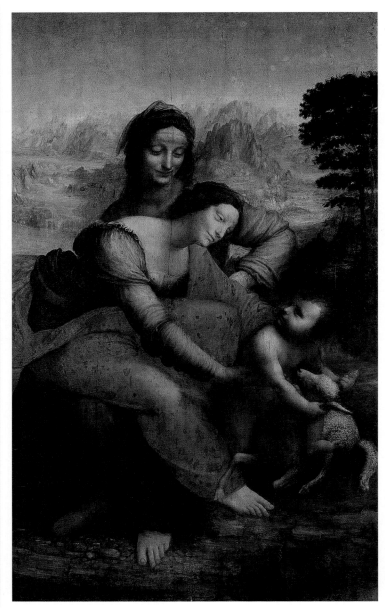

Leonardo Da Vinci's **Virgin and Child with St Anne**

because they are a group shown in full rather than close up. The focus is therefore more on the action than the individuals. The figure of St Anne provides the throne-like anchor and her elegant, long face points us towards the line of the Virgin reaching down to hold the Child and the Child holding the lamb. Taken piece by piece, it is a complex action, but very neatly simplified by lining up of the flesh colors – even the two bare feet line up to meet the point of the main diagonal.

Leonardo da Vinci 1452–1519
Madonna of the Rocks, 1483

The Madonna of the Rocks (1483) uses the light on flesh and a pool of light on the Virgin's lap to create an even tighter group. The group includes both the young John the Baptist, under the Virgin's right hand, and the Christ Child who is under the open left hand of the Virgin. The Baptist raises his hands in a praying position. The Christ Child raises his right hand in a teaching gesture. An angel protects Christ and indicates the Baptist to him. The angel is shown with a female face of a beauty comparable to that of the Virgin, who must of necessity be of great beauty. The rocks allow glimpses of spiky mountains in the distance but mostly act as a grotto for an intimate scene.

Leonardo da Vinci 1452–1519
St John the Baptist, 1513–15

Leonardo's image of *St John the Baptist* (1513–15) is of an androgynous figure not unlike the angel of the *Madonna of the Rocks*. The heart-shaped face, long straight nose, and curved smile are familiar Leonardo images, except that the smile here seems a bit lascivious and the figure at odds with its subject. It looks more like a mocking satyr than a wild prophet of the desert. The finger is usually said to be pointing to heaven, as some angels do in other Leonardo drawings.

Raphael 1483–1520
La Belle Jardinière: Virgin and Child with St John the Baptist, 1507, and *Balthasar Castiglione*, 1514–15

Although he died almost at the same time, Raphael was 30 years junior to Leonardo and very much inspired by him. Like Michelangelo, Raphael was patronized by popes and worked on major installations in the Vatican. His *Belle Jardinière: Virgin and*

Child with St John the Baptist and his portrait of the writer *Balthasar Castiglione* are both subjects that Leonardo might have tackled. They have, however, been conceived of more conventionally. The landscape behind the Virgin is of a pleasant Italian countryside on a pleasant day. The Virgin is a pretty blonde with a book to fill in the hours as she looks after the two children, both blondes also. The Christ Child is reaching for the book and the infant St John is already dressed for his future role. Castiglione comes across as an intelligent but kindly man at the peak of his career. In portraiture, realism has reached a peak by capturing both the appearance and the personality of the sitter. As such it will hardly be improved on through several centuries of portraiture.

Raphael 1483–1520
St Michael Confounding the Devil, 1518
St George, 1505

These two paintings show how Raphael handled action. Essentially, he choreographed it so that all its elements contribute to its poise and beauty of movement. Perfect creatures in perfect paintings. The extent to which he did perfect his images might be judged by comparing him with his master Pietro Perugino, whose *Apollo and Marsyas* is no less idyllic but whose figures are not such beautiful people. Raphael's calm and generous approach to painting, allied to his great skills, so endeared him to future generations that his style became a point of reference for painters across three centuries.

THE VENETIANS

The 16th century saw Venice have its own distinctive flowering of painting – Titian, Tintoretto, and Veronese being some of the best known among many peers. The Venetians were exuberant colorists and keen on dramatic and gigantic forms of hyperrealism. Their subjects are mainly religious but portraits and classically influenced scenes continue here as elsewhere.

Titian 1488–1576
Le Concert Champêtre, 1510

Neither a religious nor classical scene, this painting is a scene from the times, depicting a fantasy of the artist's life where the men create, the women undress, and shepherds establish the wholesomeness of it all. The same idea provoked a scandal when

Manet took up the theme 350 years later. It is not an erotic scene in that the men and women are not taking much notice of one another. Possibly, it is meant to put together the elements of a romantic view of art: music, beautiful bodies and pastoral peace. It is likely that Titian finished something – an idea or an actual work – by Giorgione, a painter who had turned Venetian art away from the preceding style of Bellini, Carpaccio, and others to something closer to the Central Italians' merging of figures into their landscapes. Titian's portrait of the *Man with a Glove* is well into the tradition being established by Raphael and others.

Titian 1488–1576
The Entombment, 1525, and
The Crowning with Thorns, 1542

More characteristic of Titian's legacy are the lyrical *Entombment* (1525) and the dramatic *Crowning with Thorns* (about 1542). Both set out to heighten the realistic character of the scenes: in *The Entombment* by focusing the care and grief of Christ's followers as they lay down the limp body and, in the *Crowning*, by drawing the lines of the composition to focus on the violence required to force woven thorns into a man's skull. The light contrasts the twisting of Christ's body and the unheeding bust of Tiberius, in whose name the torture is being carried out.

Tintoretto 1518–1594
Paradise, 1578–9, and
Veronese 1528–1588
The Marriage Feast at Cana, 1562–3

Tintoretto's vast, highly colored vision of *Paradise* (1578–9) was a sketch for a work for Venice's Ducal Palace. This and Veronese's huge canvas of the *Marriage at Cana* (1562–3) set out to overwhelm their spectators with color and each artist must have drawn immense satisfaction from the very fact that they could conceive of such vast but unified scenes. *Paradise* is held together by the traditional conception of heavenly spaces moving in circles. *The Marriage Feast* is unified by its towering architectural setting and dense crowding.

ITALIAN AND FRENCH PAINTING

MANNERIST AND BAROQUE PAINTING

For a good while the rather flamboyant work of the so-called Mannerist and Baroque periods was often unfavorably compared to the masters of the Renaissance. Modern scholarship, though still prone to shifts in fashion, is probably more even-handed, and we are likely now to be treated to exhibitions featuring the still lesser-known artists of the 16th and 17th centuries in Italy. The label "Mannerist" is meant to describe painters who developed individual styles that distinguished them clearly from classic Renaissance painters such as Raphael. "Baroque," like "Renaissance" is a loose category to describe many individual artists of the late 16th and 17th centuries. It has passed into the common language, where it means excessive or overly decorated.

Giovanni Battista di Jacopo (called Rosso Fiorentino) 1496–1535
Pietà, 1530–35

The author's nickname, like a wine label, announces his preferred color (*rosso* means red) and his origin (Florence). One of the leaders of the Mannerist period in Florence, Rosso Fiorentino was an emotional painter who used color as Expressionist painters do, to take his subject outside reality. The *Pietà* in the Louvre is possibly his last painting and was painted in France, where under the patronage of François 1, Rosso Fiorentino worked until his death at Fontainebleau. Rosso's *Pietà* was owned by the Prince de Condé and came into the Louvre's collection when it was seized by revolutionaries. Painted at first on wood, it was transferred to canvas. It is as emotional a work as many that would follow in the Baroque period not solely in the heavy dead main figure, the physical efforts of the bearers and the distraught mother, but also in the blood red of the garments and the diagonal tilt of the group as a whole – expressionist and abstract devices that would one day find their way into film as well as painting.

To see Rosso's influences and followers, look at nearby works of his Florentine contemporaries Andrea del Sarto (1486–1530) and Pontormo (1494–1556). Nearby is also:

Annibale Carracci 1560–1609
The Hunt, c.1585

In his time, Annibale Carracci was thought to be the equal of Michelangelo as a painter, and is acknowledged to have been a great draftsman and one of the earliest caricaturists. As a member of the Bolognese school, he fell out of fashion for a time, but is now much admired along with others of the school, such as Domenichino (see the nearby *Landscape with Erminia and the Shepherds*). *The Hunt* is a sample of his ideal landscapes in which rustic activities make a somewhat genteel foreground for amiable vistas of forests and mountains – the sorts of humanized and managed landscapes that people still seek today in their country houses and weekends. Carracci is credited with being the originator of this kind of landscape, which was taken up in French painting by Claude Lorrain. Domenichino's *Landscape* shows more explicitly the classical inspiration for such painting. They are landscapes of the mind, perhaps pieced together from reality but then molded to fit the imagined forms of the countryside of the ancient world.

Annibale Carracci 1560–1609
The Appearance of the Virgin to St Luke and St Catherine, (1592)

This work typifies the religious imagination of many a Baroque work. The main celestial figures, the Virgin and Child and onlooking saints, are unequivocally human and the angelic figures all cherubim of the infantile variety. The saints still on earth are statuesque figures in dramatic poses framing an ideal landscape. The triangular focusing of action, achieved as much by color as by gesture, is tight and vigorous. This picture was among the war booty of Bolognese and Emilian pictures carried off by Napoleon and not returned to its owners after 1815. Despite having returned many works, the Louvre still claims to have one of the largest collections outside Bologna of such painters.

Caravaggio 1571–1610
Death of the Virgin, 1605–6
The Fortune Teller, (1594–5)

Notorious for his wild life – he was often on the run, on one occasion for having killed an opponent at tennis over a dispute about the score – Caravaggio is a major figure in the shift to forms of realism that would continue through the next centuries. *Death of the Virgin* is conceived as an earthly event. Life has deserted the

Virgin's body and her companions weep for her and for their loss. There is no Assumption into the clouds, no cherubim, no welcoming son, no presiding saints or deities. The light striking across the bald heads and spotlighting the dead woman issues from the outside, as through a window, although the theatricality of the scene forbids such as prosaic detail from being shown. Both idealism and metaphysical realism have been rejected. The same spirit applied to a secular theme in *The Fortune Teller* results in a couple of characters of great charm. Both pictures are from Louis XIV's collection.

French Painting

A number of the very large canvases are on the first floor (US second floor) of the Denon wing near the Italian painting. The main collection begins in the Richelieu wing on the second floor (Americans call this the third floor) around the Cour Carré and continues in the Sully Wing. If you are already in the Italian section, see the big canvases first, then go back to the beginning, out to the *Winged Victory of Samothrace*, and look for a way up. To avoid breaking up the themes covered below, the large canvases are starred in the sections below. Under the heading for the 18th century, you'll find two by Jacques Louis David and two by Antoine Gros; under "New Realisms" a Théodore Géricault and a Eugène Delacroix.

As well as being the largest part of the total collection of paintings, the Louvre's French collection has exceptionally large collections of individual painters from the 17th and 18th centuries as well as 19th-century painters such as Eugène Delacroix and Camille Corot, whose work appears both here and in the Orsay as essential links between the Imperial centuries of French art and the foundations of modern painting.

THE AGE OF LOUIS XIV

The collection of 17th-century French painting is dominated by the royal collections, especially that of Louis XIV. The presence and example of Italy in this period was as inescapable as Paris would be in the modern era. Two of France's most notable painters – Nicolas Poussin and Claude Gellée (known as Claude Lorrain or Claude) in fact adopted Rome as their hometown. Louis XIV, however, collected a mass of their work, particularly of Poussin – Lorrain is less well represented. Charles Le Brun was one of the king's official artists. Collections always reflect fashions and it was left to later curators to value and collect painters of

the period such as Georges de la Tour.

From the 16th to the 19th century, painting, sculpture, architecture, literature, drama, education, politics, and military science were replete with references to the worlds and examples of Ancient Greece and Rome. Christianity persisted as a subject for art, but, as we see in Italian art, the stories often have classical settings. In some countries, for long periods of time, visions of the classical world eclipse religion as a subject. Shifts in philosophical thought from the 14th century onwards meant that religion had to give way to increasing interest in humanity and the world, but a great deal of this thinking was played out not in contemporary terms but in the contexts of antiquity. For many artists and thinkers, the ancients had pretty much said it all – the themes only needed working over and developing. Thus classical scenes represent an ideal of man-made landscapes, classical figures represent the range of human types and models and classical stories enact major issues of morality and human relationships. In the minds of educated people the classical world occupied the space that in our minds belongs to technology and media.

Nicolas Poussin 1594–1665
Self-Portrait, 1650
The Inspiration of the Poet, c.1630
The Institution of the Eucharist, 1640
The Plague at Ashdod, 1630
Winter, c.1660

Poussin was a passionate classicist. His use of color and light had a lot in common with Venetian painters such as Titian, but his subject matter was frequently drawn from classical mythology and his figures show an enormous admiration for classical sculpture and for the style of Raphael, whom he greatly admired. Because of his popularity with the king and others, Poussin is exceptionally well represented in the Louvre. His range can be judged from his *Self-Portrait*, the mythological piece *The Inspiration of the Poet,* religious painting such as *The Institution of the Eucharist* and theme paintings such as *The Plague at Ashdod* and *Winter*. His town and interior settings are unmistakably Roman – in the cases of *The Plague* and *Eucharist* paintings, such a setting can be justified historically. Christ lived in a Roman-occupied city and the Palestinian city of Ashdod, founded by the Philistines, was successively Egyptian, Greek and Roman in ancient times. His figures in each are just as unmistakably modelled on Roman statuary, which itself sought to blend idealism with realism. The figures of *The Inspiration of the Poet* are similarly solid

and posed but the setting is Arcadia, the perfect landscape of Greek and Roman myth. The poet (on the right) is presumably a Roman one, perhaps Virgil or Ovid. He is being crowned with laurel by the cherub assisting the god Apollo, in the middle with his lyre, who directs the poet's pen. A female muse also attends.

Claude Gellée, called Claude Lorrain 1602–1682
Landscape with Paris and Oenone, 1648
Ulysses Returns Chryseis to her Father, c.1648
The Disembarkation of Cleopatra at Tarsus, 1642–3

Lorrain is a master of the ideal, antique landscape, frequently inspired by the landscape near Rome, which is evocative of the former empire. What is most striking, however, is not so much their narrative content and carefully composed architectural detail, but the romance of their glowing skies and enticing horizons. Lorrain, like Poussin, was much appreciated by Louis XIV, from whose collections these landscapes come.

Georges de la Tour 1593–1652
The Cheat, c.1635
St Sebastian Tended by Irene, c.1649

One of the real surprises of the period, La Tour models figures in ways we might associate with some moderns. For a long time, his work was little known, with many paintings being attributed to others. Both works were acquired for the Louvre in the 1970s. The cheat, shown here with an ace of diamonds behind his back, also cheated his way through another painting with an ace of clubs. In this at least he seems to have been rumbled by the servant, who is tipping off the player in the middle. The players look a fashionable lot with their finery and a servant in Turkish headress. What is most striking about the painting, apart from the nice suspense of the implied story, is the clear, bright presence of the figures in an otherwise monotone setting. Similarly, the religious story isolates clear-cut, bright planes against dark surfaces and backgrounds in a way that would attract abstract painters many generations hence.

Charles Le Brun 1619–1690
Alexander and Porus, 1673

Le Brun was the official painter to Louis XIV and from that position able to lay down many of the rules of classicist taste for

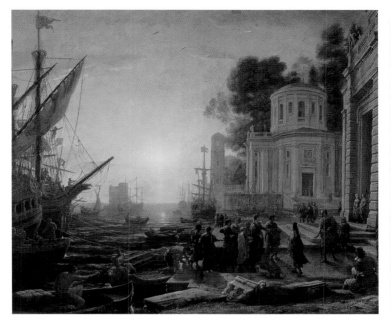

Claude Lorrain's The Disembarkation of Cleoparta at Tarsus

the period. As well as his paintings he is represented in the Louvre by the decoration of the Galerie d'Apollon. *Alexander and Porus* demonstrates both the taste for classical subject matter and the ability of many of the painters of the period to handle large scenes yet maintain a clear focus. Epic movies owe a lot to such visions and talents.

THE 18TH CENTURY

The 18th century includes a wide range of styles that follow fairly quickly from one to another. The early taste in the 18th century is for the style known as Rococo which is decorative but, unlike the preceding Baroque, avoids any grand manner. It thus depends on its grace and charm as well as its skill, and is hence likely to come in and out of favor, as indeed happened to the work of Watteau. The second half of the century sees the return of Classicism (known as Neo-Classicism), both in subject matter and style. Then, in the closing decades of the century, painters begin to tackle contemporary subject matter in heroic styles.

Jean Antoine Watteau 1684–1721
Gilles, c.1720
The Pilgrimage to Cythera, 1717

To a modern eye, the hint of vulnerability in *Gilles* is more attractive than the optimistic courtliness and nostalgia of *Pilgrimage to Cythera* (the island of Venus). Watteau was much attracted to the theater, and adept at scenery painting. Gilles is from the world of commedia dell'arte and indeed seems to be on the stage. The *Pilgrimage to Cythera* has the broadly brushed atmosphere of a stage backdrop.

Hubert Robert 1733–1808
View of the Grand Gallery of the Louvre, 1796

Hubert Robert painted a large number of real and imaginary views, especially of architecture, some of which were virtual designs for the renovations to the Louvre. This is one of the imaginary works. At the time, the gallery was a long, long corridor lit inadequately from side windows. When it was eventually rebuilt as a useful gallery Robert's imagined designs were influential. Robert himself, as curator of the royal collection, had some top lighting (as shown in his painting) installed elsewhere in the Louvre. His connection with royalty, however, landed him in prison during the Revolution, and only a case of mistaken identity saved him from the guillotine.

Hubert Robert 1733–1808
The Pont du Gard, 1787

This work captures the enthusiasm of the period for ruins of antiquity. This Roman aquaduct, built in 19 BCE, carried water from Gard to Nimes. It was one of several paintings of France's Roman heritage commissioned by Louis XVI for the palace at Fontainebleau. Hubert, like painters such as Piranesi and Guardi, combines fine architectural detail with an engaging impression of the color, life, and meaning of the site.

Jacques-Louis David 1748–1825
The Oath of the Horatii 1784☆
Madame Recamier, 1800
The Coronation of the Emperor Napoleon and the Empress Josephine, 1804☆

The Oath of the Horatii shows three brothers taking an oath to win in battle or die, as their father hands them their swords. It was painted in Rome and later exhibited in Paris and was of decisive importance in establishing Neo-classicism in French art. Its characteristics would reappear again and again in art and literature: heroic themes, ideal figures drawn from ancient history and myth, noble warriors, and stoically saddened women, all bathed in a clear Mediterranean light.

Neo-classical values transferred readily to contemporary subjects. In the second picture, Madame Recamier fits her form and elegant drapes into the curves of a chaise-longue against a bare, muted, geometric background.

In the *Coronation of the Emperor Napoleon and the Empress Josephine*, the large crowd scene benefits from a mastery of structures that simplify and unify, with the light flooding the main subject against a background of verticals and a hierarchical diagonal of attendants.

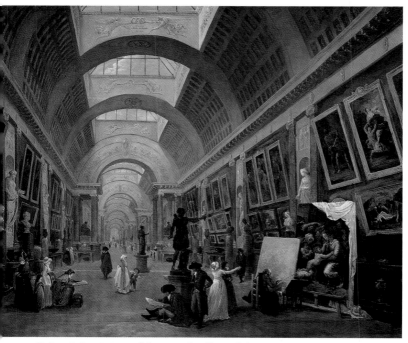

Hubert Robert's View of the Grand Gallery of the Louvre

Antoine-Jean Gros 1771–1835
Bonaparte Visiting Plague-stricken Jaffa☆
Bonaparte on the Battlefield of Eylau☆

Although many of the works of Gros were propaganda for the heroics of Napoleon Bonaparte, they are also well-composed, and in the case of the plague scene, both exotic and compassionate. Gros paints to a taste for large patriotic canvases that the Romantics Géricault and Delacroix took up with added gusto in the next generation.

NEW REALISMS

In art, "realism" can mean many things. In the 19th century, we see a Neo-classical painter such as Ingres take up new, contemporary subjects; we see contemporary subjects being used to stir emotions in much the same way as images on the news are used in our own time and, in Corot, we see the beginnings of attempts to represent the world of nature.

Jean Auguste Dominique Ingres 1780–1867
The Turkish Bath, 1862

Although Ingres gives a classic stillness to his figures, his sensual nudes and attraction to oriental detail lead him from Classicism to Romanticism. Ingres was taught by David, but his female figures are sinuous and lascivious rather than noble and composed.

Théodore Géricault 1791–1824
The Raft of the Medusa, 1819☆

This and Delacroix's somewhat smaller *Liberty* are the best known of the giant French canvases of the Romantic period. Géricault's image is about 15 feet high and 21 feet wide. It depicts the desperate plight of the crew of the shipwrecked Medusa, who spent 12 days clinging to a raft off the coast of Senegal. To underline their desperation, Géricault chooses the moment when the ship that will finally rescue them appears to be disappearing. The superbly managed scene of frantic hope and dying despair was a great novelty in being based on a real incident in the news of the times, but it also established the Romantic taste for endowing scenes with epic overtones (a taste we maintain today in news reporting).

With Delacroix and Corot we are passing into the era that saw the rise of Impressionism and, soon after, of Modernism. Paintings by these two

and some others of their period are also to be seen in the Musée d'Orsay, but their major works remain in the Louvre.

Eugène Delacroix 1798–1863
Liberty Leading the People, 1830☆
The Sea from the Cliffs at Dieppe, 1862

Liberty Leading the People is a homage to the brief hope of Parisians to restore the republic in 1830. An intensely romantic, patriotic work, it combines realistic images of dead fighters and a burning city with the epic allegory of the bare-breasted warrior icon brandishing the flag of the revolution and leading a fresh charge of the citizenry. Delacroix would be much admired later by the Impressionists for the freedom of his painting and the contemporaneity of his subject matter. His *Sea from the Cliffs of Dieppe* has plenty in common with Monet, for example.

Jean-Baptiste Camille Corot 1796–1875
The Church of Marissel
Near Beauvais
The Bridge at Narmi (1826)

The Louvre has a large and wonderful collection of Corot. He represents another definitive step towards realism. The effects of light and the forms of natural and built objects become the subjects of painting that seems to be taken from observation. The people he paints are country folk, somewhat idealized, but no longer representing great themes. The flavor rather is the more homely one of Dutch painting. Some broader views of landscapes, such as *The Bridge at Narmi*, initiate a style that will attract landscape painters into the modern era. There are many other Corot paintings to enjoy if you have the time.

This concludes this section, which has highlighted some of the most notable paintings in the Louvre. If you have more time (and are not totally exhausted!) you may wish to view some of the other collections within the museum.

This is also the end of the art trails in Paris. You will, by now, be aware that there is actually a lot more to be seen that we have covered even in these long trails. Very few cities in the world can claim to be the originator of even one major art style let alone two or more. In contrast, Paris was the site of the beginnings of Gothic art and was also the center

ITALIAN AND FRENCH PAINTING

ITALIAN AND FRENCH PAINTING

of Impressionist and Post-Impressionist art, as well as the hub of much modern art. These trails have concentrated on those periods because they are so fundamental to the Western visual imagination. However, we cannot overlook Paris' role in attracting artists from other places, especially in the 20th century, and in gathering some of the masterworks of most periods of western art. Of these, we have made a severely limited selection. Overall, we have tried to avoid judging works in too dogmatic a fashion. Nearly all the works on these trails deserve their fame and art lovers will make up their own minds anyway. We hope we have said enough to orient you towards your own Trails, and to continue your journeys of discovery through the world of art.

Other Artists, Architects and Figures of Note

Aristotle: The Greek philosopher most admired and consulted by the scholastics of the Middle Ages.

Bazille, Frederic (1841–1870): A friend of Monet and Renoir and an early Impressionist himself, Bazille was killed in the Franco-Prussian war.

Cabanel, Alexandre (1823–89): Creator of sentimental classical genre painting, Cabanel was officialdom's darling and the Impressionists' model of what not to be.

Caillebotte, Gustave (1848–94): A part-time painter in a somewhat surreal style and a great collector, thanks to an inherited fortune and personal associations with the Impressionists. His collection became the basis of the Orsay's collection.

Cassatt, Mary (1845–1926): An American Impressionist artist.

Charlemagne: A king of the Franks who was crowned Holy Roman emperor by the pope in the year 800. His reign or era, referred to as Carolingian, saw a considerable renaissance in art and learning.

Cicero (106 BCE–43 BCE): A Roman orator and philosopher.

Daubigny, Charles-Francois (1817–79): Daubigny's straightforward, open-air painting influenced Monet.

di Varaggio, Giacomo (c.1230–1298) Known in English as James of Voragio, Giacomo was born in the region of Genoa. He collected all the stories he could find in relation to Jesus, his family, their associates and followers and published them in *The Golden Legend*. The work was a European-wide bestseller with no consideration being given at the time to the fact that there was no real basis in history for many of the stories. Many of the stories around cathedrals derive from *The Golden Legend* rather than more sober sources. The book is readily available today.

Durand-Ruel, Paul (1831–1922): Possibly the first of the modern art dealers, Durand-Ruel acquired and exhibited the painters with whom he held exclusive contracts. He dealt for most of the major Impressionists and, through his association with Mary Cassatt, opened the American market to his painters.

Euclid: Greek philosopher and mathematician, commonly known as the father of geometry.

Fantin-Latour, Theodore (1836–1904): Not himself an Impressionist, Fantin-Latour included many of the group in his *Studio at Batignolles*. Noted also for his painting of flowers.

Justinian (483–565): A Byzantine emperor whose chief accomplishments were the codification of Roman law and the building of Hagia Sophia, which is still standing in Istanbul (Constantinople).

Mallarmé, Stephane (1842–98): A rather difficult poet to read, Mallarmé was a great friend and defender of Manet and Morisot.

Maurice de Sully: Bishop of Paris at the time when the building of Notre Dame was begun.

Plotinus: A Hellenistic philosopher of the 3rd century after the birth of Christ. He founded the philosophy known as Neo-Platonism. He himself was not Christian, but he influenced early fathers of the church such as St Augustine.

Ptolemy: A Greek-Egyptian mathematician, geographer, and astronomer of the 2nd century after the birth of Christ. His theory of the cosmos, which had the earth at the center, prevailed throughout the Middle Ages and until the 16th century when Copernicus disputed it.

Puvis de Chavannes, Pierre (1824–98): The simple, decorative, and symbolist paintings of Puvis de Chavannes were admired by Impressionists and can be seen as an influence on Gauguin.

Pythagoras (582–507 BCE): A Greek philosopher who lived before Socrates and was influential in the development of geometry and mathematics. Pythagoreans were the first to teach that the earth was a sphere revolving around a fixed point. To Pythagoreans, number was a supreme aspect of all things and this was continued in the work of medieval architects.

Sisley, Albert (1839–1899): Although born in Paris, he was English. Unfortunately, few of his works are in Paris.

Viollet-le-Duc: A 19th-century architect who made a detailed study of Gothic architecture and worked on restorations that saved a number of the most notable churches, especially Notre Dame in Paris.

Zola, Emile (1840–1902): Both a novelist and a critic, Zola was a fierce advocate for the Impressionists.

Saints

St Anne: The mother of Mary who was in turn the mother of Christ. She is prominent in many of the stories and legends that circulated during the Middle Ages.

St Denis: A patron saint of France, he died in 258. His name would have been Dionysius and many of the legends about him are mixed up with other personages also called Dionysius. A missionary to Gaul, it was claimed that he was beheaded on the hill now called Montmartre or the Hill of Martyrs, and then walked to his burial place carrying his head. His was buried on the site of the abbey-church of St Denis on the outskirts of Paris.

St Elizabeth: Cousin of Mary and mother of John the Baptist whom she conceived at an advanced age.

St Etienne: The French name for St Stephen (*see* below).

St Genevieve: A patron saint of Paris, she died in the 5th century. She was noted for having protected Paris against the Huns and the Franks. In 1129, her relics, carried in a procession, were said to have halted an epidemic and the miracle is still celebrated annually.

St Jerome: A father of the church, known especially as the translator of the Bible into Latin. He is often shown in a desert with a lion reclining at his feet. His views have been criticized by feminists.

St Joachim: The father of Mary.

St John the Baptist: A cousin of Jesus who foretold the coming of the Messiah and, in preparation, baptized people who came to him, including Jesus.

St Joseph: The man who married Mary although she was pregnant. According to tradition, he looked after her and the child until he died.

St Michael: An archangel who weighs souls at the end of time to decide who goes to heaven and who goes to hell.

St Peter: Previously called Simon, he took the name "Peter" meaning "rock" and was seen as the foundation of the Christian church.

St Stephen (Etienne): The first martyr, stoned to death at the gates of Jerusalem because he was associated with the recently crucified Jesus. He was adopted as a patron saint of France. A cathedral in his name was previously on the site of Notre Dame de Paris.

St Thomas à Beckett (1118–1170): This saint was murdered at the suggestion – if not the order – of an English king with the words "Who will rid me of this troublesome priest?" In death, he became a symbol of innocence, akin to the babies massacred by Herod at the time of Christ's birth.

Biblical and Christian Characters, Stories, Places, and Terms

Abraham: In the Old Testament, Abraham is asked by God to sacrifice his only son Isaac by knifing and burning him. He builds an altar, takes the unsuspecting Isaac to it and is then let off by God's instruction to use a nearby ram that has been caught up in some undergrowth. In some works from the Middle Ages, there is a hint that Abraham, like God, was prepared to sacrifice his son to achieve a greater good.

Adam: The first of humankind who, with his female companion Eve, disobeyed God, thus introducing evil into the lives of all who followed.

Annunciation: The story is from New Testament times. The young Virgin Mary is told of her pregnancy by the archangel Gabriel and his greeting "Hail Mary" or in Latin "Ave Maria" precedes his announcement. She marries Joseph who will be the child's foster father, the "real" father being God himself. The father is often pictured as a bird.

Apocrypha: Stories about Christ and his contemporaries that are not included in the official books of the New Testament. There are many charming legends that were well known in the Middle Ages and find their place in the sculpture and stained glass narratives of the time.

Apocalypse: The book of the New Testament (the Revelations of St John) describing the end of the world and the Second Coming of Christ. It is usually attributed to St John the Apostle who was exiled for a time on the island of Patmos. There were many works written about the Apocalypse in the 12th century, an age seemingly preoccupied with ideas about the end of the world. A dominant image is of Christ in judgment surrounded by four animals and 24 elders.

Ark of the Covenant: A wooden coffer containing tables of Jewish law and establishing the contract between God and the Israelites. At one time, it was housed in the Temple of Jerusalem.

Ascension: After dying, Jesus is reported to have come back to life and after some time, to have ascended "body and soul" into heaven; this journey into heaven is called the Ascension. Representations of the event usually show the apostles looking up into heaven as he ascends.

Assumption: Tradition describes how Mary's body was taken up, or assumed, into heaven after her death. God saw this as a mark of respect for his mother whose body did not then decay like those of other mortals. In the traditions of eastern Christianity, the Assumption is more commonly referred to as the Dormition, but it is essentially based on the same ideas.

Baptism of Christ: Christ lived in comparative obscurity until he emerged from a long fast and was baptized by his cousin John. John had been baptizing people and telling them that a Savior would come; when he baptized Jesus, God spoke out on his behalf.

Bethlehem: The birthplace of Jesus Christ and the city of David, his ancestor. Christ's parents had to go there to have their names taken in a census based on family origins.

Coming of Christ: The first coming of Christ was when he was born; the second is at the end of the world and is described in the Apocalypse.

Crown of Thorns: As part of his persecution during the night before he was crucified, Jesus was made to wear a crown of thorns and mockingly hailed as 'King of the Jews'. A part of the crown was sold to Louis IX, saint and king of France. He housed it among other relics in the Sainte-Chapelle and it was later moved to Notre Dame de Paris, where its container may be seen now in the treasury.

Crowning of the Virgin: After Mary's death, the story was told that she was taken to heaven and crowned Queen of Heaven by Jesus. (See also Assumption)

Daniel: A book of the Old Testament, which records visions from the life of Daniel and tells that he was a Jew exiled in Babylon but true to his faith. One of his tests is to be locked up with lions that do not attack him as he praises his God, a scene often shown in medieval art.

David: David was a king of Israel who was an ancestor of Mary and therefore of Christ. He was the author of Psalms in the Old Testament and is often shown with his harp, presumably singing his works. He was the successor of Saul.

Descent into Hell: The belief was that Jesus had died on the cross to save all mankind but that the previously deceased were shut out of heaven, so he visited the next world and got them out. This event is usually called the Descent into Hell but it was not the hell of eternal damnation; rather it was the limbo to which the good but unbaptized were sent.

Devil: Once an archangel and now an evil tempter and the organizer of the torments of hell.

Doctors of the Church: The theologians of the early Christian church.

Dormition: *See* Assumption.

Easter: The feast of the return of Jesus to life, often seen as a cornerstone of Christian belief.

Elders: A group of wise people who have a role in helping ordinary people through the Apocalypse; medieval representations show 24 of them.

Evangelists: The four authors of the Gospels, which make up the bulk of the New Testament. They were apostles Matthew, Mark, and John and a later disciple from Antioch called Luke, whose account is said to have come from first-hand accounts given to him by Mary. Mark is symbolized by a lion, Matthew by an eagle, and John by a man-angel, while Luke appears as an ox.

Eve: The first woman and Adam's companion. She listened to the devil and having first tempted Adam, joined him in disobeying God.

Flight into Egypt: Tradition says that after Jesus was born, Herod heard that a boy-child was being acclaimed as a future king. Herod sought to prevent this by having all male children of the region killed but an angel warned Joseph, and he and Mary escaped by fleeing to Egypt with the child.

Gabriel: The archangel who told Mary that she would have a son whose father was God.

Incarnation: The belief that God took on human form in the person of Christ and temporarily lived upon the earth, recalled in the words "And the Word was made flesh and dwelt amongst us." This idea was used to justify human imagery in art; iconoclasts argued that such art led to idolatry or worship of images rather than things of the spirit.

Isaiah: A prophet of the Old Testament. His genealogy for the coming Messiah was adapted to form the Tree of Jesse, the most famous representation of which is found in the stained glass at Chartres cathedral.

Jerusalem: The city where Christ died and was buried but in the Middle Ages it is also a metaphor for the holiest of all cities, which is heaven itself. It therefore appears in some heavenly scenes, often as buildings in which various saints are standing.

Job: The Book of Job in the Old Testament describes the tests that a man withstood to prove his faith in God. Because of his demeanour, Job became known for his patience.

Judas: One of Jesus' apostles, Judas agreed to hand him over to the authorities in return for a payment of 30 pieces of silver. He identified Jesus by greeting him with a kiss. Later, he despaired of what he had done and hanged himself. He is often shown leaving the table of the Last Supper.

Judith: A book included in some versions of the Old Testament, but often seen as apocryphal, tells how this beautiful woman saved her city and its people by killing Holofernes, the leader of the enemy.

King of Heaven: Christ is often shown as King of Heaven, wearing a crown. Sometimes, he carries a ball, which is a symbol of the world itself.

Last Judgment: At the end of the world, each person is judged by Jesus and found fit for heaven or hell, where they will then stay for all time. One of the archangels carries scales in which to measure a person's goodness.

Last Supper: The meal that Jesus took with his apostles early in the evening when he was arrested. At the table, John is shown as a favorite seated alongside or leaning on the host. Judas is usually revealed as the future betrayer.

Magi: Three wise men, later referred to as kings, who followed a star to the birthplace of Jesus.

Massacre of the Innocents: When Jesus was born, King Herod heard that he
would one day become king among the Jews. He could not identify which
boy-child was the one in question and so had all male children in the
district massacred.

Messiah: The term refers to a coming Savior. Christians identify Jesus as the
Messiah; Jews do not.

Mystical Rose: This is one of the names given to Mary in order to honor her;
Rose of Sharon is another. The rose windows of medieval cathedrals recall
these titles.

Nativity: The birth of Jesus takes place in a Bethlehem stable because there
is "no room at the inn." He is warmed by the breath of animals,
wrapped in swaddling clothes and laid in straw in a manger or feed
box. Angels sing "Hosanna" and tell nearby shepherds to go and
look, which they do. Later, three wise men, or Magi, often shown as
kings from the east, also arrive, guided by a special star that shines over
the stable.

New Testament: Stories of the life of Jesus and events surrounding
his suffering and death by crucifixion, a Roman form of execution
reserved for criminals. Some of the stories are told in four gospels
by writers traditionally identified as Jesus' followers. Other works in
the New Testament are letters written to early groups of
believers. Another is a long account of what to expect at the end of
the world.

Old Testament: The Christian name for the Hebrew Bible, which forms the first
section of the Christian Bible. It includes a narrative of creation; other
books contain stories, prophecies, songs or psalms, and collections of
proverbs.

Original sin: The first sin, when Adam and Eve disobeyed an order from God
and ate forbidden fruit in the Garden of Eden. As a result, all humankind
inherits original sin and the punishments that followed, such as having to
work, pain in childbirth, and ultimately, death. Apart from Jesus, only
Mary, his mother, did not have original sin and is therefore said to have
had an Immaculate Conception.

Palm Sunday: On the Sunday before he died, Jesus arrived in Jerusalem and was
greeted as Savior. He rode the streets on a borrowed donkey and the
populace waved palms before him. Several days later, they were ready to
see him die.

Pentecost: A feast 50 days after Easter, commemorating the time when the
followers of Jesus received special gifts from God such as the gift of
speaking in tongues.

Presentation: This refers to the time when Mary and her partner Joseph took the
young Jesus to the temple and presented him to the priests, who
immediately prophesied his coming greatness. A similar event was said to
have taken place after Mary was born. Both events appear in narrative
scenes on the portals of medieval cathedrals.

Queen of Heaven: A title given to Mary the mother of Jesus, who is King of Heaven. On the portals of medieval cathedrals, she is often shown being crowned by Jesus.

Redeemer: When Adam and Eve broke faith with God, they forfeited humankind's right to go to heaven. Jesus' death on the cross redeemed this right and he is therefore often known as Redeemer.

Resurrection: Jesus died on the cross, was buried and, three days later, his tomb was found empty: he had returned to life. This is the miracle of the Resurrection, a cornerstone of Christian belief in the Middle Ages and part of the set of beliefs of many Christians today.

Serpent: In stories of Adam and Eve, the devil comes as a serpent to tempt them to disobey God's ruling. The serpent often appears as a symbol of the devil, for example, curled around the earth at the feet of Mary who, as the New Woman, will defeat him.

Solomon: The son of Bathsheba and a king of the Hebrews who followed after King David. To identify which of two women was the mother of a particular baby, Solomon decreed that he would cut the child in half; he then gave the child to the woman who agreed to give it up. He wrote books of proverbs and Ecclesiastes, in the Old Testament.

Transfiguration: In the Gospels, Christ takes his inner circle of Peter, James, and John to a secluded place and shows them that he is a supernatural being by transforming himself into a blinding light. Shape-changing is one of the skills of the spirits of heaven.

Tree of Jesse: Jesse was the son of King David. Isaiah prophesied "And there shall come forth a rod out of the stem of Jesse, and a branch shall grow out of his roots: and the spirit of the Lord shall rest upon him" (*Isaiah* 11: 1-0). The idea became popular after it was used in the cathedral at St Denis, the burial place of the kings of France, in the middle of the 12th century.

Virgin: A term commonly used to identify Mary, the mother of Jesus.

Virgin Enthroned: *See* Queen of Heaven.

Woman: A name sometimes used to refer to Mary as an archetype.

Glossary

Abstractionism: Non-representational art, art that does not attempt to depict recognizable figures from reality

ambulatory: In a church or cathedral, an interior walkway around the back of the sanctuary past the chapels of the apse.

arts, seven: In medieval times, following classical traditions, there were seven recognized arts and sciences. The arts were the language-based grammar, rhetoric and dialectic and the sciences were astronomy, geometry, arithmetic and music.

baldachin: A canopy, usually on columns, erected over an altar or carried over the main ecclesiastic in a procession.

Baroque: A style prominent in the 17th and part of the 18th centuries in much of Europe, which featured grandeur, decoration, and drama in art and architecture.

buttress: A buttress supports the pillars or piers at the side of the building. A flying buttress extends out from the top of the walls and distributes the weight of the heavy masonry ceiling down to the huge blocks of masonry that make up the main buttresses.

capitals: The carved or sculpted tops of columns, a feature of architectural styles since ancient times. The Middle Ages introduced narrative scenes as well as continuing to use Corinthian columns or vegetal decorations.

caryatids: Columns in the shape of women who support the porch of the Athenian Erechthion on their heads.

chapels: In a church or cathedral, small spaces each containing an altar, often dedicated to a particular saint.

choir: The part of a church or cathedral that contains the altar. The seats for monks or a choir may still be in place.

clerestory: Above the triforium of a Gothic cathedral are tall windows, which increase the height of the building and are called the clerestory. The builders of the 12th and 13th centuries saw greater height as greater closeness to God and the clerestory allowed light from high up, symbolic of the light of heaven.

Cubism: An early 20th-century movement led by Picasso and Braque that constructed images using angular planes and surfaces.

Dada: An early 20th-century movement that took an anti-art, anti-rational, nihilistic and anarchic stance, challenging ideas such as beauty in art.

Expressionism: An early 20th-century art movement that concentrates on expressing emotion.

Fauvism: Painting from an early 20th century movement that emphasized simple shapes and decorative coloring.

Gothic: A style of late medieval art and architecture, distinguished from the earlier Romanesque by its soaring architecture and great lightness. These effects were made possible by the widespread use of ribbed vaulting and flying buttressing, which reduced wall surfaces and enabled much of the space to be filled with glass. It was originally a somewhat derogatory term introduced during the Renaissance to suggest that it was primitive. Gothic enjoyed a 19th-century revival.

Golden Legend: The Golden Legend is a colorful collection of stories about saints written by Giacomo di Varaggio (circa 1238–98). Throughout the Middle Ages, it was a popular source of stories about Mary and the saints. Some of these stories were considered "traditional" and held to be as true as the stories recorded in the Gospels.

guild: In medieval times and beyond, the tradespeople of various towns were formed into groups or guilds, which controlled some aspects of their activity.

halo: A ring shape painted or carved around the head of a holy person to suggest goodness. Occasionally, Christ's halo takes the form of a cross. It may appear in gold, when it is called an *aureole*.

iconoclast: Literally, a destroyer of images. The iconoclastic movement in the early Christian church, around the 8th and 9th centuries, was rejected by the Second Council of Nicea, a meeting of the bishops of the Christian world. Though rejected, iconoclasm had a lasting influence on eastern and Byzantine art whereas western art shifted more and more towards naturalistic images.

iconography: The use of images, pictures, statues in worship and in holy places, a practice opposed by iconoclasts.

Impressionism: A movement in painting that originated in Paris and flourished especially between 1874–86, breaking with the tradition of history subjects and concentrating on nature and the effects of light.

keystone: The large stone in the middle of an arch or vault.

korai: Young female figures in archaic Greek sculpture (kore in the singular).

kouroi: Young male figures in archaic Greek sculpture (kouros in the singular).

Labors: See also Zodiac. The Labors are cycles of images used in medieval times to depict the various kinds of work throughout the seasons. They are thus often associated with months.

mandorla: An ancient symbol of two circles overlapping to form an almond shape in the middle.

Mannerism: art of a brief period following the Italian Renaissance in which artists asserted individual styles and which focused on stylization.

Minotaur: In legend, this monster lived in a labyrinth below the palace of King Minos, now associated with the archaeological site of Knossos in Crete. The Greek hero Theseus was among the Athenians who were to be sacrificed to the Minotaur. Ariadne helped Theseus to find his way to the center of the labyrinth and take the beast unawares.

modern art: The art of the early and mid 20th century up to about 1970.

narthex: The section of the nave of a church immediately inside the west doors.

nave: The main part of a church building, just beyond the narthex. In French churches and cathedrals built in the Middle Ages, there will often be transepts crossing in front of the altar.

ogive: Ribs of stone, which cross in the middle of the stone ceiling of a medieval cathedral.

ostium: Sentry-like box shapes on the exterior of a cathedral.

parvis: The area in front of the west façade of a cathedral. The term probably derives from the word paradise.

plein-air painting: Painting in the open air, as opposed to in the studio.

Post-Impressionism: Some painters who identified with the Impressionist group when they were young developed mature styles that were quite different in spirit from Impressionism. Cézanne, Van Gogh and Gauguin are the best-known examples. They branched into forms of (or predecessors of) Abstractionism, Expressionism, and Symbolism.

rayonnant: The form of intricate Gothic architecture that spread from France in the 13th century.

Renaissance: Essentially the term refers to Western European art of the 15th and 16th centuries, although some critics include the 14th century. It was concerned with the classical past and with the growing humanism of the day.

Rococo: An early 18th-century style that favored intricate decoration.

Romanesque: The art and architecture of the Middle Ages between the Carolingian period (the 9th century) and the beginning of the Gothic period in the 12th century. It was particularly strong in the south of France and would have formed the ideas and practices of many of the sculptors of early Gothic works in Chartres and Paris.

Salon des Refusés: An exhibition set up in 1863 by Louis Napoleon for painters who had been refused space on the walls of the Academy's official Salon. The exhibition included work by Impressionists, including Manet's *Déjeuner sur l'Herbe*. In an era when dealers were scarce, the salons were an important way to become known to patrons and purchasers. The Salon des Refusés was not repeated, but the major Impressionists continued to be rejected by the official Salon.

sanctuary: The part of the church with the altar and hence the center point for the main rituals performed in the church. In the Middle Ages, the sanctuary was often screened from ordinary folk, whereas today the sanctuary and altar are open to view.

Surrealism: An art movement that began in 1924 and which focused on the irrational subconscious.

thurible: An incense burner used in church and swung on light chains to emit puffs of incense.

triforium: The upper gallery around the nave of a church.

tympanum: The part of the doorway inside the arch and above the lintel or top of the door frame. It is often semi-circular.

vault: The ceiling in the shape of an arch, rising from columns.

voussoirs: The channels inside the arches and around the tympanum. An *archivolt* is a carved voussoir.

zodiac: The signs of the zodiac were much in favor in the 12th century. The signs are based on symbols, beasts, and personages that can be seen in the stars and are thought to effect human events. In medieval art, they were related to months of the year and the activities or labors typical of life at the time. They appear on the portals of some cathedrals and often in their stained glass windows.

Index